ALSO BY ELIZABETH BARLOW ROGERS

The Forests and Wetlands of New York City

Frederick Law Olmsted's New York

The Central Park Book

Rebuilding Central Park: A Management and Restoration Plan

Landscape Design: A Cultural and Architectural History

Romantic Gardens: Nature, Art, and Landscape Design

Writing the Garden: A Literary Conversation Across Two Centuries

Learning Las Vegas: Portrait of a Northern New Mexican Place

GREEN METROPOLIS

GREEN METROPOLIS

*The Extraordinary Landscapes of New York City
as Nature, History, and Design*

ELIZABETH BARLOW ROGERS

Foreword by Tony Hiss

Alfred A. Knopf New York 2016

THIS IS A BORZOI BOOK PUBLISHED BY ALFRED A. KNOPF

Copyright © 2016 by Elizabeth Barlow Rogers

All rights reserved. Published in the United States by Alfred A. Knopf, a division of Penguin Random House LLC, New York, and distributed in Canada by Random House of Canada, a division of Penguin Random House Canada Ltd., Toronto.

www.aaknopf.com

Knopf, Borzoi Books, and the colophon are registered trademarks of Penguin Random House LLC.

All photographs not otherwise credited are by the author.

Library of Congress Cataloging-in-Publication Data
Rogers, Elizabeth Barlow, [date]
Green metropolis : the extraordinary landscapes of New York City as nature, history, and design / Elizabeth Barlow Rogers.—First edition.
pages cm
"A Borzoi book"—Title page verso.
ISBN 978-1-101-87553-7 (hardcover)—ISBN 978-1-101-87554-4 (eBook)
1. Natural areas—New York (State)—New York—History. 2. Parks—New York (State)—New York—History. 3. Landscapes—New York (State)—New York—History. 4. Human ecology—New York (State)—New York—History. 5. Urban ecology (Sociology)—New York (State)—New York—History. 6. Natural history—New York (State)—New York. 7. Urban ecology (Biology)—New York (State)—New York—History. 8. City planning—Environmental aspects—New York (State)—New York—History. 9. New York (N.Y.)—Environmental conditions. I. Title.
QH76.5.N7R64 2016
508.747'1—dc23 2015021505

Jacket illustration by Ben Wiseman
Jacket design by Janet Hansen
Maps by David Lindroth

Manufactured in Malaysia
First Edition

For

Lisa and David

CONTENTS

Foreword: Legacy ix

Preface xiii

CHAPTER 1
GREEN METROPOLIS:
BIRTH OF A LANDSCAPE
3

CHAPTER 2
GREEN WOODS AND SEVENTEEN-YEAR CICADAS:
STATEN ISLAND
15

CHAPTER 3
GREEN MARSHES AND TROUBLED WATERS:
JAMAICA BAY
41

CHAPTER 4
GREEN FOREST AND INDIAN SHELTER:
INWOOD HILL PARK
71

CHAPTER 5

GREEN HEART:
CENTRAL PARK RAMBLE

89

CHAPTER 6

GREEN COMMUNITY AND WHITE MEMORIAL:
ROOSEVELT ISLAND AND
FOUR FREEDOMS PARK

135

CHAPTER 7

GREEN GARBAGE:
FRESHKILLS PARK

165

CHAPTER 8

GREEN PROMENADE AND ELEVATED RAIL SPUR:
THE HIGH LINE

181

Directions to Places Described in This Book *205*

Acknowledgments *207*

Bibliography *209*

Index *211*

FOREWORD

Legacy

TONY HISS

Among her many exceptional talents, Betsy Barlow Rogers, who a generation ago organized Central Park's rescue when it was at the point of collapse, is an urban trailblazer—a pusher of the envelope, a seer into the beyond—who compiles compelling, meticulously and joyfully observed *Won't you join me?* updates from a landscape whose very existence she helped reveal: the deep countryside still spread out across all five boroughs of densely settled New York City. In *Green Metropolis,* which is in part a tapestry woven from such accounts, she joins, at one point, a small group that, on a single, two-hour forest walk on Staten Island, uncovers forty-five species of mushrooms just by peering around tree stumps and under fallen leaves. On another day, in Queens, sloshing in waders through shallow waters in Jamaica Bay, the great estuary that's perhaps twenty-four times the size of Central Park, she has to make way for shorebound horseshoe crabs, whose ancestors began crawling onto sandy beaches in springtime hundreds of millions of years ago, that are gently but insistently bumping against her legs.

On another Staten Island hike, through old woods in High Rock Park renowned for their tranquillity, she is immersed by a loud ringing sound "something between a singing steam kettle and jingle bells." Coming from overhead and from every point in the compass, this is a chorus produced by thousands of male, mate-seeking "seventeen-year locusts," or cicadas, which for only a few days will remain perched in the branches of the tall High Rock trees. A century ago, during an earlier cicada cycle, *The New York Times* likened this overwhelming song to the "simultaneous tuning of all the fiddles in the world." Whenever it recurs, as it has for the last half-million years, it is, collectively, as loud and insistent as a snowmobile or a motorcycle, as shocking and inescapable as a thunderclap at dawn.

Spoiler alert: Individually these adventures are vivid; cumulatively, they can rearrange your mind so thoroughly you never look at things the same way again. In 1971, Betsy Rogers's first book about exploring the city's countryside, *The Forests and Wetlands of New York City,* was exactly the kind of awakening jolt for many people that *Green Metropolis* will now be for many more. In retrospect, that earlier book was more like the short story or sketch that years later would emerge as a many-layered, multidimensional, fully realized work (but narrated with the same lightness of touch). *Forests and Wetlands* demonstrated once and for all that, damaged and ignored as it was, behind the buildings and under the asphalt, the preexisting natural New York is a permanent presence and resident in the city, its strength and resilience marvelously intact. It has friends—fierce champions in each borough and every neighborhood. Without ever saying that this was what she was up to, Betsy Rogers had flipped figure and ground, and you could no longer *not* see a "green metropolis" wherever you looked.

Green Metropolis has an advantage, because now there's so much more to report on. *Forests and Wetlands* was a *before* book, a prelude: Central Park and Prospect Park and dozens of other languishing

North American city parks had not yet been restored and transformed; the genius of their designer, Frederick Law Olmsted, was still only about to be rediscovered, and volume after volume of his papers and plans and dreams were not yet in print. His deep-rooted understanding of parks and people was not yet the guiding principle it has since become: the idea that parks are a physical embodiment of modern democracy, an actual melting pot where people from all walks of life can find their common humanity.

These recent upheavals in attitudes and approaches give *Green Metropolis* a special, buoyant flavor. Acting locally, for instance, is altogether essential for acting globally. Redesigning the Ramble in Central Park—one of Betsy Rogers's new stories—so that its beautiful woods have "unsightly" stumps, creates habitat for birds and grows the insects they eat. This also maintains the integrity of the hallway in one of the longest "homes" anywhere: migratory birds aren't so much en route somewhere as they are moving around within a unified, three-dimensional, hemisphere-encompassing air-and-land continuum, an immense structure that twice a year allows millions of them to shuttle back and forth between South America and Canada.

Perhaps the most fascinating of these many new stories, one that's both sobering and exhilarating, is *Green Metropolis*'s account of how we've finally outgrown what Betsy Rogers calls "marshfill"—her word for "landfill," itself a spuriously clean-sounding word for dumping garbage and rubble into wetlands along the edges of the city. The excuse, the punch line, the lollipop at the end of the ordeal, was that someday the landfills would be closed, capped, and turned into parks. With the discovery that wetlands are ecologically golden—intense incubators of life that also hold back floodwaters and storm surges—this had to stop, but the aftermath has been unexpected.

Take the tale of two Staten Island swamps: Great Kills Park, a capped landfill that became a city park in 1949, and Freshkills Park, whose 2,500 acres were once the largest landfill in the world, home of

"Mount Trashmore," a garbage heap taller than the Statue of Liberty. Half a century after it became a park, a police helicopter looking for terrorist activity discovered that the landfill under Great Kills had always been radioactive; now 265 acres there will be closed until at least 2020. Meanwhile, Freshkills, moving ahead far more carefully, won't fully open as a park for maybe thirty more years. Its master plan by the landscape architecture firm Field Operations imaginatively calls for crops of green kale and yellow mustard to be planted so they can be plowed under and enrich the soil. In the meantime, goats are periodically brought in to suppress the rampant growth of phragmites.

A word of caution: Don't look here for Betsy Barlow Rogers's own story; with characteristic modesty, she simply omits it. But as it says inside St. Paul's Cathedral in London about its great builder, Sir Christopher Wren: *Si monumentum requiris, circumspice.* If you seek [her] monument, look around. The next time you're walking through the Green Metropolis of New York, look around. You'll see Betsy Rogers.

TONY HISS
NEW YORK CITY
APRIL 2016

PREFACE

Green Metropolis. New York City. It sounds like a dichotomy. It is not.

In this book, we will initially reconstruct what we can of the patrimonial ecology of the five boroughs-to-be that would one day coalesce into a municipal entity known as Greater New York. But this is not simply a narrative of how nature was overlain by successive layers of urbanization, leaving only faint tracings on a cartographic palimpsest. Rather, it is an exploration of seven New York City landscapes—adventitious and designed, historic and contemporary, wild and managed.

The places discussed in this book—Staten Island, Jamaica Bay, Inwood Hill, the Ramble in Central Park, Roosevelt Island, Freshkills, and the High Line—are only fragments within the larger mosaic of New York City's public parks. Chosen for the stories they tell about urban nature, history, and landscape design, they fit within the context of the physical and cultural factors that have governed the city's growth and the building of its park system. It is therefore worth reviewing in brief the successive eras in which this constellation of green spaces has taken shape.

In the nineteenth century, when America came of age as an industrial and mercantile nation, New York City experienced exponential growth. It was incumbent upon its civic leaders to create

rural cemeteries—nondenominational exurban burying grounds—
to replace crowded churchyards. Brooklyn's Green-Wood Cemetery,
established in 1838, is an example of nineteenth-century Romantic
landscape design where the bereaved could find solace in nature. As a
place where half a million New Yorkers a year went for Sunday out-
ings, it became a potent inspiration for the creation of public parks.

In their plan for Central Park in 1858 and Prospect Park in 1866,
designers Frederick Law Olmsted and Calvert Vaux took nature as
their muse. They envisioned these landscapes as inspiring and relax-
ing pastoral retreats from the stresses of nineteenth-century city life
as well as major components in an urban-planning framework that
included the then-innovative concept of the parkway. Moreover,
they firmly believed that parks, as places accessible to all classes of
society, were fundamental attributes of democracy.

Central Park's popularity sparked the impulse to provide addi-
tional New York City parks to serve as scenic and recreational spaces
for an ever-growing populace, including the ranks of immigrants liv-
ing in crowded tenements. In a foresighted extension of the original
nineteenth-century parks movement, land was acquired beyond the
Harlem River, in what is now the Bronx, for the creation of Clare-
mont, Crotona, Pelham Bay, Van Cortlandt, and Bronx Parks, to-
gether with rights-of-way for their linking arteries—the Mosholu,
Pelham, and Bronx River Parkways.

With growing interest in the natural sciences, Bronx Park became
the site of two important institutions: the New York Botanical Gar-
den and the New York Zoological Society. Founded by nineteenth-
century Gilded Age magnates, these landscapes are dedicated to the
display and conservation of nature in both its exotic and native forms.

With the advent of the twentieth century, the popularity of out-
door games and sports took precedence over the preservation of sce-
nic retreats, especially during the time when Robert Moses served as
parks commissioner between 1934 and 1960. During these years play-

grounds, swimming pools, ball fields, golf courses, basketball courts, and other kinds of sports facilities were built, some in existing historic parks and others atop recently decommissioned landfill sites.

By the 1960s, citizens' initiatives to protect the city's remaining green spaces from Moses's proposed encroachments began when land reserved for a highway running down the central spine of Staten Island was saved as a greenbelt and wildlife sanctuary. Civic organizations' fighting against further intrusion of recreation facilities into naturalistic park landscapes also dates from this time. The actual restoration and renewed management of historic parks became formalized with the creation of public-private park partnerships, beginning with the Central Park Conservancy and Prospect Park Alliance in the 1980s.

In the meantime, Welfare Island was renamed Roosevelt Island in honor of the thirty-second president of the United States. This was the first step toward the fulfillment of a 1960s urban renewal dream: the construction of a "new town in town." The second step, the building at the island's southern tip of architect Louis Kahn's unified design for the FDR Memorial and Four Freedoms Park, did not occur until forty years later because of Kahn's untimely death in 1974 and fiscal constraints leading to the withdrawal of anticipated funding by New York State. The now realized memorial and park constitute a single modernist plan in which the monument—a three-sided roofless "room" formed of white granite slabs—is approached by the park's triangular, downward-sloping lawn bordered by twin allées of linden trees.

As landscape architects today increasingly engage in projects to reclaim obsolete and decayed portions of the urban fabric, a new aesthetic of industrial poetics governs design, and sustainability has become a byword. On Staten Island, Fresh Kills, the country's largest former landfill site, is in the process of becoming a 2,200-acre park. The environmental ramifications of decades of garbage dumping is guiding the designer's methodology, which is based not on a

construction blueprint but rather on a thirty-year program of ecological regeneration. What makes Freshkills Park particularly interesting is the fact that much of this plan is guided less by design intention than by partnering with serendipitous nature.

Nature is on an equal footing with the park planner at the High Line, too, another of the city's anomalous landscapes. Spontaneous vegetation springing up amid the ballast and rotting ties of abandoned tracks provided the design template for the rail spur's transformation into an early-twenty-first-century park.

In the first chapter, a natural-history overview of the entire city, and in the subsequent chapters focusing on selected individual parks, it will become evident that this book's underlying theme is that nature is ubiquitous, a dynamic force that, historically and now, makes New York City intrinsically a green metropolis.

GREEN METROPOLIS

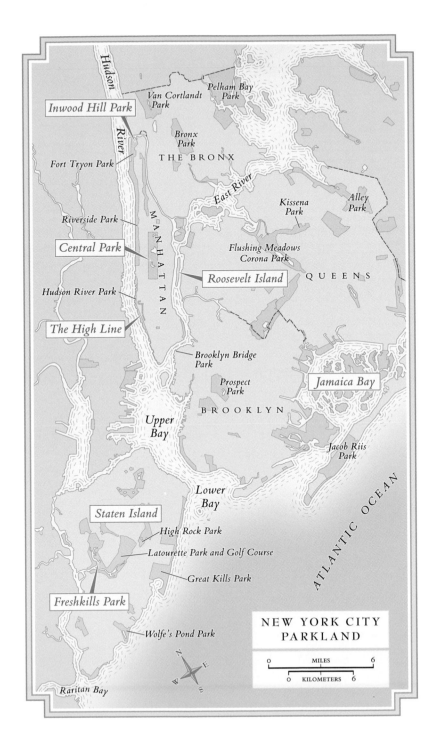

Hudson

Van Cortlandt
Park

Pelham Bay
Park

Inwood Hill Park

River

Bronx
Park

THE BRONX

Fort Tryon Park

East River

Kissena
Park

Alley
Park

Riverside Park

MANHATTAN

Central Park

Flushing Meadows
Corona Park

Roosevelt Island

QUEENS

Hudson River Park

The High Line

Brooklyn Bridge
Park

Prospect
Park

Jamaica Bay

BROOKLYN

Upper
Bay

Jacob Riis
Park

Lower
Bay

Staten Island

ATLANTIC OCEAN

High Rock Park

Latourette Park and Golf Course

Great Kills Park

Freshkills Park

Wolfe's Pond Park

N
W E
S

Raritan Bay

NEW YORK CITY
PARKLAND

0 — MILES — 6

0 — KILOMETERS — 6

GREEN METROPOLIS
Birth of a Landscape

Long before the city became real estate, divided and occupied in accordance with political and economic dictates; long before it became imprinted with human occupation; in fact, long before the human species even existed, there were the land and the sea. And just as the New York of real estate and urban planning is dynamic—a city constantly erasing and rebuilding itself—the New York of bedrock, sand, and water is forever altering itself as well, responding to the forces of geology and climate. Yet it remains difficult for us to accept the notion that the earth's geography is mutable and that even in our own lifetimes the only real permanence is change.

However, it is the particular circumstances of mobile nature within our own sliver of human history that account for the fact that a small Dutch colonial trading post became a great metropolis. Because of its large, protected, womb-shaped harbor configured by glacial deposits during the last ice age, a better situation for a port could not have been devised. Nor, because of its firm basement of tough, metamorphic bedrock, could a more ideal spot be imagined for the growth of

the skyscraper. Its temperate climate and abundant forests and wet-lands made it an ideal habitat for both wildlife and humans. Our narrative of its creation, transformation, and resilience therefore begins with the fundamentals of this extraordinary landscape—its bedrock basement and overlying mantle of vegetation with their related biota. To understand the city as nature and place requires taking a mind-boggling long view going back in time hundreds of millions of years.

The Bedrock Basement

The latest topographical configuration of New York City, the one we know at present, is essentially the product of powerful manipulation of the earth's crust through subsurface dynamics. Scientific knowl-edge of this process is a relatively recent development, dating from the late 1950s and early 1960s, when geologists and oceanographers began to understand the phenomenon of plate tectonics, a process that explains why continents drift and oceans shrink or spread apart.[*]

There are currently seven or eight major lithospheric plates be-neath the surface of the earth that are continually moving at in-finitesimal rates over vast stretches of geological time, altering the geography of the globe. As they shift position they slowly collide, separate, or grind against one another as they pass in opposite direc-tions. The impact of colliding plates causes subduction—the sideways and downward movement of the edge of one plate into the mantle beneath the other plate. As this lateral compression progresses, the earth's crust is folded into mountain ranges while below the surface bedrock strata are deformed by heat from the mantle, friction from

[*] To visualize this ongoing phenomenon, notice on a world map the jigsaw puzzle–like cor-respondence between the coastlines of South America and Africa, which are moving apart at a rate of a few centimeters a year.

the moving plates, and pressure from the overburden. Geologists call such episodes in earth history orogenies, and the rocks whose mineral structures have recrystallized under such turbulent conditions are known as metamorphic.

New York City's basic geologic structure is composed of three strata of metamorphic rocks. The Grenville orogeny, a cycle of mountain-building episodes occurring some 1,150 to 950 million years ago, created Fordham gneiss, the city's primary bedrock. It can be found as outcrops in the New York Botanical Garden and elsewhere in the Bronx. The two younger metamorphic strata formed during the Taconic orogeny approximately 495 to 440 million years ago, when plate collision and subduction caused a mountain range

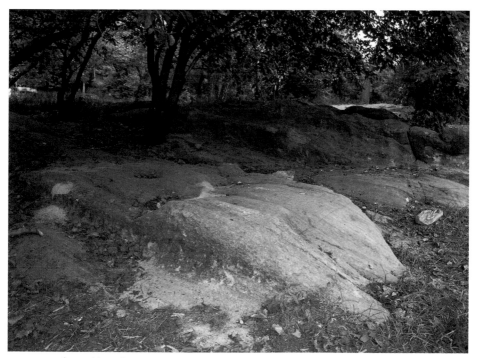

Inwood Marble, Isham Park

of Alpine proportions to rise in the eastern portion of Laurentia, forerunner of the North American continent. During this time limestone, a sedimentary rock derived from calcium carbonates deposited in the shallows of the seabed on top of the eroded surface of Fordham gneiss, metamorphosed into marble (locally known as Inwood marble after the Inwood section of Manhattan, where it can be seen in a few exposed surfaces). At approximately the same time, shale, another sedimentary rock formed of solidified mud sediments resting in deeper waters, metamorphosed into schist. During the Taconic orogeny, its regional variant, Manhattan schist, was shoved above the Inwood marble as subduction was occurring.

During the Acadian orogeny minerals of igneous origin, such as quartz and feldspar, were injected into fissures and cracks of the existing metamorphic rocks. At the same time slippage occurred, and the displacement and discontinuity between some strata created geological fault zones, which allowed a more significant intrusion of molten subterranean material into the bedrock. When cooled, crystallized, and solidified, this igneous intrusion formed dikes and sills.[*]

Where there was stratigraphic slippage, fault zones—areas of displacement and discontinuity—between strata occurred. Dyckman Street, 125th Street, and Broadway between Seventy-Second Street and Columbus Circle all follow the lines of geologic faults.

The Ice Age

Fast-forward hundreds of millions of years to the Pleistocene epoch, which occurred between 2,588,000 and 11,700 years ago. During that

[*] A dike cuts across layers of the parent rock; a sill is formed when the igneous material is intruded parallel to them. For example, the New Jersey Palisades are a sill, a solid wall whose tough igneous stone confines the west bank of the Hudson River.

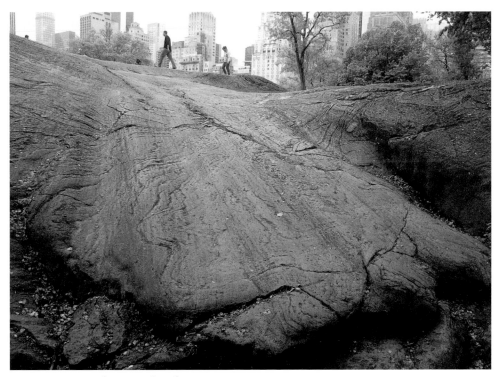

Umpire Rock, Central Park

Kettle-hole pond, Staten Island

period a series of huge ice sheets pushed down from the Arctic to cover portions of Europe and North America. The terminus of the most recent advance, the Wisconsin glacier, is imprinted on the landscape of the modern city. At this time, a wall of ice approximately two miles in height covered what are now Canada and the northern United States. As it thrust southward into the New York City region 21,500 years ago, the accumulated rocks, gravel, and other abrasive debris in the base of the ice scoured the eroded stumps of the orogenic mountains that had stood on the site several hundred millions of years earlier. When the glacier retreated from the area around 11,000 years ago, it left in its wake a landscape of hills, random boulders, an alluvial outwash plain, and lakes and ponds where chunks of melting ice had been trapped in the glacial till.

A long, ridgy mass of till, marking the final stage of the glacier's advance, created the hills of Brooklyn, Queens, and Staten Island (except for the latter's high spine of serpentinite). More till, dropped by the glacier over the mouth of the Hudson River, constricted New York Bay into the Narrows and left an elevated bracket since furnished with defensive outposts (Fort Hamilton in Brooklyn and Fort Wadsworth on Staten Island). Not only was this an ideal geographical configuration from a military perspective, but the harbor had ample protected shoreline for docks.

Thus, geology is the foundation of New York's historical evolution into one of the great port cities of the world.

The Green Mantle

In most of North America, the plants known today existed before glaciation occurred. As the huge mass of ice moved like a monolithic bulldozer across the land, plant communities shifted southward and reestablished themselves in a more temperate zone. With climatic

Salt marsh, Udalls Cove

warming as the ice retreated, the newly naked landscape would become revegetated. First solid ice was replaced by tundra mixed with hardy evergreens. Next, stands of spruce, birch, and pine were established. Then a pine zone with an admixture of oak and hemlock took hold, after which a deciduous forest of oak, hickory, and chestnut became predominant. Today this latest succession of trees is being altered by the immigration of more southern species as warmer environmental conditions are established in northern zones.

Included in this evolutionary pattern of botanical fluctuation were the wetlands established in the postglacial era when erosion deposited sediments forming flat, sandy beds in coves protected from the force of the beating surf. Beginning some 4,000 years ago in the intertidal zones where seawater mingles with freshwater, these marshes began

to grow in several places along New York City's more than 500 miles of shoreline. Here grasses with roots that trapped tide-transported sediments adapted to conditions of semi-salinity, which produced thick mats of cordgrass (*Spartina alterniflora*). Multi-branched, meandering tidal creeks traced sinuous courses through them. In the wetter areas along their banks, tall cordgrass was dominant; the upland marsh, which was inundated only at high tide, was colonized by the short salt-meadow grass *Spartina patens*.

Such was the landscape of forests and wetlands inhabited by Native Americans and beheld by the European sailors 400 years ago, a scene that was soon transformed as settlers planted seeds, slips, and roots brought from their homelands.

In addition, New York City's native plant communities were vastly augmented in the nineteenth century, a golden age of botanical discovery both in America and throughout the global network of European colonies. In 1801 Dr. David Hosack, a physician, botanist, and professor of medicine at Columbia University, established the Elgin Botanic Garden on a twenty-acre tract he purchased, on the site now occupied by Rockefeller Center. By 1805 he was able to publish a catalogue listing 1,500 plant species. Some he had propagated from seeds sent to him by Thomas Jefferson, who was particularly active in the international circle of botanical correspondents.

Flushing, a religiously tolerant community settled by Quakers and Huguenots, was especially hospitable to the early horticultural trade. William Prince's eighty-acre nursery specialized in newly discovered American species, many of which were propagated from seeds collected on the Lewis and Clark expedition. A member of the London, Paris, and New York horticultural societies, Prince imported European and Asian plants and bred fruit trees and roses. His 1828 publication, *A Short Treatise on Horticulture,* was the first such work to be written on the subject in the United States. The nursery was

taken over prior to Prince's death by his sons, William and Benjamin, who divided it into two sections. William called his part the Linnaean Botanic Garden, highlighting the nursery's role in taxonomic education, whereas Benjamin named his portion the Old American Nursery as a reminder of its origins prior to the Revolutionary War.

Samuel Bowne Parsons, who founded another nursery in Flushing in 1838, was an important source of many of the foreign and native species that were planted in nineteenth-century American gardens. Parsons introduced the flowering dogwood from the American South and was for several years the only commercial grower of hardy rhododendrons and azaleas in the country. He was also responsible for obtaining the seedling of a European weeping beech. With pendulous branches touching the ground, the tree lived for 151 years, becoming in time a prized Flushing landmark. In addition, Parsons is credited with importing the first frost-resistant honeybees into this country.

The Flushing nurseries continued to thrive throughout the nineteenth century. Catering to contemporary society's growing interest in botany, their proprietors had agents scour Europe for new plants and often commissioned ship captains to bring back seeds and slips from China and Japan. The plants they collected included such exotics as the Lombardy poplar, cedar of Lebanon, paulownia, copper beech, Japanese maple, and Langtang larch. Because it occupies the site of the old Parsons nursery, Kissena Park in Queens contains several such botanical specimens, now grown to venerable proportions.

Parks built on the grounds of former estates have similar treasures. In certain areas—notably the ridge overlooking the Hudson in Inwood Hill Park and Hunter Island in Pelham Bay Park—a few stately trees planted by landowners a hundred or more years ago still stand like distinguished foreign dignitaries at a reception, while native trees of a second-growth forest, eager to pay their respects, shoulder up around them.

The Palimpsest

What if, as in time-lapse photography, we could turn the clock back 400 years and view New York City's landscape as it was when European mariners first beheld it and then watch its transformation from then to the present day?

Upon entering the harbor, they took note of the fact that the tall trees on Staten Island would make good masts for ships. They also speculated optimistically about the mineral richness of its hills. Then there were the island's great meadows of salt grass. Similar wetlands, rich breeding grounds for fish and shorebirds, fringed the shorelines of the other future boroughs—the Bronx, Brooklyn, Manhattan, and Queens. In the then-unpolluted bays, there were thousands of oyster beds. Offshore, whales were common. Native Americans tilled the soil, stalked the forests for game, made trails through valleys, created wigwams of bent saplings and tree bark along shorelines, and formed middens—trash heaps—from discarded shells of mollusks harvested from adjacent waters.

Over the next 400 years, nature's rich legacy in New York was transformed and subdued by development of such scope and scale that the city appears to be almost entirely a human artifact. River-girt Manhattan is a glittering assemblage of concrete, glass, and steel—hard-edged and emphatic like some giant, improbable ship—while, surrounding it, waves of low-rise apartments and attached houses wash over the outer boroughs. Nevertheless, Manhattan has something approaching a wilderness in Inwood Hill Park at its northern tip. There, a tall forest grows on a steep ridge, and you can still see embedded in one side an overhanging slab of fallen schist—romantically dubbed the Indian Cave—where Native Americans once sheltered. Elsewhere an abundance of ecosystems flourish. They are found not just in gardens,

parks, and cemeteries, but in unexpected nooks and crannies: sidewalk cracks, wall crevices, sheltered undersides of building cornices, and the vertiginous tops of bridge girders.

In other words, nature is not the antithesis of urban. It is everywhere—underfoot, overhead, and all around us.

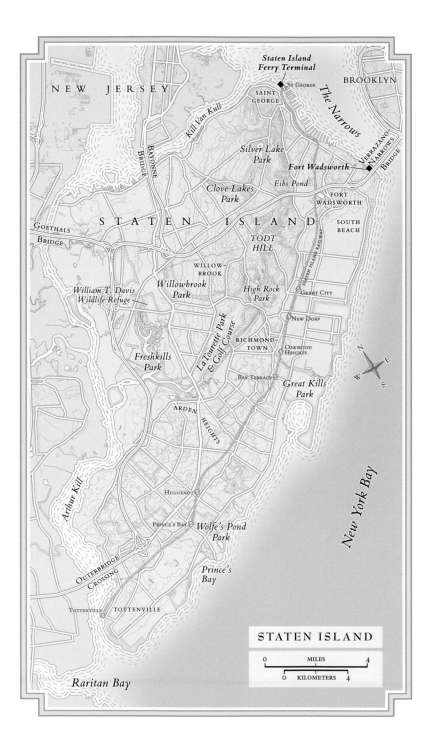

NEW JERSEY

Staten Island
Ferry Terminal

BROOKLYN

ST GEORGE

SAINT
GEORGE

Kill Van Kull

The Narrows

*Silver Lake
Park*

Fort Wadsworth

VERAZANO
NARROWS
BRIDGE

Eibs Pond

BAYONNE
BRIDGE

*Clove Lakes
Park*

FORT
WADSWORTH

S T A T E N I S L A N D

SOUTH
BEACH

GOETHALS
BRIDGE

*TODT
HILL*

WILLOW-
BROOK

*Willowbrook
Park*

*William T. Davis
Wildlife Refuge*

*High Rock
Park*

GRANT CITY

NEW DORP

*La Tourette Park
& Golf Course*

RICHMOND-
TOWN

OAKWOOD
HEIGHTS

*Freshkills
Park*

BAY TERRACE

*Great Kills
Park*

ARDEN
HEIGHTS

N

W E

S

Arthur Kill

HUGUENOT

New York Bay

PRINCE'S BAY

*Wolfe's Pond
Park*

OUTERBRIDGE
CROSSING

*Prince's
Bay*

TOTTENVILLE TOTTENVILLE

Raritan Bay

STATEN ISLAND

0 MILES 4

0 KILOMETERS 4

CHAPTER TWO

GREEN WOODS AND SEVENTEEN-YEAR CICADAS

Staten Island

In 1524 a three-masted carrack named *La Dauphine* appeared in New York Harbor. Its captain, Giovanni da Verrazzano, described the Upper Bay as a "very beautiful lake." He named it the Bay of Saint Marguerite in honor of Marguerite of Angoulême, sister of his patron, King Francis I. The seafarers landed briefly on Staten Island, welcomed by natives "uttering very great exclamations of admiration." They left hastily at the onset of a storm, but "with much regret because of its convenience and beauty, thinking it was not without some properties of value, all of its hills showing indications of minerals."

Because of his tantalizing glimpse of what lay beyond New York's constricted harbor passageway, Verrazzano's name is memorialized (if misspelled) in the Verrazano-Narrows Bridge. Finished some 440 years after the *Dauphine*'s historic visit, the bridge is the most conspicuous of four threads that stitch the island to the surrounding urban fabric. The three others link Staten Island to New Jersey: the

Goethals Bridge and Outerbridge Crossing spanning the Arthur Kill and the Bayonne Bridge traversing the Kill Van Kull. Once an undeveloped, rural borough of farms and villages—St. George, Tompkinsville, Clifton, New Dorp, and Stapleton on the north shore; Richmondtown in the center; and Tottenville at its southern tip—Staten Island is no longer isolated and remote.

The only significant part of the island that might resemble the scene that greeted Verrazzano is a chain of open spaces that includes the historic Moravian Cemetery, High Rock Nature Center, LaTourette Park, and 400-foot-tall Todt Hill—the highest natural point on the eastern seaboard from Florida to Cape Cod. These constitute the hilly eastern arm of a U-shaped greenbelt. The western arm contains the William T. Davis Wildlife Refuge, a combination of marsh and woodland. Within this green U flow the branching tributaries of Fresh Kills, the drainage system for the once-vast marshes that covered the western end of the island.

Naturalists' Cradle

It is not accidental that in the nineteenth century, when the natural-science professions were mostly in their infancy, Staten Island produced a number of distinguished scientists. These included geologists Louis Pope Gratacap and John J. Crooke and botanists Nathaniel Lord Britton and Arthur Hollick, coauthors of *The Flora of Richmond County,* the definitive volume on the botany of the island.

A younger generation, which made its contribution to unraveling the mysteries of nature on Staten Island and also achieved professional distinction in the world at large, was made up of a trio of high school friends: James Chapin, who became an ornithologist with the American Museum of Natural History and a member of the expedition that assembled the museum's first collection of the birds of Africa; Alan-

son Skinner, whose discoveries of Indian remains on Staten Island led him to become an archaeologist; and Howard Cleaves, a pioneer wildlife photographer and lecturer on the Audubon circuit.

Bridging these two generations of Staten Island natural scientists was William T. Davis, whose specialty was entomology. Davis made a lifelong study of cicadas, particularly those whose nymphs emerge from the ground on a precise seventeen-year cycle. As a youth, he was a disciple of the entomologist Augustus Grote and went on field expeditions with Hollick, Britton, and Gratacap. Later, he would serve as a mentor to Chapin, Skinner, and Cleaves, when they were boys, accompanying them on long rambles all over the island. The essence of their explorations is vividly captured in a slender little volume, *Days Afield on Staten Island,* which Davis published at his own expense in 1892. It has since become a minor classic in the literature of local nature.

At the time he wrote the book, Davis could admire across the island's entire breadth the wild, unaltered scenery today confined to the Staten Island Greenbelt: "The red maples are aglow, the pussy willows invite the bees and those big burly flies, with hairy bodies, that fly with ponderous inaccuracy. The marsh marigolds spread their yellow flowers, and the hermit thrush sits silently on the trees, his shadow cast, mayhap, in some dark, leaf-laden pool."

Geology and Botany

In geological terms, the seemingly primal island landscape admired by Davis was only the latest result of several mighty transformations. Its hilly central spine of serpentinite is a greenish igneous stone composed of ferromagnesian minerals formed in the Lower Paleozoic era about 430 million years ago during the Taconic orogeny, the same crustal uplift caused by the continental-plate collision that created the

rest of New York City's bedrock basement. Several geologic eons after the creation of the serpentine, another igneous rock, the Palisades diabase, was formed. Rising as ramparts along the New Jersey shore of the Hudson River, this sloping rock formation penetrates Staten Island, sinking belowground a few hundred yards west of the 428-acre William T. Davis Wildlife Refuge.

Seventy thousand years before the Wisconsin glacier that covered the northern four-fifths of Staten Island during the Pleistocene period scoured the iron-rich serpentine, Staten Island was a warm, semitropical swamp. Writing in 1909, the geologist Gratacap reconstructed the landscape of that remote time, the Cretaceous period of geologic history, as "a deeply foliaged low, outstretched forested plain, with sluggish streams, embayments, fresh lagoons, and swampy ponds, on which a sun of semitropical intensity shone with changing accidents of storm and flood and steaming fog, while a persistent sedimentation in the whirling or quiescent waters built up the clay reefs, shoals, and beds." These deposits, termed the Magothy formation by later geologists, can be seen around Tottenville and Kreischerville (now known as Charleston) at the unglaciated southern tip of the island. The clay beds at Kreischerville were used during the second half of the nineteenth century for the manufacture of firebricks, drainpipes, and gas retorts.

Over time, both the serpentinite and diabase became exposed through erosion, and as the glacier melted, it left in its wake large chunks of bedrock plucked from elsewhere and transported during the course of its advance. It also deposited mounds of debris, sculpting the landscape into a topography of hilly knobs and valleys marked with kettle-hole ponds. Between the serpentine and diabase is a bed of glacial outwash, its water-retentive gravel forming an aquifer. Cold, pure water used to burst spontaneously from the ground in such abundance that the locality was given the name Springville.

Before Catskill water was piped to Staten Island, the Springville

aquifer was of commercial importance. The Davis Refuge owes its existence to the dissolution of the Crystal Water Company, which exploited the aquifer, and the sale of the company's lands to the New York City Department of Parks & Recreation. Water still percolates to the surface around the now-capped wells, making boggy rings within the forested refuge.

By 1609, when Henry Hudson sailed the *Half Moon* into the waters so briefly visited by Verrazzano eighty-five years before, Staten Island's postglacial vegetation had evolved into a thick forest "full of great and tall oaks," according to Robert Juet, diarist of the voyage. Occupying the island were the Lenni Lenape, whom Juet described as going about "in deer skins loose, well-dressed." At the turn of the twentieth century, when William T. Davis spent days afield with his

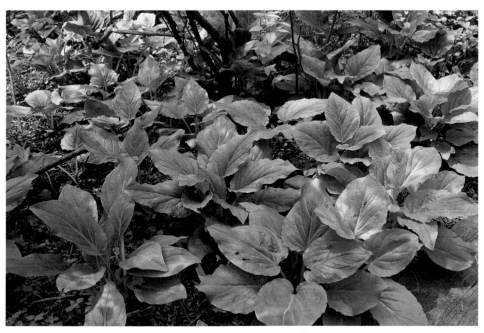

Skunk cabbage growing in bog, William T. Davis Refuge

protégé Alanson Skinner, the Staten Island shore was dotted with shell heaps and mounds of Indian artifacts.

Settlement

The landscape of the island was altered little during its centuries of Native American occupation. When the Dutch ruled New Amsterdam, fitful attempts at colonization began. On January 5, 1639, the patroon David Pietersz. de Vries, to whom title to the island had been granted, sent over a group of settlers. A few months later, some of de Vries's swine were stolen by the New Jersey Raritans. Willem Kieft, director of New Netherland, against de Vries's wishes sent one hundred troops from Fort Amsterdam to exact revenge. According to de Vries's description of the incident, several Indians were killed and the brother of the chief was captured and "misused . . . in his private parts with a piece of wood," adding, "Such acts of tyranny were . . . far from making friends with the inhabitants." Another patroon, Cornelis Melyn, also attempted settlement, but his colony was twice wiped out, once during the Whiskey War of 1643 and again during the Peach War of 1655.

Under English rule after 1664, settlement of the island began in earnest. In 1670 a treaty was signed with the Indians, whose absolute (and this time final) surrender of possession was symbolized by the presentation to Governor Lovelace of "a sod and a shrub or branch of every kind of tree which grows on the island, except the ash and elder." No doubt included in this arboreal contribution was a representative of the sturdy chestnut, which, along with the oaks remarked by Juet, dominated the island's scenery until killed by the fungus blight that decimated American chestnut trees during the early years of the twentieth century. Before its demise, however, the chestnut played a leading role in the development of the island. According to

one nineteenth-century historian, it was "laid under heavy contribution" for such things as fence posts and rails, telegraph and telephone poles, and railroad ties.

When Jasper Danckaerts and Peter Sluyter, emissaries of Friesland pietists seeking to found a Labadist colony in the New World, spent three days touring Staten Island in 1679, there were living there about "a hundred families of which the English constitute the least portion, and the Dutch and French divide between them equally the greater portion." The travelers also observed that

> game of all kinds is plenty, and twenty-five and thirty deer are sometimes seen in a herd. . . . We tasted here the best grapes. . . . About one-third part of the distance from the south side to the west end is still all woods, and is very little visited. We had to go along the shore, finding sometimes fine creeks provided with wild turkeys, geese, snipes and wood hens. Lying rotting on the shore were thousands of fish called *marsbancken* [menhaden], which are about the size of common carp.

In 1748, when Peter Kalm was commissioned by Linnaeus to catalogue American native plant life, much of the forest that Danckaerts and Sluyter had traveled through had been cleared and a prosperous agricultural community established. Kalm wrote: "The prospect of the country here is extremely pleasing, as it is not so much intercepted by woods, but offers more cultivated fields to view." He noticed apple orchards everywhere and at each farmhouse a cider press; cherry trees grew near the gardens, and "all travellers are allowed to pluck ripe fruit in any garden they pass by; and not even the most covetous farmers can hinder them from so doing."

Kalm's diary includes a description of the Fresh Kills marshes: "The country was low on both sides of the river, and consisted of meadows. But there was no other hay to be got, than such as

commonly grows on swampy grounds; for as the tide comes up this river [Arthur Kill], these low plains were sometimes overflowed when the water was high." Branching through the marsh were the twisting estuarine creeks and rivulets that fed Fresh Kills. In the days before the Fresh Kills marshes were smothered by garbage, both Richmond Creek and Main Creek were navigable for more than a mile. Boatmen gave the little capes along the route such names as Never Fail Point, Point No Point, and Cedar Bush Point. At the mouth of Fresh Kills was an island alternately called Deadman's Island or Burnt Island. Throughout the marsh were other "islands," which were not true islands but simply hummocks protruding out of the surrounding moist and tide-inundated land, many of which were studded with Indian artifacts.

Thirty years after Kalm's visit, Staten Island, like the surrounding mainland, was engulfed by the American Revolution. It was occupied by the British for the duration of the war. During that period, its hilltops were cleared and used for redoubts and its forests chopped down for firewood. There were still foxes and raccoons and opossums at this time; the last deer of the once-large herds observed by Danckaerts and Sluyter was shot a few years after the war. With the patriot victory, loyalist families from Staten Island fled to Nova Scotia. Farms that had been pillaged by the redcoats were returned to prosperity. A second-growth forest appeared on the hillsides, and the broad, rolling plain along the shore became a smiling pastoral landscape of fields and hedgerows.

Thoreau on Staten Island

This was the Staten Island that charmed Henry David Thoreau as a young man, when he became the tutor of Ralph Waldo Emerson's

nephew Haven, son of William Emerson, a Staten Island judge. In a letter to his family soon after he arrived, Thoreau wrote, "The whole island is like a garden and affords very fine scenery." Along with the second-growth forests that had appeared following the island's denudation of trees by British soldiers during their wartime occupation, Thoreau, like Kalm, observed "peaches, and especially cherries grow[ing] by all the fences."

In recommending Thoreau to his brother, the Concord Emerson had written, "I am sure no purer person lives in wide New York; and he is a bold and profound thinker though he may easily chance to pester you with some accidental crotchets and perhaps a village exaggeration of the value of facts." But Thoreau did not exaggerate in describing his first vivid impressions of Staten Island:

> I cannot realize that it is the roar of the sea I hear now, and not the wind in the Walden woods. . . . Everything here is on a grand and generous scale—sea-weed, water, and sand, and even the dead fishes, horses and hogs have a rank luxuriant odor. Great shad nets spread to dry, crabs and horse-shoes crawling over the sand—clumsy boats, only for service, dancing like sea-fowl on the surf, and ships afar off going about their business . . . I must live along the beach, on the southern shore, which looks directly out to sea, and see what that great parade of water means, that dashes and roars, and has not yet wet me, as long as I have lived.

Thoreau was intrigued by the evidence of the island's prior occupation by Native Americans. After visiting a farm on the marshy shores of the Arthur Kill, he wrote home to his sister Helen in Concord: "As I was coming away I took my toll out of the soil in the shape of arrow-heads—which may after all be the surest crop—certainly not affected by drought."

Olmsted on Staten Island

Thoreau's contemporary Frederick Law Olmsted began his career as a farmer on Staten Island. In 1848, five years after Thoreau had been exhilarated by his long walks along the island's southern shore, Olmsted acquired 130 acres overlooking Prince's Bay. It was on this farm that he first showed his bent for landscape design and construction, although he could hardly have imagined that a decade later he would become the designer of Central Park and founder of the profession of landscape architecture in America. According to a friend, "he moved the barns and all their belongings behind a knoll, he brought the road in so that it approached the house by a graceful curve, he turfed the borders of the pond and planted water plants on its edge and shielded it from all contamination." Olmsted wrote: "I do exceedingly enjoy the view from my house . . . bounded by the horizon—dark blue ocean, with forever distant sails coming up or sinking as they bid good-bye to America."

Olmsted's pursuit of farming on Staten Island was short-lived, and he sold his farm in 1854. But his relationship with the island was renewed in 1870, when he was commissioned to prepare the *Report to the Staten Island Improvement Commission of a Preliminary Scheme of Improvements*. His first challenge was to address an important public-health issue. In 1748 Kalm had remarked of Staten Island: "The people hereabouts are said to be troubled in summer with intense swarms of gnats or mosquitoes, which sting them and their cattle." In 1870 medical science had not yet made the mosquito-malaria connection, and a great deal of Olmsted's report, which he prepared in cooperation with Dr. Elisha Harris, a pioneer sanitarian, discusses prevailing medical opinion on the origins of malaria. One theory held that

the disease was caused by a "granular microphyte: accompanied by a quantity of small spores, rainbow-tinted like spots of oil, growing on the surface of the marsh water." According to another scientific model, malaria was caused by "certain gases or volatile emanations . . . which are evolved by decaying vegetable matter under the required conditions of temperature and moisture."

Staten Island at that time had more than 1,000 kettle-hole ponds, with stagnant waters the report characterized as "malarial nurseries." These small swamps were not entirely unprofitable; many were used for growing basket willows. However, Olmsted observed that "this condition of saturation of the soil locks up a treasure such as no other suburb, and probably no other community in North America, can possess; it poisons the air and threatens the ruin of the island by prejudicing the public against all parts of it as a residence." He proposed a drainage system to be constructed by laying a network of open-jointed pipes three or four feet below the ground surface, graded so that the water would flow in descending channels to outfalls near the shore. In addition, he suggested that "free-spreading trees should be common" to provide the shade necessary to guard against "wafted malaria." The Olmsted report also contained recommendations (none of which were ever acted upon) for laying out major roads and parks.

In 1880, ten years after the Olmsted report, the desired suburban growth had not yet taken place, and Staten Island's population of 39,000 lived mostly on farms and in scattered villages. Grymes Hill was a fashionable enclave for longtime Staten Islanders, and some 3,000 oystermen and their families inhabited the area around Prince's Bay. On the opposite side of the island, in Mariners Harbor beside Kill Van Kull, overlooking the green salt meadows of New Jersey, the pride of newly rich oyster captains was displayed in fine mansions along elm-arched Richmond Terrace.

Ecological Remnants

To the keen eyes of a Staten Island naturalist, what had been an ecological paradise was increasingly at risk. Davis lamented in his journal: "Houses appear where it used to be uninhabited. I see the clothes drying on the line where once I saw wild ducks, so I have to abandon a little of my rambling ground every year." Electric lights, first installed on Staten Island in 1885, shone brightly at the amusement park in St. George. South Beach, which Danckaerts and Sluyter and later Thoreau had roamed, became in Davis's day a pleasure strip with galleries, dance halls, and saloons. Davis remarked that "the unconscious sand is held at great price" and "waiters rush about with their trays, where once the crows devoured the lady crabs, and the crowd is as lithesome and gay as were the sand fleas of old." On March 4, 1894, he wrote in his diary that there were "crows holding a convention in the cedars at the highest point of the island." The cedars were then a prominent feature of the Staten Island landscape. Thoreau had written that "the cedar seems to be one of the most common trees here, and the fields are fragrant with it." Davis noted, however, that there were fewer crows coming than in years past. Today only an occasional crow is to be seen, and except for one isolated stand, the cedars have entirely succumbed to air pollution and urbanization.

This does not mean that there are no natural areas left on Staten Island, or that there is no one today who wants to spend "days afield" discovering nature's wonders in the tradition of William T. Davis. For one thing, there are still plenty of mushrooms, particularly in damp, wooded areas. Mycologists such as Gary Lincoff, who teaches a course at the New York Botanical Garden, frequently go on local mushroom forays. Most people would be as astonished as I was to

Gary Lincoff

learn what a plethora of fungi—including mushrooms in fresh, edible forms and dry, tree-clinging states—can be found at all seasons of the year in city parks throughout the five boroughs.

The group with which Lincoff is affiliated, the North American Mycological Society, has a long and distinguished history. It was formed in the 1890s by Lucien Underwood, a renowned mycologist and Columbia University professor, and following a period of inactivity, it was revived in the 1930s by William Sturgis Thomas, author of a classic mushroom field guide. The composer John Cage and mycologist Guy Nearing were responsible for its latest reincarnation, which took place in 1962. Cage's knowledge of mushrooms is legendary (in 1959 he even won one million lire for his answers to questions on fungi on an Italian TV quiz show). His book *Silence* is a compendium of diary entries combining music theory and Zenlike pronouncements with mycological expertise, mushroom recipes, and

anecdotes about the occasional mishap, such as misidentifying and then ingesting a poisonous specimen.

One fall day in 2013, I accompanied Lincoff and a group of about fifteen mushroom hunters to Staten Island's Clove Lakes Park. As we were assembling near the park entrance, we were joined by one of the society's members, Vivien Tartter, who couldn't wait to tell Lincoff about the lasagna she had recently made with puffball mushrooms: "First I dipped the mushrooms in an egg wash and then in bread crumbs; after that I sautéed them in peanut oil, added some tomato sauce, and put them in my lasagna along with some ricotta. Then I took a photograph and posted it on Facebook."

After starting our climb up a slope, which several members of the group knew from prior trips to be an excellent mushroom-foraging ground, we split apart and went off in various directions, peering around tree stumps, looking beneath dead branches, and poking among the leaves that littered the ground. I followed Lincoff, and soon someone came over to show him a massy convoluted mushroom, identified as hen of the woods (*Grifola frondosa*), which she had found at the base of an old oak tree. It is a particularly delectable species, as I found out for myself when I got home and sautéed one. On a rotting stump, Lincoff pointed out a dry turkey-tail mushroom (*Trametes versicolor*), a fungus with a curved end that fans out like the tail feathers of a preening turkey. After a couple of hours scrambling up and down the wooded slopes, everyone reassembled at a picnic table, where we spread out the mushrooms we had gathered—a total of forty-five species from five different phyla. Paul Sadowski, one of Cage's music publishers and, after Lincoff, the group's acknowledged expert, conducted a roll call of the ascomycetes, polypores, jelly fungi, crust-and-parchment fungi, and gilled mushrooms lying on the table. It was the end of the season for fresh mushrooms, but there would be plenty of dry fungi in the city's forests to keep the New York Mycological Society members active over the winter. Then, beginning in May and

throughout the summer, there would be edible bounty in the parks once more. Thinking of the morels I would like to gather next spring, I asked Lincoff to add my e-mail address to the society's mailing list with announcements of walks.

High Rock Nature Center

In the 1960s, Robert Moses in his capacity as transportation czar proposed the Richmond Parkway, a highway that would have run down the island's hilly central spine, connecting New Jersey and Brooklyn via the recently opened Verrazano-Narrows Bridge. A group calling itself the Staten Island Citizens Planning Committee and its outgrowth, Friends of the Staten Island Greenbelt, were up in arms. Their attempt to protect the designated route as public parkland exemplified the burgeoning concern for the environment and community preservation that would soon lead to Earth Day activism and Jane Jacobs's anti-Moses Lower Manhattan Expressway protest. The committee members championed a cause that was not parochial but citywide, for this forested site with its established trails and a Girl Scout camp called High Rock was prized for hiking and nature education. On their side they could count on none other than Frederick Law Olmsted, who, during the six years he lived on Staten Island, had written that it would be simple to create a four-mile-long park on the ridge extending from Fresh Kills to Stapleton. They could also invoke William T. Davis and fellow entomologist Charles Leng, his coauthor of an 1896 history of Staten Island. In their description of the island's physical assets, they maintained:

> The crowning glory of Staten Island's topography and scenery is the forest that springs from its rich, well-watered soil. . . . Irregularity of contour and excessive wetness have saved such places from village

Mike Feller, naturalist

development; and there is hope that some at least may ultimately become parklands, for which purpose they are eminently suited.

Although Friends of the Staten Island Greenbelt and its allies eventually prevailed over Robert Moses, resulting in the protection of the central part of the island as an unaltered natural landscape, Staten Island's suburbanization continued at a relentless pace. Like waves borne on a flood tide, new housing developments continue to ascend the slopes of the hilly spine, and throughout the island only High Rock Park, the William T. Davis Wildlife Refuge, Eibs Pond Park, Clove Lakes Park, Wolfe's Pond Park, Silver Lake Park, and Willow-brook Park survive as representative remnants of the original island-wide natural landscape.

For Mike Feller, who formerly held the title Naturalist within the New York City Department of Parks & Recreation, High Rock Nature Center within the Greenbelt was more than a job responsibil-

ity. "I remember the first time my family took me to High Rock," he reminisced during one of the several days he served as my guide to the natural areas on Staten Island.

This was before the Verrazano Bridge was built, and we went across on the ferry from Brooklyn. We were taking my two older sisters to the High Rock Girl Scout Camp. Even though I was only four years old, I have very finely detailed memories of driving to the ferry terminal and leaving the car belowdecks. This was my first experience on water, which made the excursion especially exciting and adventurous. I can still taste the salty pretzel and the orange drink my dad bought for me and what it was like driving off the ferry when we docked at St. George. We drove up the hill and immediately we are on this country road beneath an overarching tree canopy. I can remember what it was like arriving at High Rock, getting out of the car and being surrounded by this unreal buzzing and humming. There was already some apprehension since we were dropping my sisters off for the summer, but this was something entirely bizarre and amazing and like nothing I had ever heard before. I had no idea of what this was. My mother, who was a biology teacher, immediately registered what was going on and got all excited. Her face lit up, which was comforting to me, and she explained that the things on the ground that looked like miniature shrimp shells were the exoskeletons of the nymphs of the periodical cicadas that hatch once every seventeen years. You can't believe how shrill the sound was and what it felt like to be crunching through these insect exoskeletons as we walked to the cabins where my sisters would be staying.

Feller's introduction to this entomological phenomenon occurred in 1962. Since then there have been three other emergences of cicada nymphs, and because of the precision of this natural event's timing,

we knew there would be one in spring 2013, which is when he and I first visited High Rock Park together. Lifting a dead tree branch as we started our walk, he pointed to a hole that appeared to be the mouth of a small tunnel and explained:

> When the nymphs, who have been getting their nutrients by sucking xylem from tree roots for the past seventeen years, get ready to molt, they burrow little tunnels and come out of the ground. We may see a few nymphs, a sort of advance guard that have already emerged, but the main event, which is nocturnal, occurs during a two-to-three-week period when large masses keep coming up out of the ground every night. During the next five days, the nymphs shed their exoskeletons, and after their bodies have dried out and hardened and their wings have unfurled, they are ready to take flight and mate. If we're lucky we may be able to see a few nymphs and the holes they have dug.

We were indeed lucky, for before we started down one of the trails leading to a kettle-hole pond, Feller turned over another rotting log, and sure enough we spotted two nymphs. The insects, which looked like shell-encased worms, wriggled about as we put them on the open palms of our hands in order to study them more closely. We could see their antennae, protuberant eyes, and a pair of legs on either side of their bodies. Feller directed my attention to the insect's anatomy: "Notice how the forelegs look almost muscular and have what appear to be claws at the end. That's for digging. Now look closer. You see that budlike form next to the body at the other end of the leg? That's where an inch and a half of rolled-up wing is waiting to unfurl." Pointing to a fine line running down the center of the cicada nymph's back, he said, "That's the suture where the nymph's shell is going to crack open in order to let the insect emerge."

When I asked him how localized the emergence would be, Feller replied:

There are different broods, and the ones here are part of what is known as Brood Two, which can be found in several places in the Northeast beyond the boundaries of High Rock. There are also some Brood Ten cicadas here on Staten Island, which have a different seventeen-year cycle, but now, because so many natural areas get built over in each of the seventeen-year intervals, when the nymphs tunnel up to the ground's surface, they hit an asphalt parking lot or a concrete house foundation. But we definitely should be able to see a fairly large swarm here at High Rock in a couple of weeks.

Newly emerged seventeen-year cicada

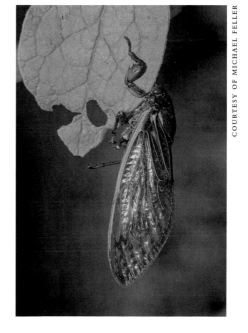

COURTESY OF MICHAEL FELLER

When we parted that day, I asked Feller to put me on the seventeen-year-cicada hotline. As promised, two weeks later the call came, and we agreed to meet the next day at the entrance to High Rock Park. I got there early and began to walk along one of the trails. Everywhere overhead—literally everywhere throughout the woods—there was a ringing sound. It is hard to describe: something between a singing steam kettle and jingle bells. I saw more holes in the ground and a few empty exoskeletons, but I was unable to spot the live cicadas making the incessant racket in the canopies of the trees above. My disappointment subsided, however, when I spotted Feller walking down the path toward me. As we listened to the noisy whirring, he described what was going on. "That's called stridula-tion," he explained. "This is performed by the wings of the male rubbing against a tiny protrusion on the thorax. It's a mating call—not as loud as I remember it back when I heard it on that first visit to High Rock as a child. Then the sound was almost painful. Perhaps it's because there aren't as many now as there were then, before Staten Island got so built up."

Picking up an exoskeleton, which looked exactly like a dead insect, Feller explained that this was just an empty sheath, a casing for the now-emerged cicada that was somewhere overhead. "But you can see the eyes, the antennae, the legs, and everything," I observed. "This is what is so remarkable," he replied. "The whole thing is just like a mold. If you could cast it, you'd have a perfect bronze cicada." I stared in disbelief as he went on:

See where that threadlike suture is split ever-so-slightly apart. The cicada fastens itself onto a branch or leaf and uses its muscular-looking forelegs to start pulling itself out of the exoskeleton. First it hunches backward and brings the head and thorax out. The wings are still very compressed in those little wing buds on each side of the thorax that I

showed you when we were here before. Once the forelegs get a good grip, it can climb further up whatever it is holding on to and pull the abdomen and everything else out. Within an hour, the pair of wings that were folded in upon themselves unfurl. Occasionally you'll see one that got stuck and didn't make it all the way, but that's relatively rare. When you think of how hard it is to crack a crab or lobster and remove the meat, it's pretty amazing that these cicadas perform such a complex metamorphosis and manage to disengage all these fine little structures and completely reform themselves with such integrity. Just look where the antennae, which is barely a hair's width, and the eyeball inside the protective integument came out and left this hollow form.

I wanted to know what happened next. "It's aerial sex. The male fertilizes the female; she then produces the larvae. After they have dried off a bit and the epoxylike integument has begun to congeal and harden, they fall to the ground, where they start burrowing to the spot where they will spend the next seventeen years." As far as the adult cicadas are concerned, their day in the sun is a brief one, for as soon as they have performed their mating ritual, they die. "That's the cicada life cycle," Feller concluded. "In a few days you'll be able to see those well-constructed bodies lying on the ground, if they don't get eaten by birds, possums, raccoons, or other woodland critters."

For Feller, nature is more than science, and when he speaks about it he uses the language of aesthetics. He remembers the frisson of frightened awe, or pleasurable terror—the hallmark of the Romantic Sublime—that he felt as a child when he first encountered the seventeen-year cicadas at High Rock when it was still a Girl Scout camp. He says that what Yosemite was to John Muir, High Rock Park has been to him:

There are emotionally cementing moments that can also be intellectually interesting, as in the case of these miraculous insects. A lot of science people are uncomfortable with the spiritual, but nature is where we touch the mystery of life. Look at Emerson and Thoreau— they were Romantics. Then there's Wordsworth and Gerard Manley Hopkins, as well as the contemporary poets Wendell Berry and Gary Snyder. I don't think everything has to be super-clinical, nor does everything have to be Sturm und Drang. There is something nice about being in the middle.

The South Shore

Staten Island's approximately two and a half miles of sandy beaches, from the Narrows to the mouth of the Arthur Kill, together with the adjacent inland neighborhoods, is known as the South Shore. Once a haunt of old-time Staten Island naturalists, this landscape was heavily developed after the opening of the Verrazano-Narrows Bridge in 1964. Along the South Shore, there are only a few protected remnants of the island's earlier wetland ecology. These can be found at Wolfe's Pond and at Crescent Beach, an arm of Great Kills where the Staten Island botanist John J. Crooke bought a piece of land in 1860 and built himself a wooden house on the beach. The area is now known as Crooke's Point.

Here is how William T. Davis described this part of the island in 1892:

> The beach-plums are a great attraction to a shore rambler, and the bay-berries to the white-breasted swallows that congregate on the Point in great flocks. . . . The branches of the bay often bend under their united weight, *and* the dark glossy blue of their backs make the group

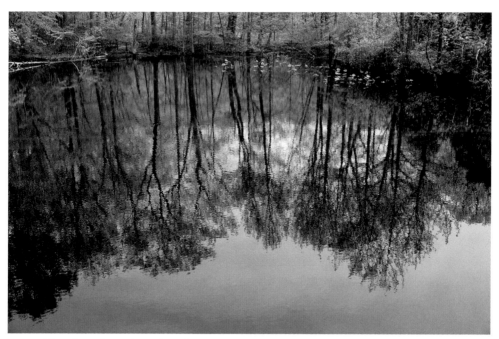

Glacial pond, High Rock Park

resplendent in color. . . . Mice are ever running in and out among the tussocks of grass, and the silent winged hawk steals upon them unawares. Then too, the great blue herons visit the unfrequented meadows, and stand sentinel there. . . . Many sandpipers run along the beach at certain seasons. . . . They look like little dancing machines, their movements are so rapid.

Beginning in the 1920s, 580 acres of the Great Kills salt marsh was used for garbage dumping. After it was filled and capped, Great Kills was converted into a park, which was opened to the public by Robert Moses in 1949. When I first went there in the late 1960s, I saw boardwalk-bordered beaches and ball fields typical of the Moses era.

There were also banks of phragmites growing in the still-moist parts of former wetlands. Now part of Gateway National Recreation Area, the Great Kills beaches are occasionally closed when water-pollution levels make it unsafe to swim. More serious has been the discovery of radiation, surmised to be from remnants of industrial machinery dumped in the park before it was decommissioned as a landfill. This finding has caused a large section of Great Kills to be closed to the public for the past several years. The National Park Service's most recent scientific analysis indicates that the contamination may be more widespread than it was originally thought to be.

Here, however, let us conclude with an appreciation of unadulterated nature on Staten Island by returning to High Rock Park, as I did with Feller in 2013, on a particularly beautiful spring day. On that occasion, we saw migrating warblers in the newly clothed trees, and the ground was covered with woodland flowers: jack-in-the-pulpit, trout lily, Canada mayflower, mayapple, Solomon's seal (both true and false), spring beauty, and swamp loosestrife. The still air over one of the kettle-hole ponds was broken by the deep, guttural "thunk" of a frog playing bass against the shrill counterpoint of the spring peepers. A Green Heron was stealthily patrolling the edge.

In the William T. Davis Refuge, we saw regiments of male Redwing Blackbirds, their handsome scarlet epaulets flashing as they flew through the marsh, while their shy, brown-and-white-striped female mates, camouflaged in the cattail reeds nearby, searched for food. Startled, a woodcock rose from her nest with a great whirring of wings. There was watercress growing in the clear brook that winds through the refuge and tender, green leaves on the drooping branches of the weeping willows beside its banks. In all the moist places where the old abandoned wells still send water percolating up out of the ground, we smelled the pungent odor of skunk cabbage. On such a

day it is natural to echo William T. Davis, who, rejoicing in the coming of some bygone spring, wrote: "The world is indeed a wonderful place and it is good to be alive even if it is only for a little while, and more than half of us do not consider our natural surroundings seriously enough."

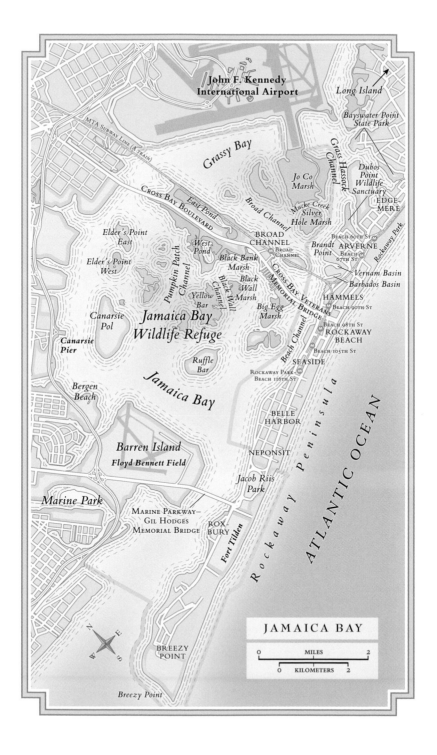

John F. Kennedy
International Airport

Long Island

Bayswater Point
State Park

Grassy Bay

MTA SUBWAY LINE (A TRAIN)

Grass Hassock Channel

Dubos
Point
Wildlife
Sanctuary

Jo Co
Marsh

CROSS BAY BOULEVARD

East Pond

Broad Channel

EDGE-
MERE

Mucke Creek
Silver
Hole Marsh

Elder's Point
East

West
Pond

BROAD
CHANNEL

Brandt
Point

ARVERNE

BEACH 60TH ST

Rockaway Park

BROAD
CHANNEL

BEACH
67TH ST

Elder's Point
West

Black Bank
Marsh

Vernam Basin

Pumpkin Patch Channel

Black
Wall
Marsh

CROSS BAY VETERANS MEMORIAL BRIDGE

Barbados Basin

Elder's Point
West

Yellow
Bar

Black Wall Channel

HAMMELS

BEACH 90TH ST

Canarsie
Pol

Jamaica Bay
Wildlife Refuge

Big Egg
Marsh

BEACH 98TH ST

ROCKAWAY
BEACH

Beach Channel

Canarsie
Pier

BEACH 105TH ST

Ruffle
Bar

SEASIDE

Rockaway Park—
BEACH 116TH ST

Bergen
Beach

Jamaica Bay

BELLE
HARBOR

Barren Island

Rockaway Peninsula

ATLANTIC OCEAN

Floyd Bennett Field

NEPONSIT

Marine Park

Jacob Riis
Park

MARINE PARKWAY—
GIL HODGES
MEMORIAL BRIDGE

ROX-
BURY

Fort Tilden

N
E
S
W

BREEZY
POINT

Breezy Point

JAMAICA BAY

0 MILES 2

0 KILOMETERS 2

GREEN MARSHES AND
TROUBLED WATERS

Jamaica Bay

Window-seat passengers who look down just before landing at Kennedy Airport see a stretch of water interspersed with a patchwork of marshy islands through which creeks form looping ribbons that meander through thick mats of cordgrass. This is Jamaica Bay, bounded by the Rockaway Peninsula—the last of the barrier beaches stretching from here to Montauk Point—and the southern edges of Brooklyn and Queens.

Runways, sewage-treatment plants, highways, and garbage landfills have reduced and straightened the bay's natural perimeter, thereby destroying its once extensive wetland fringe. Yet even in their diminished state, the waters and marshes of Jamaica Bay collectively constitute one of the richest, if most imperiled, ecosystems along the Atlantic coast. For this reason, advocates for the bay's protection were instrumental in getting Congress to create the 26,600-acre Gateway National Recreation Area in 1972, the country's first

urban national park, of which Jamaica Bay constitutes one unit.* The establishment of the park inaugurated a new but by no means final chapter in the history of this piece of New York City's coastal landscape, one that continues to be rewritten by many forces, including, most recently, Hurricane Sandy.

Early Days

The first known inhabitants of the area around Jamaica were the Canarsie people, members of the Lenape branch of the Algonquian Indian nation that once occupied much of northeastern America. As so often elsewhere, the place names conferred by these Native Americans are still in use today, with *Canarsie* meaning "fenced land" and *Rockaways* being a derivation of the tribal name Rechquaakie, translated as "people of the sandy places." The abundant marine life of the bay constituted the primary diet of these natives, and large middens of their discarded oyster shells dotted the shores before landfills covered them over. Grain must have nourished them also, for they are reputed to have cultivated a great cornfield in what is now the southeast corner of Brooklyn.

Beginning in 1636, Dutch settlers occupied the edge of the bay in southern Brooklyn, or, as they called it, Breuckelen, "broken land." Their community of Flatlands, with its sea-level landscape like that of Holland, is the first known settlement on Long Island. Nearby Flatbush, known also by its Indian name of Midwout, was settled in 1651.

In 1656 a patent was issued granting the Canarsie meadows, lying east of the Indian planting ground, to Midwout's "indwellers and inhabitants." These meadows, part of a system of salt marshes surrounding

* The other units of the Gateway National Recreation Area are parts of Staten Island and Sandy Hook, New Jersey.

Jamaica Bay, were valuable for the salt hay they produced. Dutch traveler Jasper Danckaerts (1639–c. 1703) described their appearance:

> There is towards the sea a large piece of low flat land which is over-flowed at every tide, like the *schorr* with us, miry and muddy at the bottom, and which produces a species of hard salt grass or reed grass. Such a place they call *valy* and mow it for hay, which cattle would rather eat than fresh hay or grass. . . . All the land from the bay to the Vlacke Bos [Flatbush] is low and level, and without the least elevation. . . . This marsh, like all the others, is well provided with good creeks which are navigable and very serviceable for fisheries. There is here a gristmill driven by the water which they dam up in the creek; and it is hereabouts they go mostly to shoot snipe and wild geese.

When New York was a British colony, Jamaica Bay was considered the property of the freeholders of Jamaica, Long Island. The patent confirmation granted by Governor Richard Nicolls in 1665 was for lands "to extend southeast to the Rockaway Swampe" from the early boundaries of the town. In 1670, in an effort to attract more colonists, Daniel Denton (c. 1626–1703) published a promotional pamphlet titled *A Brief Description of New-York: Formerly Called New-Netherlands,* in which he wrote: "Upon the South-side of *Long*-Island in the Winter, lie store of Whales and Crampasses, which the inhabitants begin with small boats to make a trade Catching to their no small benefit. Also an innumerable multitude of Seals, which make an excellent oyle; they lie all the Winter upon some broken Marshes and Beaches, or bars of sand."

The little Dutch towns and the English settlement at Gravesend in the south-central section of Brooklyn eventually became part of the bay's perimeter landmass. The mills that once stood beside the streams entering the bay have long since been replaced by the pollution-control plants of the Department of Sanitation. Dikes and floodwalls

constructed by the Army Corps of Engineers and the Shore Parkway built by Robert Moses have sealed off the tides that inundated the marshes, transforming areas where the cordgrasses were mowed for hay into waving expanses of phragmites. The eroding marsh islands, their future imperiled by further pollution and climate change, and hummocks in the bay are for the most part all that is left of the vast salt meadows that once extended for thousands of acres around its perimeter. The rich oyster beds have succumbed to pollution, and the wintering seals that once lolled on the Rockaway beaches have been supplanted by surfers and sunbathers.

In the past, Jamaica Bay and the Rockaways served as one of the finest sources of finfish and shellfish on the East Coast, with oysters ferried daily in huge quantities to oyster bars and restaurants in Manhattan. Railroad construction in the 1880s linked Brooklyn with the Rockaway Peninsula as well as with the community of Broad Channel in the middle of the bay, ushering in the area's heyday as New York City's prime summer playground. Great wooden resort hotels facing the ocean sprang up in the Rockaways, and in the interior of the bay, three were sited on the marsh island known as the Raunt. As sport fishing, boating, and swimming became popular, rows of look-alike wooden bungalows sprang up in Arverne and other Rockaway communities, bringing recreation and relief to city residents during the dog days of summer. Subway-served amusement parks opened at Broad Channel, Bergen Beach, and Canarsie, attracting a host of day-trippers.

In the twentieth century, the economy of bay and beach tourism was superseded by industrial development, some of it related to the dawn of the age of aviation, more by the ever-pressing need to dispose of the increasingly populous city's sewage and garbage. Not surprisingly, several outfalls for sewer lines were sited around the bay, and much of its marshlands were obliterated as garbage scows and sanitations trucks smothered them with waste and debris.

In 1914 an ambitious scheme was advanced to dredge the bay and transform its eighteen thousand acres of water and marshlands into a huge industrial port and ship terminal. Proponents of the plan boasted that Jamaica Bay would then be greater than the combined ports of Liverpool, Rotterdam, and Hamburg. As a start, Canarsie Pier in Brooklyn was built as a berth for oceangoing vessels, but after the costly port project was abandoned, this intended ship dock became a wharf for fishermen.

The flatlands on the margin of the bay were the obvious place to accommodate runways for airplanes when the need arose. In 1930 Barren Island, adjacent to Brooklyn's southeastern shore, was chosen as the site of Floyd Bennett Field, the city's first municipal airport. Most of its 387 acres, which comprised thirty-three small hummocks of cordgrass, were covered with six million cubic yards of dredged sand, thereby cohering the marsh fragments, raising the surface sixteen feet, and joining this new-made land to the adjacent shore. Later, another wetland on the north shore of Long Island, Flushing Meadows, was filled in to create LaGuardia Airport, making Floyd Bennett Field obsolete. In 1952 it was sold to the U.S. Navy. But because commercial air transportation at LaGuardia had exceeded capacity, in 1947 Idlewild (now Kennedy) Airport, eight times the size of LaGuardia, was created on a 4,527-acre tract of marshland on the eastern perimeter of Jamaica Bay. With 53 million cubic yards of dredged sand from the bay, the new airport's runways were raised twelve feet above high tide.

The city's appetite for converting marshes to terra firma did not abate. In several cases, marsh surfaces were raised above tide level by dumping "clean" landfill—nonorganic materials such as beach sand, excavated dirt and rocks from the construction of new buildings, and the rubble yielded by the demolition of old ones. Household garbage gobbled up more marshland. Around the bay's perimeter, massive mounds of refuse continued to rise. Department of Sanitation trucks

plied their slopes like busy ants, continually expanding the size of each landfill site with empty glass and plastic bottles, worn-out mattresses and treadless rubber tires, crushed tin cans and broken appliances, and a jumble of discarded newspapers, magazines, old shoes, meat bones, pickle jars, and orange rinds. Once a given site was full, it was decommissioned, stabilized, and capped with soil before being turned into a park or building lots.

In Jamaica Bay, urban visionary Robert Moses, dubbed "the power broker" by his biographer Robert Caro, demonstrated the canny political tenacity that made him New York's indomitable master builder for thirty years. In 1938, municipal warfare broke out between Moses and the commissioner of sanitation, who saw the watery "wasteland" of the Jamaica Bay with its scattering of low marshy lands as a convenient supplement to the overflowing landfills elsewhere. Seizing the initiative, Moses countered this proposal with a plan of his own. In one of the many brochures advertising planned or completed public works under his administration as parks commissioner, the bay was depicted in before-and-after fashion. An artist's sketch labeled "Civic Nightmare" displayed in lurid detail a mountain of smoking garbage, its malodorous fumes wafting across Brooklyn and Queens; a companion rendering showed a blue expanse of water flecked with sailboats and fishing craft, its periphery of landfill sites, which he proposed to decommission, rimmed with six sparkling white beaches and green-shaded waterfront parks.

Moses's campaign was successful: state legislation was passed transferring Jamaica Bay to the jurisdiction of the New York City Parks Department in 1938. The newspapers gave prominent coverage to his plan for turning the bay into a huge marine playground. However, the proposed beaches never materialized because pollution from nearby sewage outfalls made the water unsafe for bathing, a problem that has continued to mar every subsequent proposal for water recreation around the bay's perimeter. Several parks did get built, most

on soil-capped garbage landfills, between the Belt Parkway and the shoreline of the bay.

Although Moses's chief aim was to build parks whose purpose was active recreation rather than protection of the natural environment, he can nonetheless be credited with providing New York City, in 1951, with one of its prime ecological jewels—Jamaica Bay Wildlife Refuge. The curious history of its creation is the outgrowth of a characteristic Moses ploy. Where the subway now runs, a branch of the Long Island Rail Road, spanning the bay on a wooden trestle, carried passengers to the Atlantic beaches and the once-elegant seaside resorts in the Rockaways. The trestle, built in 1877, would periodically catch fire, and in 1950 it was severely damaged by flames. The railroad decided to withdraw its service to the Rockaways, and the New York City Transit Authority agreed to purchase the old spur for its Rockaway line. Instead of rebuilding the trestle, the Transit Authority wanted to dredge sand from the bay to create a new embankment on which to build the elevated subway tracks that now carry the A train to the Rockaways. Since the bay was by this time a jealously guarded piece of Moses's now-considerable park empire, he refused to permit dredging to take place unless the Parks Department received something in return. It was therefore agreed that, in conjunction with its dredging operations, the Transit Authority would construct a series of dikes to impound fresh water. Two ponds, one on the east side of Cross Bay Boulevard, the other on the west, were created, and Moses appointed a veteran Parks Department gardener, Herbert Johnson, as superintendent of the newly designated Jamaica Bay Wildlife Refuge.

In addition to the ponds, a nesting area was created on one of the larger islands in the bay, thanks to another act of interdepartmental gamesmanship on Moses's part. This time he maneuvered the Sanitation Department to pipe organically rich sludge from the 26th Ward Sewage Treatment plant located on the bay's perimeter to Canarsie Pol, a barren island in the middle of the bay. After the sludge had been

worked into the sandy surface to form rich topsoil, Johnson began setting out tufts of beach grass to serve as habitat for waterfowl.

Broad Channel, the largest of the marsh islands in the center of the bay and the only one that remains inhabited today, was also part of the refuge-in-the-making. With the demise of regular rail service, the popularity of the adjacent Raunt as a middle-class summer resort had declined. Its remaining population was made up mostly of old-timers living year-round in the weather-beaten former summer bungalows perched over the water on wooden stilts next to a rickety wooden boardwalk running the length of the settlement. Potable water was collected in rain barrels and plumbing was nonexistent. Its three summer hotels had become decrepit. Because the little marine colony in the middle of Jamaica Bay did not fit Moses's grand vision for New York City's growing parks empire, he had no qualms about planning its demolition in 1939 during construction of the Cross Bay Parkway Bridge (now the Cross Bay Veterans Memorial Bridge) connecting Cross Bay Boulevard with the Rockaways.

With imperial authority, Moses decreed that all the remaining structures on the Raunt be demolished, along with the cabins that dotted the marshes around contiguous Ruffle Bar.* The dispossessed residents had only scorn for the new refuge and swore that the birds would ignore the two ponds. However, as the ponds collected rainwater and became almost like freshwater lakes, aquatic plants took hold: widgeon grass, muskgrass, and sago pondweed. Once the refuge was

* The remaining residents, many of whom had become year-round occupants, waged a protracted battle to purchase the land under their houses. The city denied their repeated requests to buy the properties they continued to inhabit as squatters until 1982 when they were finally granted the right to take ownership. Broad Channel is now a thriving Queens community of well-kept homes, churches, shops, restaurants, a fire station, a VFW meeting hall, and other neighborhood amenities. The visitor walking down the street sees trim flowerbeds and driveways in which boats as well as cars are parked. Today the dockside houses that received the brunt of Hurricane Sandy have all been repaired.

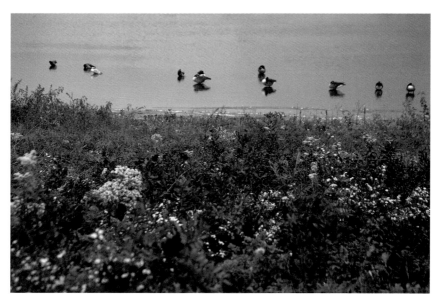

West Pond, Jamaica Bay Wildlife Refuge

in operation, Johnson was left largely unsupervised to do as he pleased. From cuttings he gathered at other marine locations, he propagated such berry-producing plants as autumn olive (*Elaeagnus umbellata*), *Rosa rugosa, Rosa multiflora,* bayberry (*Myrica pensylvanica*), and chokeberry (*Aronia*). With seeds from pinecones, which he collected in Jacob Riis Park, he started a nursery of Japanese black pines (*Pinus thunbergiana*), later transplanting the seedlings to form groves throughout the refuge. Since grain was another means of attracting birds, he sowed wheat, oats, and rye.

By 1953 the outlines of the refuge were in place, and soon the birds did come, by the thousands. Migrant ducks that normally breed on the freshwater lakes and ponds of the prairie states—Baldpates, Pintails, Gadwalls, Ruddy Ducks, Green-winged Teals—began to nest at Jamaica Bay along with the more common Mallards, Black Ducks, and Greater and Lesser Scaup. Brants came to graze on the sea lettuce that covered the bay bottom, and soon Black Skimmers, terns, and

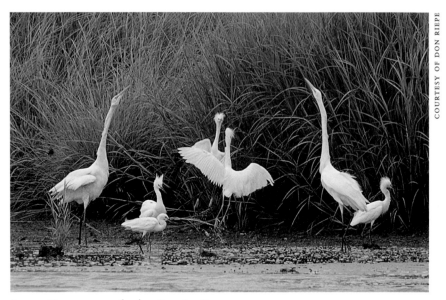

Snowy Egrets on marsh edge, Jamaica Bay

egrets started to lay their eggs on the sand in the beach grass. The wealth of grain, seeds, and berries resulting from Johnson's horticultural labors attracted land birds, which supplemented the flourishing shorebird and waterfowl populations. In 1958, five years after the refuge was started, 208 species had been sighted at Jamaica Bay; the following year the count had climbed to 238; in 1960 it reached 242; and by 1962 the tally was 283. Today's list stands at 332 (nearly half the bird species so far recorded in the Northeast).

In addition to Johnson's habitat creation, an important reason for the success of the Jamaica Bay Wildlife Refuge as a major bird-watching destination is its position on the Atlantic Flyway at the point of intersection of two separate streams of migratory waterfowl, one following the eastern coastline to Newfoundland, Nova Scotia, and New Brunswick, and the other taking a flight path that veers to the Midwest and pushes northward into Ontario. The refuge therefore

has a unique geographical significance as a place of confluence for both land birds and shorebirds during the fall and spring migrations. There are, in addition, many birds that stay and build their nests and raise their young in the protected reeds and grasses. Osprey, formerly decimated by DDT and nonexistent in Jamaica Bay, now nest on the elevated platforms that have been erected for this purpose in the refuge as well as elsewhere near the perimeter of the bay.

In addition to its 332 bird species, more than seventy species of butterflies and many small mammals, amphibians, and reptiles inhabit the refuge. Diamondback terrapins lay their eggs in the sand. A mating ground for horseshoe crabs, the bay boasts one of the largest populations of these curious crustaceans in the Northeast.

But there is no guaranteed happy ending to this success story. A wetland can be compromised in many ways, and sustaining not only the refuge but also the rest of Jamaica Bay as a viable ecosystem has proved challenging. Fortunately, there is someone who makes the health of the bay waters, marshes, and wildlife his ongoing mission.

Guardian of the Bay

Don Riepe is a former National Park Service ranger who was the resource manager at the refuge soon after it had become part of the federally operated Gateway National Recreation Area in 1972 until his retirement in 2005. Riepe is a resident of Broad Channel, his house perched over the water where he docks his boat. It is appropriately named *Guardian of the Bay*.

To get to Broad Channel on the subway, I took the A line, bound for Far Rockaway. Just before the train reached the Aqueduct Racetrack stop, it emerged from the ground and continued along a trestle. At the next station, riders with suitcases got off to take the shuttle bus to JFK. As the doors closed and the train started up again, I gazed out

Don Riepe

Broad Channel waterfront with Riepe house and dock in foreground

at the watery expanse of the bay and then at the green of the refuge's forested upland on either side of the tracks. Descending the stairs at the Broad Channel stop, I took a close-up look at the community that had been built improbably on the southern end of the long, narrow marsh that lies within the center of the bay.

Today there is scant evidence of Broad Channel's old, ramshackle character. Instead, as I walked from the subway to Cross Bay Boulevard, I saw images of the Virgin Mary along with a wealth of other garden statuary in yards with freshly painted picket fences. There were motorboats in many driveways, and American flags in people's yards up and down the street. I passed Saint Virgilius Roman Catholic Church and its neighbor, Christ Presbyterian Church, both built of wood, with gable roofs adorned with steeples. Because it was March, there were large shamrock posters decorating windows and doors. Except for its unusual location, Broad Channel is by all appearances a typical New York City Irish neighborhood.

Turning south on Cross Bay Boulevard, I walked a couple blocks to 9th Road, turned right, and at the end of the block found Riepe's waterside address. A sign outside announced that this was the headquarters of the American Littoral Society, Northeast Chapter. It is also the office of the Friends of Jamaica Bay Wildlife Refuge, as I learned when I sat down with Riepe in the half of his kitchen that is not given over to newsletters-in-the-making and all the other paraphernalia of a busy life as nature's advocate. In addition to heading these two organizations, Riepe is affiliated with several others seeking to protect the bay's water quality, fragile ecology, and periphery from infringement by continued urban development. These groups include New York City Audubon, Metropolitan Waterfront Alliance, Rockaway Waterfront Alliance, and Natural Resources Defense Council. Riepe is their watchdog, since he spends approximately two days a week patrolling Jamaica Bay's marshes and shoreline in his boat, looking for such violations as illegal crabbing, dumping, and

commercial rather than recreational fishing. He helps these groups plan conferences to develop concerted policies for dealing with environmental issues, coordinates volunteer beach cleanups, and participates in raptor-banding operations as a way of monitoring the bay's population of ospreys, hawks, eagles, and owls. Closely allied with him in these efforts are his two neighbors Dan Mundy Sr. and Dan Mundy Jr., founders of Jamaica Bay Ecowatchers. The Mundys, zealous activists who have worked closely with wetland scientists to measure the high levels of nitrogen in the bay waters—the primary agent in the current, rapid erosion of marshes—have been tireless in their efforts to force government officials and politicians to pay attention to the issue of pollution in the bay.

Riepe, who grew up adjacent to Jamaica Bay, has spent almost his entire life within its confines, fishing and observing birds and other wildlife. He counts himself lucky to have found the perfect career niche in 1976 when he became a National Park Service ranger assigned to the Jamaica Bay Wildlife Refuge unit of the Gateway National Recreation Area. After serving as refuge manager, he decided to bypass the climb up the government agency's career ladder in order not to transfer elsewhere, where he would have had a higher position in the National Park Service.

After we had coffee in Riepe's kitchen-cum-office, he offered to take me on a walk in the refuge, which is a short drive from his house. As we started down the trail that encircles West Pond, I noticed a Tree Swallow poking its head through the entry hole in one of the several nesting boxes that Riepe had previously installed. "Look," he exclaimed, pointing out a nest of sticks on a tall, plank-topped pole. "See, there's an osprey on the nest. You remember back in the sixties when they were practically extinct because of DDT spraying? The first osprey nest to be built in this region was on a platform that Herb Johnson erected here in the refuge. Now we have ospreys nesting on all fifteen of the platforms we have put up around the bay."

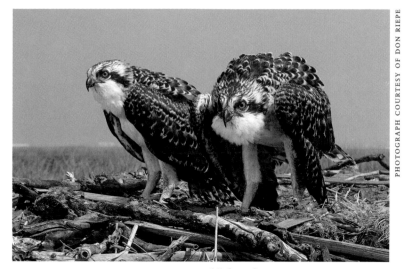

Young ospreys on nest, Jamaica Bay Wildlife Refuge

Circuit path around West Pond, Jamaica Bay Wildlife Refuge

I looked up in the sky above the osprey nest and saw a huge jet from JFK taking off above the bay. "That's a Delta," Riepe said. "After I got to know all the birds, I learned to identify airplanes. Sometimes on a slow day in the refuge or out on the bay in my boat, I like to see what kinds of planes are in the air." Speaking with regret about one extinct species, the Concorde, he said, "I know I'm an environmentalist and am supposed to have minded and that some of the people nearby complained about the noise, but those planes were really elegant. Beautiful lines. I miss them." The airport's plan for continued expansion into the bay remains a hot issue, particularly among naturalists and bird-watchers. Runway patrols sometimes shoot birds that come within the flight path, much to bird lovers' dismay.

Gateway's current National Park Service staff at the refuge has shifted its focus from resource management to visitor services. Riepe believes that while they do more programs in the visitor center, they give less attention to nourishing and maintaining the refuge's natural-seeming but horticulturally needy landscape. He finds this change of administrative direction discouraging: it is difficult for him to watch Herbert Johnson's carefully created lifework being neglected, along with his own achievements, after the decades he has spent protecting Johnson's legacy. He complains that some areas are mowed as lawn but none are pruned to maintain shoreline views and open habitats. However, he tries to compensate for this by directing landscape-care projects performed by volunteers under the aegis of Friends of the Jamaica Bay Wildlife Refuge. In addition, Riepe is a talented photographer whose work has been featured in several nature magazines, and as we concluded our walk at the visitor center, I noticed that many of the blown-up nature photographs on exhibit had been shot by him—either in the refuge or on American Littoral Society field trips.

Since Riepe was obviously the right person with whom to tour the entire bay, I called him up again a couple of months later when the weather was warmer and his boat had been put in the water. "Come

Horseshoe crabs mating, Little Egg Marsh, Jamaica Bay

around eleven o'clock," he said. "That is when it will be high tide. It's a good day to go out and see the horseshoe crabs." When I arrived at his house, Elizabeth Manclark, his part-time assistant, helped me into a pair of waders, and the three of us climbed into Riepe's boat. Heading south through Broad Channel, we stopped a short distance away at Little Egg Marsh. Manclark assisted Riepe in anchoring the boat, and then I clambered over the edge and into the water. There in the shallows along the edge of the marsh were hundreds and hundreds of horseshoe crabs (*Limulus polyphemus*). These strange-looking arthropods are, according to the fossil record, a species that is at least 450 million years old. Normally they live on muddy bottoms and the sandy ocean floor, but during the high tides of new and full moons in the breeding season, they come ashore to mate.

Luckily for us, this was the breeding season, and we were in the right moon phase to observe horseshoe-crab mating in full swing. I learned that the larger ones scrabbling in the sand making little

depressions were females. The males, two-thirds their size, were positioned behind them, their front claws, which look a little like miniature boxing gloves, holding on to the back of their partners' domed shells as they were dragged along toward the high-tide line. "She's laying her eggs, and he is covering them with sperm as she pulls him over the nest. Look," he explained, picking up a male and turning it over, "do you want to see something X-rated? He has two penises." Sure enough, beneath a protective plate on the underbelly of the horseshoe crab, which Riepe held open for inspection, was a double set of tiny genitals.

The horseshoe crabs were not the only attraction. Skittering along the shoreline of the marsh was a flock of Semipalmated Sandpipers (*Calidris pusilla*), along with some Dunlins. There were a pair of striking black-and-white American Oystercatchers, their long red bills poking about the tidal flats, feasting like the other shorebirds on the millions of newly deposited horseshoe-crab eggs. There were numerous Laughing Gulls, which often breed on marsh islands such as those in Jamaica Bay. "Look over there." Riepe pointed to a large, dark wading bird with a long downturned bill. "There's a Glossy Ibis."

I felt the shore-bound horseshoe crabs brushing against my waders as I walked back to the boat through the water. Manclark pulled up the anchor while Riepe started the motor and then steered the boat back through one of the little creeks that wend their way through Big Egg Marsh. We came out into Beach Channel, which runs along the northern edge of the Rockaway Peninsula, its shoreline indented here and there with boat basins. Passing under the Cross Bay Bridge, Riepe pointed to a Peregrine Falcon perched high up on a ledge between two girders.

Continuing beneath the trestle carrying the subway tracks across the channel to the Rockaways, Riepe turned the boat into Vernam Basin in order to show me a recently designated city park. The spit separating Vernam from Barbadoes Basin was where, encouraged

by the city's Economic Development Corporation, a developer had planned to build a truck-body customizing operation, an enterprise staunchly opposed by local citizens. Through their efforts, coordinated under the auspices of New York Audubon's Buffer the Bay program, the land was instead transferred to the Department of Parks & Recreation. Riepe pointed out that this might be the first bit of green that migratory birds on the Atlantic Flyway see as they approach Jamaica Bay.

Returning to the main part of the channel, we passed Brant Point, so named because numerous members of this geese species winter in the bay until it is time for them to migrate to their breeding grounds on Baffin Island and in the High Arctic. Next we came to Dubos Point, a larger spit embraced by Conchs Hole Point and Motts Point. This forty-five-acre peninsular appendage was a marsh before it was filled with dredged material in 1912 to create solid land for real-estate development. Its current state as scrub forest is due to nature's reclamation of the site after development did not occur. Another Buffer the Bay success story, it was transferred by the Office of General Services to the Department of Parks & Recreation and designated a nature sanctuary in 1988. Its naming honors René Dubos, the microbiologist instrumental in developing modern antibiotics. Dubos was also a much-esteemed author of several books on the relationship between humankind and the environment, and the originator of the injunction "Think globally, act locally." His wife, Jean, was a driving force behind the creation of the sanctuary; its name commemorates them both.

We were now in Grass Hassock Channel alongside Jo Co, the largest marsh in the bay. According to Riepe, it is the best marsh in the bay for nesting. I could see the long necks of numerous Snowy Egrets sticking up above the mats of cordgrass. Here Laughing Gulls, American Oystercatchers, Common Terns, Forster's Terns, Seaside Sparrows, Willets, Glossy Ibises, and Clapper Rails also make their nests.

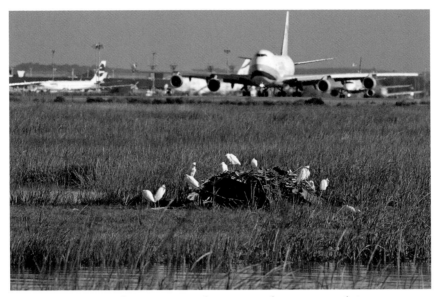

Egrets nesting in marsh grass next to John F. Kennedy International Airport

Protecting the integrity of this and the other Jamaica Bay marshes is the focus of the New York City Audubon Society's Jamaica Bay Research and Management Information Network, which over the past twenty years has sponsored the Harbor Herons Nesting Survey, an annual data-collection project. A companion Audubon effort, the Harbor Herons Shore Monitoring Program, is a citizen-science initiative funded by the New York City Environmental Fund. Its mission is to observe the colony of herons, egrets, and ibises on Canarsie Pol and the marshes surrounding it in order to determine their flight lines and foraging patterns. Riepe participates in both these projects, making day-to-day observations as he patrols the bay in his boat. At the same time, he is able to check on the ospreys nesting atop the fifteen platforms scattered across the bay.

Now JFK Airport was directly ahead of us, its longest runway already penetrating the eastern edge of Jo Co Marsh. Riepe and other

Buffer the Bay advocates are engaged in an ongoing dialogue with airport officials over proposals to build more runways out into the bay. As a member of the Bird Hazard Task Force, he tries to counter their fears that gulls, geese, and ducks in flight pose a serious danger to low-flying planes. As Riepe brought the boat as close to one of the runways as possible, through my binoculars I happened to spot simultaneously a Great Blue Heron gliding over Jo Co Marsh and a Delta airplane. I then understood why he liked to watch both soaring birds and jumbo jets rising into the sky in a straight line and landing with such precise purposefulness.

Having reached the airport's no-trespassing zone at the eastern edge of the bay, we turned around and headed back along Grass Hassock Channel beside Jo Co Marsh. Across the water at Elders Point Marsh we spotted a rookery in a big tree: cormorants occupied at least two dozen large stick nests in its branches. Riepe next steered the boat into Mucke Creek, which separates Jo Co Marsh from Silver Hole Marsh. Because of the rising tide, we were able to thread a passage through the dense mass of marsh grasses. On either side of the boat we saw a large number of nesting egrets and other shorebirds. Passing out into Broad Channel, Riepe went north toward the open water of Grassy Bay. The edge along the airport side has been extended with dredge spoil in a perfectly straight line, a project carried out by the Army Corps of Engineers.

The Corps' relationship to the bay is a complex one; it is charged with constructing and managing the nation's military and civil infrastructure, but its purview includes water resources as well. It is therefore the governmental agency responsible for working with the Environmental Protection Agency, which has as its stated goal "the protection and maintenance of the chemical, physical, and biological integrity of the nation's waters." Although these words do not include the phrase "restoration of marine ecologies," the Corps is involved in projects directed toward environmental regeneration,

which in the case of Jamaica Bay means using its dredging equipment to rebuild marshland. Unfortunately, the existing marshland is continually shrinking. According to studies made by the New York State Department of Environmental Conservation, since 1974 the rate of loss of intertidal marsh islands has been accelerating. Between 1974 and 1994, 526 acres of marsh islands were lost—an average rate of 26 acres per year. Between 1994 and 1999, 220 acres were lost—an average rate of 44 acres per year. Thus, unfortunately, the Corps' work is far from being a zero-sum operation.

Riepe blames the accelerating marsh erosion less on climate change than on the city's combined storm-water and sewage system: when it rains heavily, untreated water from the four large sewage-treatment plants on its perimeter gets discharged into the bay. Even without such events, though, the treated wastewater does not meet clean-water standards. Although it is detoxified and the sludge separated out, Riepe feels that the effluent still has too much nitrogen content. "The bay gets overnutrified, and this causes the bloom of algae," he explained. "Then you get bacteria and nematodes working together, and this starts to eat away the root systems of spartina grass and other vegetation that holds each of the marsh islands intact. As this process destroys them from the inside as well as the outside, they start to fragment, and that increases the amount of edge that can erode." Using irrefutable data showing the level of marsh-eroding nitrates leaching out of the residual sludge and contaminating the bay, Riepe and the Mundys, father and son, were instrumental in enlisting a consortium of environmental organizations to join the American Littoral Society and the Jamaica Bay Ecowatchers in making the case for a lawsuit brought by the Natural Resources Defense Fund in 2010 against the City of New York. It was successfully settled out of court, with the result that efforts are under way to reduce the 57,000 pounds of nitrogen per day being discharged in the bay—double the amount of twenty years ago—to a limit of 22,000 pounds per day.

Saving the Bay

It is obvious that if the bay is to retain its character as a fecund wetland where birds breed, fish spawn, and horseshoe crabs mate, the Army Corps' marsh-rebuilding efforts with federal environmental mitigation funds need to be accelerated. The work is necessarily incremental, expensive, and slow, raising the question of whether reclamation can keep up with reduction. In the race between gain and loss, at this point it would appear unwise to bet on the remaining Jamaica Bay wetlands staying intact, much less accreting.

Nevertheless, Riepe is hopeful. As we turned west into North Channel, he pointed to a marsh with an orange fence surrounding it. "This is Elders Point West, the Army Corps of Engineers' first major marsh-reclamation project to be completed after Elders Point East. Since the agency works with the Port Authority on keeping shipping channels deep enough for large oceangoing vessels, it is sometimes a case of one hand helping the other. Here the Corps brought the sand dredged out of the shipping channel at the Rockaway Inlet near the mouth of Jamaica Bay into this area and stored it. Then they pumped it onto this piece of marsh, increasing six acres to thirty. After that, they planted spartina grass on top. It took two years to get the whole thing up and going, but I think they did a very good job."

As he turned the boat around and started back south through Pumpkin Patch Channel, Riepe pointed out Black Wall Marsh and Yellow Bar Marsh, two fragmented marsh hummocks, both encircled with orange mesh fencing. He explained that this was the combined site of the Army Corps' next marsh-reclamation project, which would be performed in conjunction with volunteers he had helped organize under the aegis of Jamaica Bay Ecowatchers. "In two weeks," he said, "we have a few hundred volunteers coming for four days to plant

88,000 plugs of spartina grass. We've been working with them since the fall, when we harvested 250 pounds of spartina seeds with sickles. The seeds are now germinating at a nursery in Pinelands, New Jersey, where they've been kept wet and cold in saltwater tanks over the winter." Manclark chimed in, "We're super-excited! It's the first time a not-for-profit group has been able to get out and do a marsh restoration project." I asked if I could come and take part in one of the volunteer grass-planting days and was assured that I would be welcome.

On the beautiful April morning that had been scheduled for the event, I arrived at the dock when the bay was at low tide. There I found myself in the company of 160 young volunteers from the Church of God. Group by group, we clambered aboard the motorboat that was to ferry us to thirty-acre Black Wall Island, whose surface had been augmented with 155,000 cubic yards of sand dredged from Ambrose Channel by the Army Corps of Engineers. As we approached and the water became too shallow to go farther, a raft was waiting to take us to the point where we could wade the rest of the way ashore. Sneakers in hand, I enjoyed the sensation of bottom ooze between my toes and seaweed brushing my ankles.

Flats containing plugs of spartina grass had been delivered earlier, and Manclark was instructing the first batch of volunteers on how to plant it. "This is a jig," she said, holding a waist-high wooden tool with two perpendicularly crossed planks at the bottom, one of which had round, pointy pieces about six inches in diameter fastened to either end. A short footboard fastened above it allowed the hole diggers to use their weight to push the points into the sand. "Okay," Manclark said. "We use the jig to mark the places where we want to make holes, because the plugs of grass have to be planted two feet apart. You make the first two marks, and then you move the jig so

that the back point goes into the second of the two depressions you've just made in the sand. You press down on the jig again, and now you have another mark. You keep moving forward, and pretty soon there will be a straight row showing where we are going to plant the plugs of grass." Holding up another device, which looked like an oversized version of the kind of tool gardeners use to plant bulbs, she said, "This is a dibble. Now the next person in line holds one of these and pushes it into the marks that have just been made. When you pull it up, a cylinder of sand comes out; you lay this to one side and move on to the next mark. We may not have enough dibbles, so there are also spades and trowels over here. Next the planter comes along with a plug of grass and puts it in the hole and uses the loose sand beside it to pack it in." She then explained why the plugs had to be planted in such a way that the grass just above their roots was securely covered with sand. "Remember, the tide is going to come in and completely submerge the island, so we're concerned about salinity shock. The shoots may turn a little brown at first, but then they will become green as the roots take hold."

Soon there were lines of young people, most in their teens and early twenties, who were wearing bright green vests emblazoned with "World Mission Society of the Church of God," happily moving in assembly-line fashion along straight, evenly spaced planting rows. Others sat in little groups on the sand, pulling apart the plugs of grass whose roots had grown together in the flats. I wondered how so many volunteers had been assembled. Wilmer Rapozo, the event coordinator, was only too happy to tell me about the church's global reach and ability to enlist volunteers from churches in Manhattan, Queens, Long Island, and New Jersey. He said, "We are the fastest-growing church in the world with fifteen hundred local churches in over one hundred fifty countries. We were originally started in South Korea in 1964 by Second Coming Christ, Ahnsahnghong, who wanted to restore the truth of the Early Church and remind us of the

Church of God volunteers planting with dibble, Black Wall Marsh, Jamaica Bay

teachings of Jesus Christ. Christ Ahnsahnghong revealed to us the truth of Heavenly Mother. She is the force of love, who is now here in the flesh in these last days to fulfill the prophesies in the Bible from Genesis to Revelation." When I queried, "Really in the flesh?" he beamed beatifically and replied, "Exactly! She is on earth at this time in order to lead us to the Holy City, New Jerusalem. She is directing us. She has told us that it is greater to give love than to receive love, and that is why we are here. We want to love the earth as well as the people of the earth."

I turned to talk to Dan Mundy Jr., whose passion for the bay, his lifelong home, equals Riepe's. An ardent ecologist, he explained how he would go out in a boat on the bay from the time he was six years old. Pointing to the Broad Channel shoreline, he said, "See those two houses over there? I helped my dad build his twenty years ago, and then ten years ago I built mine next door. We started Ecowatchers

Church of God volunteers pulling apart plugs of spartina grass in Black Wall Marsh, Jamaica Bay

because we've seen the deterioration of the bay over the years and felt it was time to do something to put a stop to it. Now we're getting these kids here to care about the importance of preserving marshlands. You can see they are having a ball."

I mentioned the specter of climate change and rising sea level, but this did not trouble Mundy. "When Sandy came, you might have thought that this island would have washed away. But it didn't. If we can get the nitrate content of the water under control, the reeds in the marshes actually act as a deterrent to storm damage and erosion by dissipating the strong winds. They also take the carbon out of the atmosphere and counter global warming. Besides this, the marshes are the most biologically fertile places on earth. We've got all sorts of shorebirds and fish and horseshoe crabs breeding in these marshes, which is why it is so important to save them. There has been an unbelievable loss, and we are now finally getting the National Park Service

and the Department of Environmental Protection to pay attention to the scientific data that shows how forty to fifty acres of marsh a year are disappearing.

Dan Mundy Sr., who had joined us, said, "Danny found out that the dissolved oxygen content in the water was below the tipping point of the New York State standard." He enumerated the causes:

> There are three sources of pollution: the nitrates coming from the sewage-treatment plants, the stuff leaching from the thirty-one land-fill sites around the bay, and the glycol that the airport uses to de-ice the runways. But now, at last, we've been able to reduce some of the contamination by getting legislation passed to prevent the dumping of toxic material in the borrow pits, where sand was previously dredged in order to construct the runways. We've even got some oyster beds started. Did you know that oysters can metabolize nitrogen and that they filter-feed thirty-five gallons of water a day?

I wondered at the optimistic tenacity of the Mundys in the face of so many sources of bay degradation, but then I remembered something Don Riepe had said to me.

> It's tough being an environmentalist in a world where there is one disaster after another. We are living in such dire conditions, and if we can't handle population growth, the result is going to be chaos and revolution. But here at Jamaica Bay, we have an example of nature healing itself, where it's been given a chance. Look at it this way: despite over a hundred years of deterioration, the Jamaica Bay ecosystem serves as a natural oasis surrounded by a sea of eight million people. An amazing diversity of species still survives in its waters, marshes, and uplands. It is imperative that we preserve and protect the bay and remaining natural areas within the city, as the future of our species may well be dependent on it.

After I got home following my day on Black Wall Marsh with the Church of God volunteers, I called Riepe to thank him for all he had shown and taught me walking through the refuge, sightseeing by boat, observing horseshoe crabs mating, and planting spartina grass. When I asked him to explain his strong attachment to Jamaica Bay, he replied, "I guess I have the nature gene. Nature has been a great healer whenever I have felt discouraged or depressed. I like to lead American Littoral Society birding tours to such places as Nicaragua and Iceland, but I really don't need to go far away to experience such an abundance of natural phenomena as you find here. Broad Channel is my home, and Jamaica Bay is my backyard. I can't see living anywhere else."

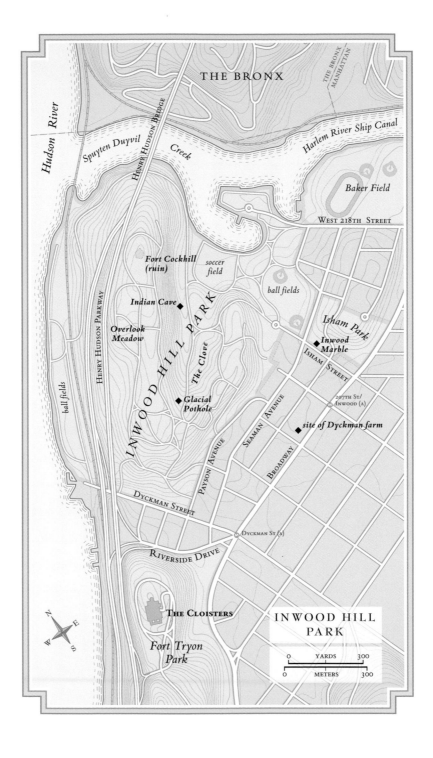

THE BRONX

Hudson River

Spuyten Duyvil

HENRY HUDSON BRIDGE

Creek

Harlem River Ship Canal

THE BRONX
MANHATTAN

Baker Field

WEST 218TH STREET

Fort Cockhill
(ruin)

soccer
field

ball fields

HENRY HUDSON PARKWAY

Indian Cave ◆

INWOOD HILL PARK

Isham Park

Overlook
Meadow

The Clove

Inwood
Marble ◆

ISHAM STREET

ball fields

Glacial
Pothole ◆

PAYSON AVENUE

SEAMAN AVENUE

207TH ST/
INWOOD (A)

site of Dyckman farm ◆

BROADWAY

DYCKMAN STREET

DYCKMAN ST (A)

RIVERSIDE DRIVE

N
W E
S

THE CLOISTERS

INWOOD HILL
PARK

Fort Tryon
Park

0 YARDS 300

0 METERS 300

GREEN FOREST AND INDIAN SHELTER

Inwood Hill Park

The topography of the northern tip of the island of Manhattan is marked by the towering Fort Washington escarpment, the extended ridge of upraised schist that embanks this section of the Hudson River. Today the ridge is divided by Dyckman Street, which follows the cleft of a geological fault. South of the thoroughfare, the bluff is occupied by Fort Tryon Park, named for one of the redoubts used to defend the Hudson during the Revolutionary War. The part of the ridge above Dyckman Street is also a park—Inwood Hill—an anomalous piece of urban real estate as close to wilderness as anything one is likely to find in Manhattan. Although mostly covered by forest, it is not a place of pristine nature. Rather, it has had several lives, the latest of which proves how the opportunistic resilience of nature can create a new environmental reality that evokes an earlier, native landscape.

Geological Textbook and Botanical Miscellany

Our history of Inwood begins with deep time, when the geological formations that define the topography of this part of Manhattan came into being. As I found out when I took a walk with American Museum of Natural History geologist Sidney Horenstein, the Inwood neighborhood is the best place in the city to see, all at the same time, outcrops of the three principal formations that constitute the bedrock underpinnings of New York City. For this reason, our first stop was Isham Park, adjacent to Inwood Hill Park and the site of what was once the Isham family estate. Here, next to Isham Street's sidewalk, is one of the few visible surface outcrops of Inwood marble in the city.

This stone, as we will recall from our earlier overview of the city's geology, is the softest and most erodible of New York's bedrock formations, less durable than the Fordham gneiss and Manhattan schist. Horenstein explained that in this area there were several quarries when marble was a commonly used building material in Manhattan. As we examined the tilted and folded striations of the bedrock protrusion, he said, "See how contorted it is; the rocks were obviously subject to intense pressure during the Taconic orogeny 465 million years ago, and they just flopped over because of all the pushing that occurred as the continental and oceanic plates collided. Look where the striations are almost vertical here, and over there where they are horizontal because of the compression and folding they underwent."

Crossing Seaman Avenue, we entered Inwood Hill Park. Facing north toward the Bronx on the opposite bank of the Harlem River, Horenstein said, "Over there you have a ridge of Fordham gneiss. It's the oldest of the city's bedrock formations and was exposed at the surface in the places where the younger formations of Manhattan schist

Sidney Horenstein

Manhattan schist, Inwood Hill Park

and Inwood marble have been eroded." Turning west and pointing, he said, "That's the schist, the city's uppermost formation. It is the primary bedrock of the island of Manhattan." He then explained how the steepness of the ridge, which exceeds the height of the outcrops in Central Park and elsewhere in the city, is due to the fact that, after the schist's original formation, subsequent tectonics shoved up this section, thereby creating a disjuncture with the lower-lying marble we had observed opposite the entrance to the park.

We walked over to the hillside and stood in the cool shade of the forested slope. We had now entered the Clove, a U-shaped valley that separates the Inwood escarpment into two steep-sided prongs. Drawing a diagram on my notepad, Horenstein said, "Here you get an upfolding, which geologists call a breached anticline, and then a downward fold. That's the trough where we're now standing. Then over there you see the second upward fold forming another anticline. That's why we see two parallel ridges here. It's just like the way a piece of cloth is shoved into folds when you push it across a table."

The Inwood forest of the present day consists mainly of deciduous trees and shrubs. A few evergreens stand out colorfully in winter against the bare branches of the deciduous plantings. Native trees include silver maple (*Acer saccharinum*) and box elder (*Acer negundo*), plus several species of oak—red oak (*Quercus rubra*), white oak (*Quercus alba*), black oak (*Quercus velutina*), chestnut oak (*Quercus prinus*), and pin oak (*Quercus palustris*). Huge tulip trees (*Liriodendron tulipifera*) with columnar trunks that rise fifty or more feet find the valley of the Clove an especially congenial ecological niche.

As we made our way further into the Clove and began our ascent to the apex of the forked ridge, we saw halfway up the escarpment to our right what is colloquially known as the Indian Cave. It is not actually a cave, but rather a heap of slablike pieces of Manhattan schist that fell off the ridge, forming a sheltered space several feet above the path. Beyond this, there is a round, well-like cavity, holding

Indian Cave in Inwood Hill Park

Glacial pothole, Inwood Hill Park

rainwater, in the side of a large boulder. It is a reminder that the entire area was once glaciated, and when the ice melted, stones trapped in some rock depressions were swirled in a circular fashion, creating what geologists call potholes.

Along with the oaks and hickories, Inwood Hill Park hosts a number of other tree species. There are hackberries (*Celtis occidentalis*), American hornbeam (*Carpinus caroliniana*), hickories, birches, red buckeyes (*Aesculus pavia*), and horse chestnuts (*Aesculus hippocastanum*). The black cherry (*Prunus serotina*) and ailanthus (*Ailanthus altissima*), both vigorous self-seeders, abound. The park also has a grove of black locusts (*Robinia pseudoacacia*), white-flowered in late spring, and several Osage orange trees (*Maclura pomifera*), whose thorny branches make an impenetrable haven for birds. Its light green, orange-size fruit has a convoluted skin resembling the exterior of the human brain, and its wood is so hard that Indians used it for arrows and policemen for nightsticks. On top of the ridge, beside what is known as Overlook Meadow because of the spectacular views of the Hudson River it offers, are three immense eastern cottonwoods (*Populus deltoides*). One also finds in this location some huge European beeches (*Fagus sylvatica*), most likely survivors from more than a hundred years ago when the scenic ridge was the site of several large estates and charitable institutions. There is also a gingko (*Ginkgo biloba*) so venerable that it must have been one of the first of that species imported from the Far East in the early nineteenth century, and until recent years a copper beech with a girth of over thirteen feet was still standing.

Beneath the tree canopy, the fragrant-leaved spicebush (*Lindera benzoin*) flowers brilliant yellow in the early spring and, as the days grow warmer, such native species as jack-in-the-pulpit and what is probably the last remaining patch of mayapple (*Podophyllum peltatum*) on Manhattan Island are in bloom. The five-leaf aralia (*Eleutherococcus sieboldianus*), indigenous to Japan, grows in several dense clusters throughout the woodland. Staghorn sumac (*Rhus typhina*) can be found in sunlit

clearings. Raspberry, blackberry, and other members of the Rosaceae family (*Rubus spp.*) are abundant. There is a groundcover of running myrtle (*Vinca minor*) growing in the shaded borders of crumbling old walls. The rubble, wound about with poison ivy, is all that remains of Inwood's grand mansions and charitable institutions.

Birds are attracted to this hospitable environment. On my walk with Horenstein, I was able to observe a Blue-headed Vireo, an American Robin, a Northern Cardinal, and several Blue Jays. There were Red-tailed Hawks circling overhead, and Song Sparrows could be heard, along with four different woodpecker species. In the sheltered recesses of the Clove, there were Tufted Titmice and Red-eyed Vireos, Northern Cardinals and Rose-breasted Grosbeaks. Spring and fall bring numerous species of migrating warblers. Along the Harlem River shore there are waterfowl year-round: Canada Geese, Mallard Ducks, and Ring-billed Gulls. In the summer, Black-crowned Night Herons and Double-crested Cormorants frequent this area.

Native American Fishing Ground

From the end of the nineteenth century until well into the twentieth, Inwood Hill Park was frequented by archaeologists and historians. The first Native American remains were found there in 1890, when three archaeology buffs began exploring the area. Geography accounts for the evidence of aboriginal occupation they discovered. In former times, in the section now occupied by ball fields, the Clove opened out into a broad and fecund salt marsh fed by a cold freshwater spring. Early settlers referred to the spring, which discharged an estimated six gallons per minute, as the fountain against the high land. A copious water supply, protection from winter winds in the sheltering valley, and access to the fishing grounds of the Hudson and East Rivers made the area ideally suited for habitation by the Wickquasgeck, the

Lenape clan whose territory covered what is now northern Manhattan, the Bronx, and part of Westchester County. Their main village was called Shorakapok, variously translated as "the sitting down and resting place" and "the wet ground place." The human and animal remains, stone tools, projectile points, cooking implements, and large shell mounds found in the vicinity of this settlement suggest that it was a sizable area, a rich source of fish and shellfish, as was the salt marsh adjacent to the Clove. The occupants are thought to have used the area primarily as a summer fishing ground and then decamped in the winter, either to sheltered locations in the Bronx or to a Wickquasgeck village at Dobbs Ferry.

Probing in the dry bed of the old stream that once ran through the bottom of the Clove, the archaeologists discovered three large refuse heaps containing oyster shells, animal bones, and pipe fragments. One of them noticed the overhanging rocks embedded in the hillside that Horenstein had pointed out to me earlier. After digging away dirt and forest debris, he found the entrance to what was to be christened the Indian Cave. With mounting excitement, he turned the soft earth with his trowel, uncovering many large pottery shards. According to a newspaper report from the era, "after six hours of digging Mr. Chenoweth had all the fragments of six pots of curious forms and unique manufacture." On the following day, as he again dug into the cave floor, he discovered an entrance leading into a second chamber, the size of which caused him to conclude "that it was the main room of a cavernous retreat." In it he found a rude fireplace, illuminated by light gleaming through a chimney crevice in the rocks overhead. In addition to this putative cave that had been formed when frost and glacial meltwaters loosened rock slabs from the cliff face, causing them to collapse into the side of the hill, there were two others. One was a crevice near the foot of the cliff; another merely an excavated area under a fallen fragment.

The Wickquasgecks made a distinctive impression on European

settlers. Each male wore a long forelock hanging to one side of his head and shaved off the rest of his hair except for a bristling coxcomb. In addition, the men tattooed their bodies and painted their faces, declaring they were the *mannette* (devil) personified. They wore clothing fashioned out of turkey feathers and animal hides, and they were fond of dancing and feasts. Marriages were determined by which man could give the most *zeewan* (shell money) to a prospective bride.

For food, the Wickquasgecks had abundant game, testified to by excavated bones of deer, bear, beaver, and turtle. Fish and oysters constituted an important part of their diet as well. In addition, according to one early observer, they ate "badgers, dogs, eagles and similar trash, which Christians in no way regard," not to mention "snakes, frogs, and such like, which they usually cook with offals and entrails." Around 1000 CE, they began to cultivate beans and corn—Mesoamerican staples carried north as intertribal seed gifts. The corn stalks served as climbing poles for the bean vines. After the harvest, the corn was dried and then pounded and mixed with water to form a mush called *sapaen*. It accompanied meals and sometimes served as a meal in itself.

In 1609, when Englishman Henry Hudson sailed the Dutch vessel *Half Moon* into the mouth of the North River, the Wickquasgecks became one of the first tribes in North America to gape at Europeans. Proceeding upstream as far as present-day Albany, the ship was met by natives eager to barter tobacco and corn for the white man's knives and beads. When a canoe filled with Wickquasgecks rowed out to meet the *Half Moon* as it put in near Spuyten Duyvil, the crew managed to capture two of them, perhaps with the intention of taking them back to England to display as curiosities. The captives later escaped, one drowning in the process. The survivor made his way back to Nipinisicken, a Wickquasgeck village, opposite Shorakapok on the north shore of Spuyten Duyvil. A war council was held, and when Hudson and his men returned to the mouth of Spuyten Duyvil,

two canoes full of angry Wickquasgecks attacked them with bows and arrows.

A cannon fired from the ship dispatched two Indians. The rest quickly returned to shore and fled into the forest of today's Inwood Hill Park. A third canoe ventured forth, and one more Indian was slain by a cannon shot. Then Hudson's men fired their muskets, killing an additional three or four. With this parting salvo, the strange invaders set sail for home, and the Wickquasgecks had only their neighbors and the growing Dutch colony on the island they called Manahatta to quarrel with.

Hudson's crew and subsequent early explorers observed with keen interest that the Indians clothed themselves in beaver pelts, deerskins, and "divers sorts of good furres." They brought back to Amsterdam news of forests and streams filled with mink, muskrat, otter, beaver, and fox. In 1621 the Dutch West India Company was authorized to capitalize on the lucrative New World fur trade. The company financed the foundation of commercial colonies at Fort Orange (now Albany) and Fort Amsterdam. Peter Minuit, appointed director of Fort Amsterdam, negotiated his legendary purchase of Manhattan from the Lenape in 1626. Although the location of the sale is uncertain, in 1954, surmising the transaction to have occurred in the Wickquasgeck settlement of Shorakapok, the Peter Minuit Post of the American Legion dedicated a plaque at the base of Inwood Hill near the mouth of the spring. The site was also chosen to commemorate a magnificent tulip tree that had grown on the spot. Estimated to be 280 years old, it was extolled as having been the oldest living thing on Manhattan Island until felled by the disastrous 1938 hurricane.

However the Dutch may have interpreted the terms of the agreement, the Wickquasgecks, who had been badly misused by continued colonial belligerence, felt no obligation to relinquish their portion of Manhattan. During the first few years, when the little settlement of Dutch traders consisted of a few wooden houses huddled around a

fort at the southern tip of the island, the question was moot. Later, as the residents of New Amsterdam wished to extend their vegetable gardens, or boweries, northward, it became necessary to enter into a series of new treaties and purchases. It was not until 1715 that they finally succeeded in getting the Wickquasgecks to abandon Shoraka-pok, and for the next sixty years the Jan Nagel and Jan Dyckman families farmed the lands they had formerly occupied. The Nagels used the Clove as their woodlot, and the Dyckmans planted apple and pear orchards where the Wickquasgecks had once grown corn. But this rural prosperity was interrupted from 1776 until 1783, when northern Manhattan was enfolded in the drama of the Revolutionary War.

Revolutionary War Encampment

At the beginning of the war several of the farmhouses in the area were appropriated as staff quarters for the patriot army, and an encampment for soldiers was established on vacated Nagel and Dyckman farmland at the base of Inwood Hill. On the heights, with their commanding view of ship movements up and down the Hudson, a chain of fortifications was constructed. Fort Washington and Fort Tryon stood on Long Hill, the present site of the Cloisters. Beyond the valley of Broadway, to the east on Laurel Hill, lay Fort George. Farther north on the Inwood cliff was Cock Hill Fort, a five-sided earthwork overlooking Spuyten Duyvil Creek.

American occupation of these defensive outposts was brief, for on November 16, 1776, the redoubts and adjacent encampment fell into the hands of the British. The victory was executed largely by mercenaries commanded by General Baron Wilhelm von Knyphausen, and Fort Washington was rechristened Fort Knyphausen in his honor. The soldiers—called Hessians because they were from the Landgraviate of

Hesse-Kassel—were among the troops hired out to the British by a group of debt-ridden Germanic princes. Marching toward the King's Bridge and Inwood Hill following the Battle of White Plains, they presented a ferocious spectacle, with their towering, brass-fronted caps; tallow-plastered hair braided in waist-length queues; mustaches dyed with blacking; and bayonet belts and scabbards. Their blue coats were crossed with belts whitened by pipe clay above yellow breeches and black cloth gaiters, and they fastened their coats with pewter buttons bearing regimental insignias. Several of these buttons have been found in Inwood Hill Park, along with other relics of the Revolutionary occupation.

Terrified of the Hessian reputation for brutality, the patriot soldiers remaining in the garrison after the surrender of Fort Washington attempted to ingratiate themselves by offering their captors punch, wine, and cold cakes. Nonetheless, they were forced to march between a double line of Hessian soldiers and lay down their arms, before being taken away under heavy guard to Bridewell, the debtors' prison next to City Hall that the British military had commandeered for the incarceration of American prisoners.

The British occupation of Manhattan Island lasted for the next seven years, and Hessian and British troops used the area around Fort Washington as a military base. The soldiers were housed in huts built into the hillside below the fort along what is today Payson Avenue. There were ten men to a hut and nine huts to a company. The diary of a young Saxon chasseur, Sergeant John Charles Philip von Krafft, details the miseries and deprivations of the occupation. The men, plagued with diarrhea and mosquitoes, were often on the brink of starvation. On the march they received nothing but salt pork, crackers, and rum for rations. Though officially forbidden to pillage nearby farms, they frequently did so. In the fall of 1778, when the hungry soldiers were on the verge of mutiny, they staged a massive raid on the Bronx countryside. Pigs and chickens were slaughtered, and fruit

trees were stripped bare. Angry farmers fired muskets as the soldiers returned to camp two abreast, each pair of men carrying the plunder on a stake between them. The feasting was soon over, and after that the scoured land yielded only chestnuts. As winter set in, food was scarce or nonexistent, and provision ships coming up the Hudson were frequently ice-bound or otherwise delayed. Then the soldiers were reduced to a monotonous diet of oat-grits bread, which von Krafft says "weighed very heavy and with the same weight it lay in our stomachs."

Besides being hungry, the men were often near freezing. Although the huts had large fireplaces, snow drifted in through roof crevices, often forming piles too high for the fire to melt them. By 1779 the once-dense Inwood forest had been cut down for firewood, and rain carved muddy gullies in the denuded hillside. Between bouts of sickness and melancholy von Krafft wrote letters to girls—Miss Weinstock, his sweetheart back home in Braunsberg, and Madame Follert, a Canadian actress with whom he had fallen madly in love while en route to New York. Stricken with fever that summer, he cried despairingly in his journal: "I would be glad to die, were it not that I must die a sub-officer (that worries me on account of my relatives, even on the brink of the grave)."

The war had its lighter side as well. Cock Hill Fort, because of its isolated location and the steep climb to reach it, was rarely visited by staff; it was therefore a good spot for gambling and grog parties. There was a large contingent of camp followers, including a number of wives. One soldier managed to be married by different English and German chaplains "sixteen times to loose women of the town." He told von Krafft that he hoped to repeat the ritual often before making up his mind "to take the last one in real earnest."

With the coming of warm weather, the men were able to plant vegetables and so relieve the shortage of fresh food. According to von Krafft's description, the entire hillside between the huts was covered

with garden plots. He himself had "two pretty spots" near his hut on which he raised "almost all necessary vegetables."

As the war drew to a close and summer brought on another epidemic of cholera, desertions among the Hessian soldiers were frequent. A gallows was erected in September 1783, from which deserters were hanged in effigy. The punishment for insubordination was running the gauntlet; in one instance, a soldier was forced to pass naked between a double line of 200 men as they lashed his backside with the flat side of their swords.

After the war was over, the Dyckmans and Nagels went about reconstructing their farms. The Dyckman apple and pear orchards had been cut down to form a barricade between Fort George and Fort Tryon. The denuded ridge was dusty in summer and awash with mud in winter. Embedded in the Dyckmans' portion of the hillside were the remains of the Hessian encampment. Laboriously, their farmhands removed the huts and planted a new apple orchard in the depressions left in the earth.

Landscape Transformation

From the 1840s into the early twentieth century, much of present-day Inwood Hill Park was the site of country homes and philanthropic institutions, including a charity house for impoverished women. At that time the salubrious air of the high ground overlooking the Hudson provided relief from both heat and the fear of malaria, a scourge at that time identified with damp, low-lying areas. The foundation of the home of the Isidor and Ida Straus family, the owners of Macy's department store, is still embedded in a side of the ridge.

As the area became increasingly inhabited following the construction of the Inwood station of the New York Central Railroad, a free public library—later known as the Dyckman Institute—was formed.

However, by the second decade of the twentieth century, things began to change. The construction of the IRT subway line brought working-class residents to northern Manhattan via the A train, and as the area surrounding Inwood Hill became built up, well-to-do New Yorkers no longer considered it a desirable summer retreat.

Industrial development provided a further incentive for them to abandon Inwood Hill. In 1895 Spuyten Duyvil was realigned to form a continuous channel with the Harlem River for the purpose of creating a navigable passage for large ships traversing between the Hudson River and Long Island Sound. Plans were advanced for creating a port at the base of the ridge between Dyckman Street and the Harlem River, and in 1912 the heavily wooded northern tip of the hill was sold to a private shipping company, which announced that "the work of clearing the hill of timber will soon be underway, and ground will be broken for the construction of the docks and warehouses in the spring." Luckily, neither the shoreline nor the hilltop disfigurement occurred, and the property fell into the hands of a speculator, who hoped to profit by the sale of lots. However, with the growth of the parks movement in New York City and cultural interest in the recent archaeological discoveries in the area, Inwood Hill became a natural candidate for conservation. The idea was first broached in 1895, and although the purchase was initially resisted by the city on the grounds that the site was too remote, when the shipping company made a formal offer of sale on April 22, 1914, the Board of Estimate approved the purchase. Thereupon the city map was changed: Riverside Drive was redrawn to its present terminus at Dyckman Street, and Inwood Hill and its surrounding lowland areas were officially designated a park on May 29, 1926.

By the time the Parks Department acquired the land, the Inwood forest had long since regenerated, and the low-lying wetland next to Spuyten Duyvil Creek was still intact. These natural areas were left undisturbed, although the now-abandoned remaining mansions and

institutions were demolished. Not surprisingly, during the years after New York City's all-powerful parks commissioner Robert Moses took office in 1934, the notion of parks as places of active sports and children's play was reflected in the agency's capital budget. Most of Inwood's wetland was sacrificed to soccer fields, and a neighborhood playground was built at the park's southern end. Light posts and asphalt paths were installed on former woodland trails in keeping with an agency policy of nighttime illumination for safety even in semiwilderness areas. Today, however, nature is reclaiming the park. Asphalt paths are cracked and crumbling, and most of the luminaires atop light posts are broken or missing. However, none of the park's regular visitors complain of the maintenance workforce's policy of

Inwood Hill forest

benign neglect or the planned removal of the lights and conversion of the asphalt paths into a system of woodland trails.

Inwood Hill Park thus provides a cogent example of place as cultural palimpsest. The narrative here of its several lives is a powerful reminder that the same piece of land can be sequentially inscribed with radically different stories—in this case, those of Native Americans, Dutch farmers, Hessian soldiers, estate owners, industrial developers, and parkgoers—and yet, in obedience to nature's relentless dynamic and human aspirations, continue to create new landscape patterns as settings for stories yet to be written.

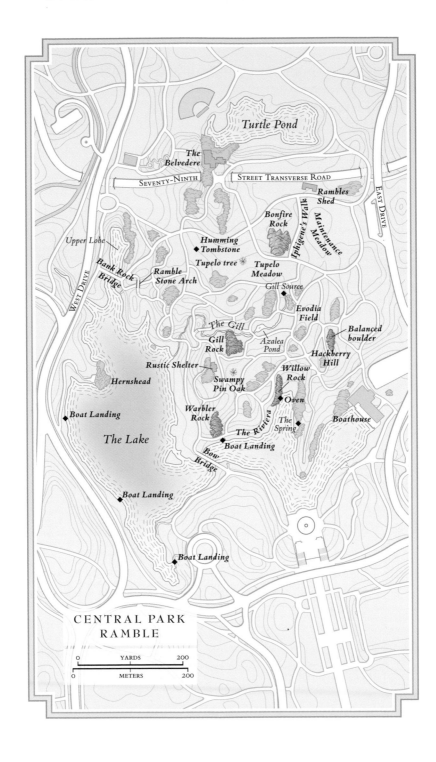

Turtle Pond

The Belvedere

SEVENTY-NINTH | STREET TRANSVERSE ROAD

EAST DRIVE

Rambles Shed

Bonfire Rock

Maintenance Meadow

Iphigene's Walk

Upper Lobe

Humming Tombstone

Tupelo tree

Tupelo Meadow

Bank Rock Bridge

WEST DRIVE

Ramble Stone Arch

Gill Source

Evodia Field

Balanced boulder

The Gill

Gill Rock

Azalea Pond

Hackberry Hill

Rustic Shelter

Willow Rock

Hernshead

Swampy Pin Oak

Oven

Boat Landing

Warbler Rock

The Riviera

The Spring

Boathouse

The Lake

Boat Landing

Bow Bridge

Boat Landing

Boat Landing

CENTRAL PARK
RAMBLE

0 YARDS 200

0 METERS 200

GREEN HEART
Central Park Ramble

On June 11, 1859, New York lawyer and diarist George Templeton Strong took a carriage ride uptown with a friend to view the construction work going on in Central Park. Barely a year had elapsed since the plan Frederick Law Olmsted and Calvert Vaux had submitted under the name "Greensward" was declared the winning entry in the design competition for the new park. Strong noted in his diary:

Reached the park a little before four, just as the red flag was hoisted—the signal for the blasts of the day. They were all around us for some twenty minutes, now booming far off to the north, now quite near, now distant again, like a desultory "affair" between advanced posts of two great armies.

The gunpowder charges that Strong heard were fracturing Manhattan schist bedrock, leveling certain outcrops where the Greensward plan called for uninterrupted openness. The blasting was also

necessary to excavate the terrain where four sunken transverse roads were intended to carry ordinary city traffic across the park without visually or physically impeding the visitor's experience of tranquil scenery. And this blasting was just a first step in a public works project that was no less monumental than the construction of Stonehenge or an Egyptian pyramid. The rubble left in its wake would be turned into raw and dressed stone and the rough and swampy ground into an idyllic landscape of carriage drives, pathways, ponds, streams, meadows, lawns, and woodlands. Taken together, the blasting of bedrock and the excavation, grading, underground plumbing, and planting of the grounds surrounding the remaining outcrops constitute the building of Central Park.

That so much could have already been accomplished toward the fulfillment of the Greensward plan when Strong made his reconnaissance in 1859 is astonishing. Even more surprising is the fact that Olmsted and Vaux could have envisioned a masterpiece of landscape design on such unpromising terrain in the first place. And for those who are interested in geology, botany, and ornithology, Central Park's function not just as the city's premier playground but also as a grand natural-history textbook continues to be a revelation.

Remodeling the Landscape

So taken for granted is the park's naturalistic appearance today that people have largely forgotten this 843-acre pleasure ground is entirely man-made—a brilliant overlay of nineteenth-century engineering technology with pastoral and picturesque scenery. It is therefore hard to imagine a time when it was a ragged stretch of mostly undeveloped, sparsely inhabited land lying between brownstone New York and the rural estates of northern Manhattan. There were a few small

farmsteads and a community of African American freedmen and German and Irish immigrants called Seneca Village located near Eighty-Fifth Street and what is today Central Park West. In order to create the park, these private holdings were acquired by the city through eminent domain and their owners duly compensated, in spite of their strong reluctance to abandon their properties. Elsewhere squatters were evicted, their shanties torn down, and a bone-boiling works that recycled animal carcasses was razed.

What was left was rough topography, thin soil, and scraggly vegetation. Olmsted and Vaux did not see these defects as liabilities. In the 1859 annual report to the park's board of commissioners, Olmsted wrote:

> Casual observers have been apt to think the selection of the site an unfortunate one, its general ruggedness being rather forbidding, than expressive either of dignity or grace. But this was due very much to the absence of soil and foliage. As these are supplied, the quality of picturesqueness becomes agreeably prominent. Grass and shrubbery can be formed anywhere, but rocks, and those salient forms of earth-surface which are only found in nature where rock exists, can never be imitated on a large scale, with perfect success. Although, therefore, it will require a heavy expenditure to make the Park complete, the final artistic effect should be much finer than could have been expected upon a tract of the richest and most easily worked soil, the natural outlines of which were invariably graceful.

In their plan for the park, the designers developed an aesthetic of harmonious contrasts: pastoral scenery, such as that created by England's famous eighteenth-century estate "improver" Capability Brown, alternating with the ruggedness associated with the Picturesque and Sublime. For this reason, not all of Central Park's

Groove from gunpowder cylinder used for blasting bedrock in Central Park

Manhattan schist bedrock was fractured by the insertion of cylinders of gunpowder whose detonated charges Strong and his companion had heard. Some bold protrusions were consciously incorporated into the landscape, whether as grand sculptural presences or vantage points. Huge chunks of loosened bedrock and glacial boulders were relocated to fulfill picturesque purposes.

Indeed, the entire park served as a quarry during the period of its construction. A small army of stonecutters transformed pieces of schist that had been removed into slabs for stairs and masonry for walls. Sometimes they incised steps directly into a rock face or leveled the top of an outcrop to create a platform for a gazebo; sometimes they flattened one side to make a straight vertical wall flanking the edge of a path.

Besides the stonecutters necessary to turn blasted Manhattan schist rubble into rough-hewn building blocks, the workforce consisted

Rustic shelter, Central Park Ramble

of masons to construct walls, steps, and structures built of the same dressed schist; bricklayers and stone-carvers to erect the arches that would carry pedestrians safely beneath the carriage drives; and foundry employees to manufacture the ornamental cast-iron bridges that allowed park visitors to cross over the bridle trail without being impeded by horseback riders.

Because the park was swampy in places, laborers trenched the ground and laid drainage tiles and sewer lines below the surface. Other workmen dug the lakes and ponds we see today, which were then furnished with water piped from the reservoir of the recently constructed Croton Aqueduct, whose opening in 1842 as the city's first source of pure water is memorialized by the beneficent angel atop the fountain at the Bethesda Terrace. As an aside, the reader should note that the original rectangular-shaped reservoir, later known as the Old Reservoir, predated the park's existence. It occupied the

COURTESY OF SARA CEDAR MILLER

Bethesda Fountain, Central Park

low-lying area immediately north of the Belvedere until 1931, after which it was filled in and its site subsequently reborn as the Great Lawn. The so-called Receiving Reservoir between the Eighty-Sixth and Ninety-Sixth Street transverse roads—the one whose perimeter is used as a running track today—is contemporary with the construction of the park.

In addition to Central Park's on-site labor force, there were the drivers of horse-drawn carts carrying the hundreds of thousands of loads of topsoil needed to grade the ground into a smooth, rolling surface where the Greensward plan specified open meadows and lawns of grass surrounded by trees and beds of shrubs and flowers. Whereas numerous outcrops were left exposed for scenic purposes, elsewhere workmen mounded soil on the flanks of rocky protrusions in order to create gentle knolls. They also heaped and graded more tons of soil adjacent to the retaining walls of the sunken transverse roads, thereby creating berms that reinforced the concealment from sight of non-park traffic between Manhattan's East Side and West Side.

In all, the building of Central Park was an immense public-works project. The statistics in the 1873 Annual Report to the Board of Park Commissioners tell the story:

> The quantity of material handled in grading, fertilizing and building has been four millions, eight hundred and twenty-five thousand (4,825,000) cubic yards, or nearly ten millions of ordinary city one-horse cart-loads, which, in single file, would make a procession thirty thousand (30,000) miles in length. Of the above amount 4,140,000 cubic yards were of the original ground material of the Park, and the change in place of this has been equal to the lifting and re-arrangement of all the ground to a depth of three and three-quarters (3¾ feet); four hundred and seventy-six thousand (476,000) cubic yards of rock (besides small boulders) have been excavated, removed and reset, and, in the blasting out of this quantity, twenty thousand eight hundred (20,800) barrels (25 lbs. each) of gunpowder have been used.
>
> Two hundred and seventy-two thousand (272,000) cubic yards of masonry have been laid, chiefly of first-class building stone, one-third of it in curved work. More than half of the stone has been quarried in the Park. All the masonry laid is equal to twenty-seven (27)

miles in length . . . [and] sixteen inches thick. The larger part of it is either under ground or below the level of the eye and concealed from observation.

One hundred and fourteen (114) miles of subterranean channels have been laid in the Park, of which thirty-three (33) miles consists of close-jointed sewer pipe, and nineteen (19) miles of metallic pipe, the remaining sixty-two (62) miles being nearly all cylindrical earthenware tile laid with collars. Over ten miles of curbing has been set on curves, vertical and horizontal, of constantly varying radius. In the study of the plans and for the guidance of the operations fourteen thousand (14,000) drawings (maps, tracings and copies included) have been prepared, and a million and a half stakes set.

The workforce listed in the same annual report included the superintendent (Olmsted), architect (Vaux), a topographical engineer, engineers, assistant engineers, draftsmen, surveyors, levelers, roadmen, chainmen, axmen, tapemen, blacksmiths, plumbers, head gardeners, division gardeners, blasters, rockmen, skilled laborers, laborers, teamsters, and pile drivers. In addition, there were patrolmen, gatekeepers, night watchmen, and female attendants as well as clerical employees.

The Ramble

If we think of the park as a kind of landscape symphony, we pass from one scenically varied movement to another—broad meadow to lakeshore to wooded grove—within a single unified composition. As in music, there are themes and variations that repeat themselves. But nowhere within this Central Park symphony is there anything quite like the Ramble: thirty-six wooded acres stretching from a point of land projecting into the Lake opposite Bethesda Terrace to Vista Rock with its crowning Belvedere.

Olmsted has left us a description of the site as it was at the time: "a broad hill-side, broken by ledges of rock and bestrewn with boulders." His vision for the future was one in which "the whole breadth of the Park will be brought into this landscape." With the Bethesda Terrace as its foreground, the view of the scenery of the Ramble on the opposite shore would "be enriched with architectural decorations and a fountain." The middle distance would be rugged—composed of rocks, evergreens, and dark shrubs that would be reflected in the Lake. Beyond, the background, like that of a landscape painting, would be one of "intricate obscurity." This would be achieved by "carefully planting shrubs of lighter and more indistinct foliage among and above the gray rocks." Significantly, Olmsted pointed out that the hillside, "being isolated in position, is crossed by no road but entirely laid out with secluded walks bordered by shrubbery." Along with its Romantic design, this separation from the rest of the park's circulation system is what gives the Ramble its special character as a mysterious little forest within the larger park.

This part of the park was one of the initial areas opened to visitors. Strong and his companion headed there after the sound of blasting had died away. In his diary he noted, "Its footpaths and plantations are finished, more or less, and it is the first section of the ground that has been polished off and made presentable. It promises very well." Let's see how this unique area within Central Park has fared over the past century and a half.

The Ramble's Rocky Bones

Intended by its designers to simulate in miniature famous vacation haunts in the Catskills or Adirondacks known to many New Yorkers either firsthand or in paintings of the Hudson River School, the Ramble is the most purely Romantic part of the park. Unlike other

Central Park Ramble pathway next to Manhattan schist rock face

areas, intricately meandering byways foster the impression that one is traversing an extensive, quasi-natural woodland. Massive outcrops, glacial erratics, and sheer drops where bedrock plunges below the surface of the Lake foster the illusion of a wild landscape. Some of the boulder heights are crowned with structures from which visitors can survey the surrounding view. Others are simply striking elephantine presences to be admired or climbed. However, in some places the stone was quarried and used elsewhere in the park as building material. When left in situ and dressed on one side, an outcrop could provide a sheer wall lining a path. Sometimes it appears that a tireless Sisyphus was at work shoving and heaving great pieces of Manhattan schist in order to make waterfalls and other picturesque features.

The Ramble is therefore a good place to ponder how an army of

laborers under Olmsted's direction—up to a thousand at a time—manipulated the park's original landscape by transporting huge pieces of the blasted bedrock to various locations while also building stairs and structures of the cut stone. An engineer, Egbert Viele, Central Park's original surveyor as well as its earliest overseer of clearing operations, noted that its rocky outcrops "exhibit no uniformity with regard to strike and dip [and] show everywhere violent dislocations, owing to the intrusion of various veins of granite." The predominant gray of the schist is broken by crystals of burgundy-colored garnet, striations containing quartz and feldspar, and flecks of sunlight-reflecting mica. Smooth tactile surfaces have been scoured, polished, and grooved by the passage of grit-laden glacial ice. Many boulders offer comfortable surfaces to sit or lie back on. The impulse

The Belvedere atop Vista Rock, Central Park Ramble

to climb them turns to invitation in several places, where stairs have been carved into their bases. Vista Rock is the most prominent outcrop in the Ramble and the second-highest point in the park. Its crowning feature, the Belvedere designed by Vaux, is built of rough-hewn blocks of quarried-on-site Manhattan schist, which, when viewed from the Great Lawn below, makes this turreted Victorian Gothic structure appear to grow out of the parent bedrock. In the nineteenth century it was visible above the Ramble's tree line to promenaders on the Mall; today it is a fine place from which to survey the Great Lawn and the skyline of towers along Central Park West and Fifth Avenue.

A walk with Henry Towbin, a recently graduated Oberlin College geology major, gave me an opportunity to understand the rocks' mineral composition as well as to admire the ingenuity of the designers and the feats of labor required to turn the Ramble into what, to most people, appears to be nothing more than a little patch of woods.

As we sat on a lakeside bench opposite the Ramble before starting our meander along the twisting paths winding through it, Towbin gave me a preliminary Central Park geology lesson. In summary, it went like this:

> On the scale of a single outcrop of Manhattan schist we can observe what appears to be a homogeneous mineral structure. But a closer look reveals bands of various color patterns and textures representing diverse mineral assemblages. Each band, such as the clear whitish ones composed of quartz, tells of a difference in the composition of the sediments deposited on the ocean floor hundreds of millions of years ago before the rocks metamorphosed into the schist formations we see today. Although the bands containing these mineral sediments were contorted by heat and pressure in the process of metamorphosis, we can tell that they are made up of what were once horizontal layers of clay and sand deposited in a flat seabed. The evidence for this lies in

Henry Towbin

Manhattan schist bedrock with bank of quartz

Stone arch at the western entrance to the Ramble

the fact that, even though the bands bend as they traverse rock, they all remain parallel to one another and approximately the same thickness from one end to the next.

We also see pink stripes cutting across several rocks. At first we might think these bands are just another variation in the sediments being deposited, but a closer look reveals several important clues as to their origin. If you follow them closely, you will notice that, while they are somewhat curvilinear, they don't necessarily follow all of the bends of the originally parallel layers. In fact, they actually cut across many of the bands. This is a sign of a magmatic intrusion— molten-rock injection into fissures in the schist. In the beginning, before the schist was further contorted by subsequent metamorphosis,

these ribbons of igneous origin would have appeared as straight lines on the rock's surface.

At the conclusion of this introductory lesson, we got up and crossed Bank Rock Bridge (an obvious name because of its proximity to the immense outcrop forming the edge of the Lake in this location) and took the path that leads beneath an elongated stone arch, one of several park structures constructed of masonry blocks hewn from on-site schist. The opening of the arch appears to have been cut through a mammoth outcrop whose bulk presses tightly against its sides. However, this is not quite the case. Only on one side does an actual outcrop hug the wall of the arch, whereas on the other, two upended pieces of blasted rock—giant fragments of an outcrop transported from elsewhere in the park—complete the embrace.

Stairs of rough-hewn Manhattan schist masonry, Central Park Ramble

The Gill, Central Park Ramble

Nearby, a loose retaining wall composed of smaller pieces of harvested rock is supported by blocks of rustic masonry. Pointing to a place where the bedrock outcrop rock meets the ground, Towbin showed me the marks made by the stonemason's tool, explaining, "This is where they did some work to give it a flatter, more finished surface."

Beyond the arch, the path took us up a few steps made of the quarried-on-site schist—more evidence of the labor of masons. Veering right, we headed south toward the Gill, an artificial stream that flows through the Ramble from a boulder-concealed valve, giving the illusion of a natural spring. Throughout its course, this deceptively natural water feature is punctuated with picturesque waterfalls and rustic bridges. Standing at the bottom of the declivity where

the stream spills into the Lake, we looked up at a steep waterfall the designers had created, an expression of the same American Romanticism that inspired the painters of the Hudson River School. Here we could see the way in which the artificial cascade had been engineered by tumbling huge pieces of rough schist over the edge of a slope. I was amazed to think of how these rocks had been transported by nothing more than horse-drawn wagons and human labor and then levered into place in such a way that they looked like a perfectly natural mini-avalanche of stones.

From here we took one of the circuitous paths leading up to the Belvedere. After mounting some steps that the park's nineteenth-century crew of stonemasons had cut into the face of Vista Rock, we reached the terrace in front of the entrance to the Belvedere. Here we could see how pieces of the schist had been cut and dressed to form the terrace walls. Looking closely, we noticed several vertical grooves where sticks of gunpowder had been used to break the quarried stone into blocks that are roughly uniform in size and with a relatively flat surface plane.

At this point we turned around to face the weather station, a small fenced compound containing the meteorological equipment whose readings constitute New York City's daily weather reports. Next to it is a steep stairway made of more of the cut-schist masonry. I was beginning to feel tired, so I suggested that we sit down on the top step and rest before descending to the small meadow that contains my favorite Central Park tree, an enormous tupelo (*Nyssa sylvatica*).

As we looked at the step below the one on which we sat, Towbin resumed his professorial role:

Here we can see how variations in the elemental composition of the local sediments from which the schist was formed determine its appearance. In this band we find small garnets, where in the adjacent bands

we find none. Differences in minerals in metamorphic rocks arise from differences in their chemical composition and in the temperature and pressure at which they formed. The bands here are so close that they must have experienced similar temperature and pressure, but, from the presence or lack of garnets distinguishing one band from another, we can make the assumption that there were subtle variations in the mineral composition of the sediments being deposited on an ancient seabed before they metamorphosed into schist.

After we made our way down the steps and back into the Ramble, I called Towbin's attention to an enormous outcrop with sparkling flecks of mica (the rich presence of this mineral in the park's outcrops and those elsewhere on the island of Manhattan is what gives this particular local formation its full name, Manhattan mica schist). He then explained, "Mica is another mineral, and just like every other mineral it has a unique crystal structure. In this case you have a shiny silicate material that forms in plates that look like fish scales or a bunch of stacked sheets, which is why this kind of crystal pattern is sometimes referred to as a 'book.'" I was about to stand up from where we were crouching at the base of the rock examining mica "books" when Towbin exclaimed, "Look here, we have some garnets!" Sure enough, I could see some small round burgundy-red crystals embedded in the schist.

Lest I should think that the processes of plate tectonics and climatic action that cause mountain building, erosion, more crustal upheaval, another cycle of erosion, and so on had been put on hold now that we were standing beside this solid stone outcrop and looking *backward* through the long lens of earth history, Towbin made the point that geological time is *ongoing* and the bold rock outcrop whose mica we were studying only appeared to be durably solid and stationary. Pointing at the root of a tree that had wedged itself into a crevice, he said,

Glacial erratic, Central Park Ramble

See how the rock is being fractured and separated in the place where the root is wedging it apart? Naturally, everything we can see on the surface of the earth is subject to continual erosion from wind and rain and snow, and the tree that's helping split the rock is just pushing things along. Freeze and thaw plus the interaction of all sorts of vegetation occupying every tiny pocket of soil where a seed can germinate are also responsible for the decomposition of rocks. It's a basic geological fact that erosion is perpetual and the process of continual change in material structure and the transformation and recombination of the earth's basic elements can never be arrested.

After we had traced the Gill to its source, the "spring" that flows out of the ground beneath a rocky ledge, we headed toward the Boathouse. Before we walked down the sloping path that would take us

to its café for a cup of coffee, we stopped to look at an erratic boulder poised on the surface of one of the Ramble's larger outcrops. Neither of us could say for sure whether or not this was the location where the ponderous glacier had deposited it when the melting ice was unburdening its load of gathered debris. Knowing of Olmsted's eye for design detail, the overall Romantic character of the Greensward plan, and the engineering ability and manpower on hand when the park was built, I tend to believe that it was hoisted to its dramatic perch as part of the same legerdemain that gives the Ramble its intended character as a wondrous woodland.

Horticultural Transformations

In 1857, a year in advance of the design competition that would result in the choice of Olmsted and Vaux's Greensward plan, Egbert Viele described the existing soil of the area that would become Central Park as derived from "drift or diluvial deposit . . . varying in thickness from a few inches to thirty feet in thickness, and affording at best very poor soil." In spite of this discouraging assessment, the botanical survey Viele undertook identified forty-two plant species. Thus we have a starting point for describing the Ramble's botanical fortunes through the years.

Since at that time no horticultural effort had yet been made to alter the appearance of the landscape, the plants Viele listed were almost entirely native species. Among the trees were approximately 9,000 silver-leaved maples (*Acer saccharinum*), 2,000 beeches (*Fagus ferruginea*) growing as tall as fifty to sixty feet high, and two kinds of dogwood—1,500 variegated white (*Cornus alba*), and 1,500 American (*Cornus florida*). In addition, there were 500 tulip trees (*Liriodendron tulipifera*) forty to eighty feet tall, and 2,000 red oaks (*Quercus rubra*)

fifty to eighty feet in height. The understory included 1,500 witch hazel bushes (*Hamamelis virginiana*), 250 spicebush shrubs (*Lindera benzoin*), and 600 white honeysuckles (*Lonicera maackii*). Most of these were probably situated in the park's northern section, since historic photographs confirm the general barrenness of the southern part of the park. The challenge now was to incorporate the existing vegetation into a designed landscape that included exotic species as well as native. To accomplish this, new plants were propagated in an on-site nursery; others were purchased from the Parsons Nursery in Flushing.

In Olmsted's final report to the park commissioners in 1872, it is clear that Central Park was New York's premier horticultural showcase before the founding of the New York Botanical Garden in 1891. Since its inception, somewhere between 400,000 and 500,000 hardy trees, shrubs, and vines had been planted, along with 160,000 hardy ferns. An appendix compiled by botanist Robert Demcker of all the plants in the park at that date lists 402 separate species of deciduous trees and shrubs; 149 nonconiferous evergreens; 81 species of conifers; 815 hardy perennial and alpine species; and 1,561 species of exotic and tender plants cultivated in a conservatory where the Conservatory Garden now stands at 104th Street and Fifth Avenue.

Following Olmsted's resignation, Vaux became head landscape architect of the New York City Parks Department, bringing with him his associate Samuel Parsons Jr. (1844–1923), grandson of the founder of the Parsons Nursery in Flushing. Upon Vaux's death in 1895, Parsons, whose original title was superintendent of planting, became his successor. His tenure, which lasted until 1911, effectively marked the last stage of what may be termed the Greensward era, a period in which an ethos of scenic recreation prevailed over that of sports recreation.

Louis Harman Peet's 1903 *Trees and Shrubs of Central Park* makes clear that during this time Parsons concurred with Olmsted and Vaux's

belief that foreign and indigenous species could be comingled in such an artless manner that no one but a botanist would care to discriminate between them. The book is divided into a series of inventories accompanied by maps for each section of the park. The one for the Ramble pinpoints 110 notable species, among them numerous native plants first recorded by Viele as well as the exotics listed by Demcker, including a Japanese pagoda tree (*Sophora japonica*) and several English hawthorns (*Crataegus oxyacantha*). Following Peet's itinerary for this part of the park, it is obvious that, although many of the species were the same as those on the earlier inventory, almost none found on the key are in the locations pinpointed on the map. This leads to the obvious conclusion that here, as everywhere else in nature, Central Park's vegetation has been vulnerable over the years to aging and accident. In fact, the largest trees we see today in the park, with a few notable exceptions, were for the most part planted during the second half of the twentieth century.

Thus, the Ramble, like the rest of Central Park, is a vegetative palimpsest. An examination of its different historical layers reveals that after Parsons's retirement, Parks Department commissioners no longer focused on landscape design. Certainly a different philosophy prevailed during the three decades after Robert Moses became parks commissioner in 1934. During that period, the appearance of the park landscape was considerably altered. Twenty-two playgrounds were built around the park's perimeter, and several Olmstedian meadows were converted into ball fields. Buildings such as the Wollman Rink, the North Meadow Recreation Center, and a new brick Boathouse to replace Vaux's wooden one were constructed. Rustic gazebos crowning rock outcrops were removed. A Chess & Checkers House replaced the largest of these, covering the top surface of the Kinderberg (so named because the rock outcrop is a mountain from a child's perspective and is situated in the area of the park that was originally set aside as a children's precinct). A Model Boathouse, the Carousel, and several

other park structures were also built in Moses's preferred architectural idiom of brick with alternating bands of limestone and a slate roof with a crowning cupola. And although numerous trained gardeners from large Long Island and Hudson River Valley estates found employment in the Parks Department during the Great Depression, by this time Olmsted and Vaux's picturesque planting principles had been abandoned altogether.

Following Moses's retirement in 1960, the park began a fifteen-year slide into dereliction. A mismanaged and underfunded Parks Department and demoralized workforce remained inactive as lawns and meadows turned to bare dirt and the drug culture invaded the now crime-ridden, graffiti-covered park. In the Ramble, spontaneous vegetation began to grow rampantly, crowding out species that had once given it picturesque variety. When considered individually,

Golden ragwort (Packera aurea)

some of these plants—black cherry (*Prunus serotina*), ailanthus (*Ailanthus altissima*), Norway maple (*Acer platanoides*)—are not unattractive, but their aggressive spread created monocultural pockets where there had once been a pleasing diversity of plant species. The worst invader of all, Japanese knotweed (*Fallopia japonica*), appropriated the ground plane of the Ramble almost entirely.

Such was the condition of the Ramble when the Central Park Conservancy was created in 1980. With more Olmstedian passion for re-creating the original sight lines to the Belvedere than sensitivity to constituency politics, in the early days of its existence the Conservancy removed a handful of spindly, self-seeded black cherry trees, creating a furor among the Ramble's bird-watchers, for whom this section of the park is still proprietary turf. Because of their vociferous outrage, the Conservancy was forced to prioritize projects elsewhere in the park and allow knotweed and other volunteer species in the Ramble to follow nature's indiscriminate course for the next fifteen years.

By the mid-1990s, however, the Conservancy had developed a community outreach program and was in an ongoing dialogue with the park's multiple constituencies. Its formation of the Woodland Management Committee at that time marked the beginning of a new relationship between birders and the Conservancy. Gradually, as trust grew, the restoration of the Ramble through a small-project-by-small-project approach began as staff horticulturists replaced patches of knotweed with wildflowers, ferns, and other native woodland plants.

The principles underlying the Ramble's new botanical era, however, were far different than in the period when it was a picturesque wildwood. Nor were the Central Park Conservancy horticulturists interested in returning to the paradigm formed in the days when the entire park, including the Ramble, served as something of a botanical showcase for a large diversity of plant species, both exotic and

Rotting log, Central Park Ramble

Neil Calvanese

native. Indeed, it is hard to imagine what Olmsted, Parsons, or Peet would think of the appearance of the place today if they saw the dead branches, standing tree stumps, and mud flats along the shorelines of the Gill and coves of the Lake. This, however, can be considered an enlightened type of park management in an ecologically aware age. To learn more about this seemingly novel kind of horticultural practice, I made a date to walk through the Ramble with Neil Calvanese, the Central Park Conservancy's recently retired director of horticulture, whose thirty-three-year career spanned almost the entire period of the organization's existence.

"Today we have a much healthier landscape in the Ramble than there was back in the 1980s," Calvanese told me. "We've listened to the concerns of the bird-watchers and are incrementally creating a landscape that really is like a natural forest with a shrub understory and wildflowers and ferns on the ground instead of a jumble of weeds. We are not removing a lot of broken tree trunks and branches because they attract insects, a prime food source for certain kinds of birds, and because they also serve as habitat for woodpeckers."

Eco-culture, the term I like to use with regard to this type of horticultural management, is one involving certain judgment calls and inconspicuous interventions. According to Calvanese, "We don't just leave every limb on the ground in the spot where it fell; sometimes we move things around a bit. Where you see a log lying near the edge of the path, we've probably dragged it there to act as an unobtrusive barrier so that people don't trample the new wildflower areas we are planting. We're also using low wire fencing to enclose some of the sections we've reclaimed. I know the Ramble's supposed to look like a natural woodland, but we have to control the foot traffic in recently planted areas, and the fences are temporary and can easily be taken down whenever we want to do so."

Although "invasive exotic" sounds like a politically charged term,

current management favors native species over foreign imports, since the latter, being immune to the pests and diseases that keep the indigenous species in check, often outcompete them in the fierce struggle for plant supremacy. "Look at the ailanthus," he said. "There's nothing wrong with it. It's an attractive tree. Native trees are mostly held in check by the fact that there are various predatory organisms and diseases that keep the population in balance, but imported species such as the ailanthus or the Japanese knotweed have certain immunities, and this allows them to overtake the plants that are less aggressive in propagating themselves. Yet even native trees, particularly the black cherry, the predominant volunteer species in the Ramble, can be classified as invasive when its seeds are distributed all over the place by birds and people's shoes."

Calvanese went on to explain the Central Park Conservancy's current editorial approach, which capitalizes on nature's regenerative power, giving free rein to certain self-generating species while eliminating others. Selective weeding of seedlings sprouting from the ground—conservancy staff and volunteers use a tool called the "weed-whacker," a metal rod with an open-shut clamp at one end to grab the root—is one way to prevent black cherries or Norway maples (another prolific volunteer species) from completely colonizing an area. Japanese knotweed is impossible to uproot in this way, so its elimination is accomplished by closely monitored, selective use of an herbicide. Once an area that has been aggressively appropriated by this plant is opened up, it is revegetated in two ways. Some native weeds—for instance, joe-pye weed (*Eutrochium*) and lamb's quarters (*Chenopodium album*), which are attractive plants and not rampant spreaders—are allowed to thrive and multiply, but not so much that they take over a large portion of ground. Other native species, such as Virginia bluebells (*Mertensia virginica*), trout lily (*Erythronium*), wakerobin (*Trillium*), mayapple (*Podophyllum peltatum*), wild geranium

Lenten rose (Helleborus orientalis)

Wild geranium (Geranium maculatum)

(*Geranium maculatum*), and columbine (*Aquilegia*), acquired from native plant nurseries, are encouraged to self-propagate at random.

Eco-culture is not always governed by a policy of selective plant removal. This process is sometimes accomplished by acts of nature, such as violent storms and high winds. For instance, a 2009 micro-burst cut a devastating swath across the park's northern end, upend-ing several hundred-year-old trees and leaving their extracted roots pointing skyward. While the same microburst did not fell as many trees in the Ramble on this occasion, an abundance of fallen limbs required a major cleanup operation in which some branches, if not trucked away and turned into wood chips off-site, were repositioned on the ground where, with the help of insects and fungi, they would decompose into humus.

"We don't necessarily think we have to replace every tree that dies or falls down in a storm," Calvanese replied, when I inquired about the Conservancy's overall planting policy. "The park is a living cre-ation, and change is part of life. Helping change occur in the best way possible should be our goal. The idea that you have to replant a tree for every tree that is gone is wrong. What happens when you don't replace a tree is that you get more sunlight, and this encourages a nice mix of wildflowers to grow where there was just bare ground before. Edge conditions—places where there are open grassy areas next to a woodland—are also ideal places to find birds. We try to look at the park in its entirety both in terms of ecology and design and think of it as a total work of nature and art." Consulting a fact sheet, he said, "In 1983, when we made our first survey, there were 24,000 trees in the park. Today we have 19,500. Back then we counted 4,262 black cher-ries; today there are 3,111. We had 1,310 Norway maples at that time, and now there are 426. And look, there are still so many trees that you don't really notice the ones that are gone."

To get a sense of Calvanese's eco-culture aesthetic in action, I called Regina Alvarez, the Conservancy's former director of horticulture

and woodland management. Alvarez's principal responsibility during eleven of her nineteen years with the Conservancy was the restoration of the Ramble according to the ecological principles Calvanese had described to me. I readily accepted the invitation to take a walk with her and Daniel Atha, botanist and collections specialist at the New York Botanical Garden and her collaborator in a Conservancy-sponsored survey of the plant species that self-propagate throughout the park.

After meeting at the Boathouse we paused beside the pathway entering the Ramble to notice what to anyone without a botanical fascination would think of as merely a weedy tangle. For Alvarez and Atha, however, this was a perfect showcase of native plants. They pointed out a large patch of snakeroot (*Ageratina altissima,* formerly *Eupatorium rugosum*), covered with a frosting of small white fall-blooming flowers. A little farther along the path we stopped to discuss another variety of this genus, common boneset (*Eupatorium perfoliatum*), easily distinguished from its cousin by the paired leaves fused around the stem and taller, more open inflorescences. A mass of another fall-blooming wildflower, white panicle aster (*Symphyotrichum lanceolatum*), also drew our attention. According to Alvarez, "Only a handful of natives survived and self-propagated during the pre-1980s decline of the park. These include white wood aster (*Eurybia divaricatus*, formerly *Aster divaricatus*) and snakeroot (*Ageratina altissima*), mostly. As part of our restoration efforts we introduced native species such as the boneset and heart-leaved aster (*Symphotrichum cordifolium*). As the habitat recovered, these species have become established." She went on to explain how, although the eupatorium and a few other indigenous species had been growing in the Ramble when the Conservancy took over its management, most of the ground was blanketed with the troublesome Japanese knotweed. Now, as it is being reclaimed patch by patch, the Ramble can boast a large and diverse population of native species. What seemed so happenstance to my eye was

Striped white violets (Viola striata)

actually the result of annual planting, selective weeding, and ongoing decision-making about when to allow nature to simply take its course.

The current eco-culture era in the park's vegetative history is one in which decisions about what to eliminate, what to leave in place, which plants to encourage to self-propagate, and what to buy from nurseries in order to increase plant diversity and enhance the wildwood aesthetic are continually being made. Eco-culture sometimes involves habitat transformation. As Alvarez explained, "Up in the north end of the park there were a few struggling patches of trout lilies, but it was just too shady for them to thrive. There were way too many Norway maples, so when we weeded them out, guess what happened—a beautiful groundcover of trout lilies, masses of them that still keep on spreading wherever there's sufficient sunlight to be found."

I wondered how, without a specific horticultural design, decisions were made regarding which new plants to introduce into the Ramble's artificial woodland ecosystem. Alvarez said, "Our thought process is to increase diversity as much as possible while using primarily native species. If there are exotics such as the azaleas around Azalea Pond, they are just part of the scenery, but we wouldn't go out and buy more of these, whereas we buy ferns and wildflowers such as lady's slippers and trilliums from nurseries because we want them for variety and also because we want to protect all endangered plant species along with those that need to be prevented from becoming endangered. Among the ones we like are white violets. They make a beautiful groundcover. Another criteria are plants that support bird-life, either because of their seeds, fruit, or the fact that they attract insects and offer nesting material and shelter. And finally, we want to help preserve endangered species at a time when so much construction is destroying our natural woodlands."

Pausing to point out the beautiful burgundy-colored papery seed-pods of a golden rain tree (*Koelreuteria paniculata*), she emphasized the fact that even if the Conservancy doesn't purposefully plant exotic species in the Ramble, there are no hard-and-fast rules about keeping them off-limits. "The wind blows and birds eat seeds that they poop all over the park, so naturally there will be some exotics that germinate in the Ramble. We leave them be, because it's interesting to see what appears as long as they don't become a monoculture and take over an entire area."

As soon as she had uttered these words, we came upon the opposite of exotic promiscuity: a stand of American chestnut (*Castanea dentata*) trees with shoots approximately twelve feet tall and large sawtooth-edged leaves coming out of the ground. Once the most prolific member of the triad that, along with the oak and the hickory, made up the dominant plant association in the North American forest, the

American chestnut is the Peter Pan of the plant world: a tree destined never to grow up. Ever since the beginning of the twentieth century, when an imported Asian bark fungus girdled and killed virtually the country's entire population of American chestnut trees, those that resurrect themselves from old rootstock are contaminated before they reach maturity by the inexorable blight caused by pathogenic spores that live on and then get disseminated by wind, water, insects, animals, and people's shoes. When I remarked how this sapling stand looked pretty healthy, Alvarez said, "These may last a little longer, but that's all."

Once more confirming the cosmopolitan character of the Ramble's plant population, we took note of a catalpa (*Catalpa speciosa*) with its big heart-shaped leaves, which is native to the Caribbean, East Asia, and certain temperate regions of North America. Climate warming has aided its immigration into Central Park, and its two thin windborne wings on the small flat seeds formed in its long dangling seedpods have aided its proliferation in the Ramble. Thus, we saw several catalpas in various stages of growth, from small saplings to mature trees twenty feet tall.

Not to be outdone by this alien, the sassafras (*Sassafras albidum*), which is indigenous to North America, also has a high rate of reproduction. However, its seeds, instead of being windborne like those of the catalpa, come from its fruit, which is consumed and excreted by birds. It is a tree instantly recognizable by its eccentrically shaped leaves. Some are a simple un-lobed oval, others have one small and one large lobe and look like mittens, and others are three-pronged. The roots of sassafras can be steeped to make tea, and perfumes and soaps can be made from an essential oil derived from steam distillation of dried root bark. I crushed a leaf and rubbed it between my fingers in order to inhale its distinct aroma. It was still in my pocket when I got home, and so I smelled again its special wildwood fragrance.

Habitat and Stopover

The eco-culture approach of coaxing the Ramble toward the state of a self-generating wildwood now enjoys the approval of the bird-watchers, who no longer insist on a status quo ecology. Their ranks continue to grow, especially during the spring and fall migration seasons, when this green sanctuary is one of the choicest rest and refueling spots in the metropolitan area for birds traversing the Atlantic Flyway.

But no matter the season, there are always plenty of birds to see throughout the park. Along with the Ramble, the North Woods and Strawberry Fields are likely areas for spotting warblers in the spring. In winter, the Reservoir is a good place for observing ducks and the Pinetum a promising locale to look for owls. The surfaces and shorelines of the Lake and Harlem Meer are auspicious regions to scan for ducks, egrets, herons, swans, cormorants, and other waterfowl throughout the year. In addition, binoculars often tilt skyward to look for the Fifth Avenue nest of Pale Male, the celebrity Red-tailed Hawk, and his succession of mates. These raptors can be spotted soaring above the park as they hunt for rodents and other prey. Some of their progeny are probably among the Red-tails nesting elsewhere in Manhattan, sometimes searching for parkside buildings where they can build aeries of their own.

As for myself, I am a tagalong birder, a binocular-toting parkgoer out for a morning walk, who sidles up to the expert whose keen ear identifies the call of an as-yet-invisible bird and whose quick eye finds the branch or bush where it can be seen. There are several of these expert birders who rove the park, some of whom can be seen with a group of amateurs like me following them as they pause and linger wherever a "good bird" reveals itself—say, a Scarlet Tanager, Balti-

more Oriole, or Hooded Warbler. House Sparrows, American Robins, and Blue Jays belong to what I like to think of as the "Just a . . ." genus—birds that "real birders" consider too common to mention, because they are in the park all year.

The European Starling tops the list of birds getting the silent treatment. It is a nonnative species imported from England by the American Acclimatization Society, whose chairman sought to introduce into this country all the birds mentioned in Shakespeare's plays. In 1890, a hundred were released in Central Park, where they nested and multiplied. In a few decades their progeny had spread throughout the United States, appropriating tree holes after aggressively driving out previous occupants such as Northern Flickers. In diametrical contrast to the once vastly abundant Passenger Pigeon, whose extinction occurred at about the same time, the European Starling's exponential population growth has made it a bird to be disparaged rather than mourned. A number of years ago, when, as an even more rank novice than I am now, I was admiring the iridescent sheen of the plumage of a starling on one of my first walks in the Ramble, my companion, an expert birder and longtime member of the Linnaean Society, snorted "Turd bird!" when I asked him to identify it for me.

Expert birders carry what amounts to a field guide in their heads; however, while knowing by heart the markings and calls of all the birds they are likely to spot, their ability to identify plant species is often a matter of indifference. "It's to the right in the dark tree over there," someone says, pointing to a holly. Or, indicating a pin oak: "Look on the second branch after the fork in the tree just behind the skinny one with the light green leaves." Somewhat more helpful is "It's in the bush with the white flowers" (if the mock orange shrub in question happens to be flowering at the time). Most useful is the commonly used metaphor of the clock: "It's up there somewhere over to the right around three o'clock or four o'clock."

Regional bird-watching and recordkeeping is a long-standing

activity in New York City. The first list of birds found in Central Park was published in 1886. In 1900, Frank Chapman, curator of ornithology at the American Museum of Natural History, author of several field guides, and founder of *Bird Lore* (later *Audubon* magazine), originated and organized the ongoing Christmas Bird Count, a volunteer-run census to replace the tradition of competitive holiday "side hunts" by sportsmen. The Chapman Hall of Birds, the natural history museum's earliest diorama display, contains many of the species collected on bird surveys Chapman sponsored in the New York area.

In 1923, in *Birds of the New York City Region,* Ludlow Griscom, assistant curator of ornithology at the museum, deplored the introduction and proliferation of the House Sparrow and starling and the wholesale diminution of native bird species in the region. But he enthused at length about the migratory birds to be found in Central Park: "Probably no locality in America has been visited so often, so regularly, and by so many people as Central Park. It is an ideal station for studying the migration of birds, and is unquestionably the best place for the insectivorous transients in the region. Astonishing as this statement may seem, it is amply justified by the facts, and warblers, for instance, are more abundant here individually and specifically than anywhere else. It is an oasis in a vast desert of city roofs, in which the tired hosts must alight to rest as the day breaks, and where the great variety of shrubbery and trees affords an ample food supply and shelter."

Continuing his assessment of the birdlife to be found in the city and the park, he concluded that "although definite historical evidence is lacking, it is highly probable that most of the common species are far more abundant individually today than two hundred and fifty years ago." As proof, he could cite a count of sixty-six species on May 10, 1922, of which sixty were migratory birds.

Today, like the city's other big parks, Central Park is even more

of an oasis, especially for the tens of thousands of birds that must fly over the city every spring and fall en route to their winter or summer habitats. The number of birds nesting in the park has also increased, which comes as a surprise, given urban growth on a scale that Griscom could hardly have imagined. True, there are more ornithological eyes to lengthen birders' lists, but the ecologically sensitive restoration of the Ramble and other parts of the park has probably been an important factor in increasing the avian population from the 186 tallied in Griscom's day to about 300 currently. Part of the statistical boost may also be due, at least in part, to climate change, which has enabled several bird species formerly restricted to southern parts of the United States to take up year-round residence in New York and New England over the last few decades.

Like other kinds of aficionados, birders form a community made up of variously motivated individuals. Although the distinctions are loose and overlapping, they can be divided into categories: ornithologists, conservationists, listers, competitors, and enthusiasts.

The ornithologist is by definition a scientist for whom anatomy, historical distribution, seasonal range, ecological behavior, vocalizations, and other quantitative and qualitative factors are of prime interest. Conservationists, on the other hand, are birders with a habitat-protection mission. They are particularly concerned with maintaining sufficient natural bird fare—berry-producing trees and shrubs, insect-riddled wood, and marshlands rich in marine organisms. They consider weeds good shelter for ground-feeding birds and standing dead tree trunks ideal nesting sites for woodpeckers.

Listers are bird-watchers who tally whatever they see in a day, a year, or a lifetime. "Already got it," one will say, not bothering to look when a particular bird is pointed out. However, since many pairs of eyes are better than one, listers are team players, helping other birders with their expertise.

In contrast, competitors are birders who vie with one another to have the most comprehensive life list, country list, state list, or even Manhattan borough list. The well-heeled among them have an advantage, being able to travel globally. But one can still be an acknowledged master birder at a continental or regional level. For instance, a "world series" is held every May in New Jersey, an event that routinely attracts roughly a thousand of the world's top birders. Divided into four-member teams, they spend a twenty-four-hour period, from midnight to midnight, identifying in their respectively designated areas throughout the state as many species as they can by sight or sound. Then there are just-for-fun competitions such as the Birdathon, a species count hosted by the Wildlife Conservation Society at the Bronx Zoo during the spring migration, which is open to experienced birders, families, novices, and enthusiasts—people like me, who consider the fact of being able to glimpse so much feathered beauty in a city like New York something of a miracle.

Broadly speaking, there is in Central Park an observable gender and age difference among types of birders. I've noticed that the ones who go on organized walks are often women over forty. The men who are real experts, like my friend Roger Pasquier, are ones I like to think of as "boy birders," whose formidable knowledge of the salient markings, distinct calls, and behavioral patterns of different bird species began early in life. Whether ornithologists or listers—usually both—theirs is an enviable expertise, which is often accompanied by a near-photographic memory that allows them to carry no notepad and still compile an accurate record of every bird spotted each day when they get home.

When I asked Pasquier to tell me why he thought boys more often than girls were likely to embark on birding as a lifetime pursuit as children, he said, "Boys like to collect things: model airplanes, stamps, coins—that sort of thing. Also, there's the male hunting instinct, only

Joe DiCostanzo

this way you are using binoculars instead of a gun." Girls, he believes, are more often interested in individual relationships with animals than in the pursuit and cataloguing of creatures that are oblivious of their observers. "Think of girls and horses," he said.

Unlike today's novice birders, who are equipped with apps that have recorded sounds as well as pictures, Pasquier did his learning entirely in the field, listening to bird calls and songs and then finding the bird and matching its pitch and notes with its appearance. "To learn things, you have to work at it. If someone identifies everything for you, you probably won't remember much when you are on your own." he said. "I will never forget the time when I was a boy at camp in Maine and first heard some Nashville Warblers singing. They were so high in the trees that I couldn't see them for a long time. I felt they were just teasing me, so when I finally identified that unfamiliar song, the experience fixed the Nashville Warbler forever in my mind. Learning that way makes things stick in your head, especially

when you are young—in the same way it's so much easier for a child than an adult to learn a second language. Birdsong, in fact, *is* a second language!"

Beginning in April, with the arrival of the advance guard of the spring migration, the American Museum of Natural History sponsors a series of Central Park bird walks. My first walk of the season this past year was on April 24 with Joe DiCostanzo, a scientist in the ornithology department. At 7:00 a.m., fourteen other birders and I met DiCostanzo beneath a canopy of new leaves that had just unfurled on the giant elm at the Seventy-Seventh Street entrance opposite the museum. Descending the slope to the West Drive, we crossed over to the Hernshead, the poetic name chosen by Olmsted and Vaux for the tiny peninsula jutting into the west lobe of the Lake opposite the Ramble. Next to the shoreline there is an immense, near-vertical rock outcrop and an adjacent smooth rock, shelving down to the edge of the water. On the placid surface of the Lake there were several Canada Geese and Northern Shovelers, the males handsome in their breeding plumage: iridescent green head, white breast, and rufous flanks. Someone pointed to a Northern Cardinal on the ground and a Red-bellied Woodpecker in a nearby tree. DiCostanzo called our attention to a Yellow-rumped Warbler, a Ruby-crowned Kinglet, and a Blue-gray Gnatcatcher in a willow at the water's edge. Singling out the gnatcatcher, he said, "That's a cute little guy, like a miniature mockingbird with a squeaky, insectlike call." After cocking his head and listening to a whistling series of notes and then turning in the direction from which this flutelike sound came, DiCostanzo pointed to a Baltimore Oriole. With its bright orange breast, jet black head, and white wing bars, it is an unmistakable bird. One member of the group asked if it was called a Baltimore Oriole because it was first found in Baltimore. "No," DiCostanzo replied. "Orange and black were the colors of Lord Baltimore's coat of arms, so that's how it got its name."

COURTESY OF CAL VARNBERGER

Baltimore Oriole

"Now let's head into the Ramble," he suggested, as we left the Hernshead and crossed the bridge over Bank Rock Cove. Pausing, he pointed out three Pine Warblers and a Blue-headed Vireo—"see the white spectacles"—on the opposite bank of the cove. We turned south on the path bordering the Lake, where he hoped we would be able to see the Cape May Warbler that was the big bird sensation of the previous day. We were out of luck on that score, but along the way to Bow Bridge we saw a couple of Ruby-crowned Kinglets and a Yellow-rumped Warbler.

"Okay," DiCostanzo announced, "we're going to go over to the Point." The Point is at the southern tip of the Ramble, facing Bethesda Terrace. A high ridge with water on either side, it is a particularly good place to spot birds, and we ran into a man who helped us sight a Black-and-white Warbler working its way up the trunk of a black cherry tree and a Hermit Thrush poking about in some leaf

Cape May Warbler

litter. The birder next to me called my attention to a Downy Wood-pecker, and DiCostanzo said it was too bad that the sapsuckers had by now passed through the park, since a bird-watcher from Ireland he had encountered the previous day particularly wanted to see one. I began to understand how timing is everything in birding and why only the birders who are willing to put in hours every day are able to log all the species that pass through the park during the migration. This day the celebrity bird on the Point was a female Summer Tana-ger, bright yellow rather than bright red like the male. I felt a thrill as it flashed through the trees below me near the Lake.

There is a good deal of ongoing comradeship and communica-

tion among birders, no matter their level of expertise—at least in Central Park. Formerly, the faithful recordkeepers wrote reports of their daily sightings in a notebook that was kept in the Central Park Boathouse. Nowadays, an Internet subscription hotline called eBirds NYC is the preferred means of tracking avian comings and goings. In addition, the smartphone provides the opportunity for instant communication, and birders call or text friends on the spot to advise them to rush over to an area of the park where a rare species has just been seen.

Identifying the location where a bird has been spotted was long ago simplified by a series of informal names that birders conferred on different spots in the Ramble. In addition to the Point where DiCostanzo took our group, birders know where to go when someone says they saw such and such a bird along the Riviera (a stretch of woods beside the Lake), the Oven (a narrow cove of the Lake on the west side of the Point), or Mugger's Woods (formerly a dangerous area where birders had to look over their shoulders as well as up into the trees). Less abstruse names are Azalea Pond, a section of the Gill beside which these shrubs bloom in the spring, and Tupelo Field, named for the particularly beautiful and venerable specimen that I had pointed out to Towbin on our geology walk through the Ramble. Nearby is the Humming Tombstone, an electrical transformer in a concrete box, a useful landmark. Maintenance Meadow refers to the lawn to the south of a comfort station (the time-honored term for restroom in New York City parks), which the department's field workers long ago christened the "Rambles Shed," since it is also used as a supplies depot.

Ever since I put myself on the eBirdsNYC hotline, feathered friends, whether visitors or residents, are flying fast and furiously into my computer. Overcoming my ambivalence about being overwhelmed by yet more e-mail, I find that keying into the birding community can be addictive, especially as visits to the park lead one

to become acquainted with people who make regular postings. For instance, I was pleased to see that on May 1, which turned out to be the first really big day for 2014 spring migrants, Chris Cooper had found "a Louisiana Waterthrush skulking in the shrubs along the Maintenance Field at about 11 a.m." Doug Kurz continued the conversation: "I didn't make it to the park until mid-afternoon, but still had a wonderful four hours of birding. Highlights included Scarlet Tanager over Captain's Bench, a trio of three male Rose-breasted Grosbeaks together by the tupelo tree, Worm-eating Warbler and Blue-winged Warbler together in the fenced-in flowering trees at Maintenance, three Swainson's Thrushes (Oven, Azalea Pond, Swampy Pin Oak). Sparrows included Field, Swamp, Savannah, Song, White-throated, Chipping, a junco on the Point (bathing in the gully), and Eastern Towhee. Warblers included Palm, Yellow-rumped, Blue-winged, Worm-eating, Chestnut-sided, Prairie, Yellow, Black-and-white, Black-throated green, American Redstart, Northern Waterthrush, Canada, Ovenbird, and for good measure, the Yellow-throated on the way out."

DiCostanzo is an especially faithful recorder, and for a comprehensive list of the birds sighted in Central Park or wherever else he happens to be on a given day, all one has to do is look at his daily blog posting. The fact that he birds with ears as well as eyes gives him the advantage of not only being able to locate an invisible bird, but also to legitimately add to the day's total a species caught by sound though not by sight. When I read his online report later in the day, I was amazed to find that on a gray, drizzly morning in early May when I had ventured forth beneath my umbrella at 7:00 a.m. along with three other hardy souls to join his scheduled walk, we (or, to be more truthful, he) tallied forty-one species. The next day, after a southerly wind had helped push the migrants northward, the list that appeared on DiCostanzo's blog totaled fifty-one, among them "a Swainson's

Thrush by Turtle Pond, a Cedar Waxwing by Azalea Pond, and a male Orange-crowned Warbler singing in Maintenance Meadow."

When I think of how many times I have heard someone exclaim, "Central Park, I couldn't live in New York without it!" I know that I feel the same way. It is the park in its entirety that never ceases to delight me, and within it, the Ramble—this wholly contrived little woodland—is where I feel most amazed by nature's omnipresence throughout the green metropolis that is New York City.

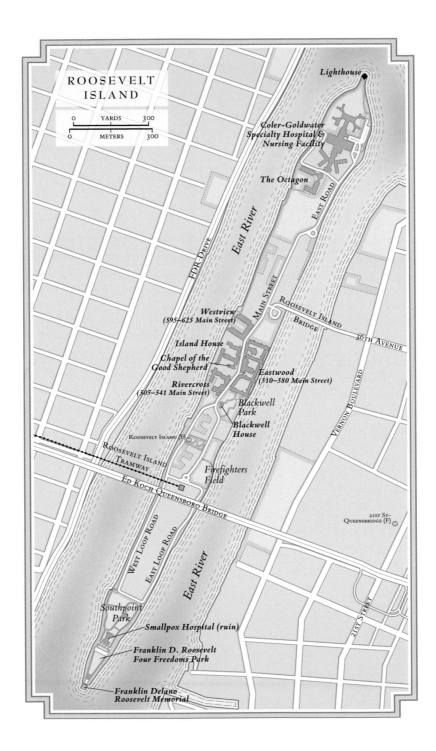

ROOSEVELT
ISLAND

0 YARDS 300
0 METERS 300

Lighthouse

Coler-Goldwater
Specialty Hospital &
Nursing Facility

The Octagon

East River

FDR DRIVE

EAST ROAD

Westview
(595–625 Main Street)

Island House

Chapel of the
Good Shepherd

Rivercross
(505–541 Main Street)

MAIN STREET

ROOSEVELT ISLAND

BRIDGE

16TH AVENUE

Eastwood
(510–580 Main Street)

Blackwell
Park

Blackwell
House

VERNON BOULEVARD

ROOSEVELT ISLAND (F)

ROOSEVELT ISLAND
TRAMWAY

Firefighters
Field

ED KOCH QUEENSBORO BRIDGE

21ST ST-
QUEENSBRIDGE (F)

WEST LOOP ROAD

EAST LOOP ROAD

East River

Southpoint
Park

Smallpox Hospital (ruin)

Franklin D. Roosevelt
Four Freedoms Park

21ST STREET

Franklin Delano
Roosevelt Memorial

CHAPTER SIX

GREEN COMMUNITY AND WHITE MEMORIAL

Roosevelt Island and Four Freedoms Park

In a ceremony on September 24, 1973, Mayor John V. Lindsay officially renamed a two-mile-long, 800-foot-wide 147-acre piece of land protruding from the East River Roosevelt Island in honor of the thirty-second president of the United States. Unlike the rechristening of Idlewild Airport as John F. Kennedy International Airport in honor of the thirty-fifth president, however, this name change was not merely a titular form of homage. The very identity and purpose of the island was already being radically altered, and its new name signaled both its transformation into a planned middle-income community by the New York State Urban Development Corporation and the construction at its southern end of the Franklin Delano Roosevelt Memorial designed by architect Louis I. Kahn.

Before the date of its rechristening by Mayor Lindsay in the presence of former governor of New York State Averell Harriman, then

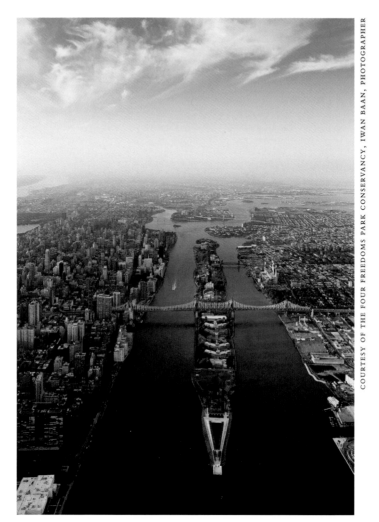

North-facing aerial view of East River and Roosevelt Island

current governor Nelson Rockefeller, and other dignitaries, it was called Welfare Island because of the several hospitals that had been built there in order to safeguard the city's population from smallpox and other infectious diseases and to sequester patients with mental illnesses. Other older names denote its long history.

Ghosts

The known history of Roosevelt Island begins in 1637, when the Dutch called it Varcken (Hog) Island because swine were pastured there. At that time it was owned by the colonial governor Wouter van Twiller, who had bought it from the Lenape Indians. It was subsequently transferred to the British crown in 1664, and in 1668 Governor Richard Nicolls granted Captain John Manning a patent to the island, which he held in absentee ownership. After being court-martialed five years later due to his hasty surrender when the Dutch staged a naval assault on Fort James (formerly Fort Amsterdam at the tip of Manhattan) in an attempt to regain control of their former colony, Manning was banished to the island that now bore his name. His punishment, like that of Boss Tweed, who, two centuries later, in 1871, also paid his dues on the island for besmirching the city's honor, was not entirely painful. Manning lived in a fine mansion dubbed "the castle" and entertained his visitors with bowls of rum punch.

The site of Manning's "castle"—at the southern end of the island opposite Turtle Bay (today the site of the United Nations)—was also the site of Tweed's home on the island, the city penitentiary. Designed by James Renwick, architect of the Smithsonian Institution, with a nostalgic eye toward medieval dungeons, the penitentiary also resembled a castle, with rounded turrets and a roof profile of notched battlements. Tweed purportedly had a picture window cut into one wall so that he could better view the city he had swindled.

Between the time of Manning's exile and its purchase by the city in 1828 as a likely place to quarantine its convicts, the island passed through several bucolic generations in the hands of the Blackwell family. The first Blackwell was Robert, who married Captain Manning's stepdaughter and heir. Their grandson, Jacob Blackwell, was

the proprietor during the Revolutionary War, when the island figured only marginally in the tumult swirling all around it. British troops, following their victory on Long Island, landed on Blackwell's Island, but they were immediately repulsed by rebel cannon shot fired from the batteries located on Manhattan Island. In 1782 a British officer inspecting the prison ships made the compassionate suggestion that the prisoners should be allowed on Blackwell's Island during the daytime in the hot season, but it is not known whether this recommendation was carried out.

Jacob Blackwell bequeathed the island to his sons in 1780, but finding themselves in financial trouble following the war, they put it up for sale. The advertisement that appeared in London's *New-York Packet* in March 1784 describes its scenery at that period:

For Sale, that pleasant agreeably situated Island, known by the name of BLACKWELL'S ISLAND, On the East River, about four miles from this city. It is without exception one of the most healthy situations in this state. It is remarkable for the number of fish and fowl that is caught there in the different seasons. There is on the premises, two small Dwelling Houses, a Barn, Bake and Fowl House, Cyder Mill; a large Orchard, containing 450 of the best grafted fruit trees, such as Newton & golden pippins, spitsinburghs, peirmans, bow apples, pears, peaches, plumbs, cherries, &c. There is a number of the best stone quarries, ready cleared to begin breaking immediately; and the subscriber has a complete set of quarry tools, with all his farming utensils and stock to dispose of at the same time. The Island abounds with running springs of most excellent water. The above contains 107 acres, eight of which are a salt meadow, and the whole has been considerably improved with manure, and in good fence.

A buyer was not found and so the property remained in the hands of Blackwell heirs until the city purchased it. Not long after

that, the old quarries were being worked by convict labor, and soon the banded gray gneiss stone they yielded was transformed into what one nineteenth-century newspaper account characterized as "a little city on the waters . . . a city in which all the misery, despair and viciousness of the metropolis are epitomized." Scattered across the island by the middle of the nineteenth century were a small-pox hospital, a lunatic asylum, a workhouse, an almshouse, and a penitentiary.

With his penchant for documenting human wretchedness, Charles Dickens gave a vivid description of these Victorian penal and medical institutions after visiting Blackwell's Island in 1842 during his travels in this country. In his *American Notes for General Circulation* he wrote about the lunatic asylum at the northern end of the island:

> The terrible crowd with which these halls and galleries were filled, so shocked me, that I abridged my stay within the shortest possible limits. . . . The moping idiot, cowering down with long dishevelled hair; the gibbering maniac, with his hideous laugh and pointed finger; the vacant eye, the fierce wild face, the gloomy picking of the hands and lips, and munching of the nails: there they were all, without disguise, in naked ugliness and horror.

The almshouse, with its long segregated dormitories and work-rooms, impressed him "very uncomfortably," while the penitentiary at the southern end of the island—that battlemented, turreted fortress where Tweed was later imprisoned—inspired his compassionate ire. To conjure up an adequate impression, he suggests:

> Make the rain pour down, outside in torrents. Put the everlasting stove in the midst; hot and suffocating, and vaporous, as a witch's caldron. Add a of collection of gentle odours, such as would arise from a thousand mildewed umbrellas, wet through, and a thousand

buck-baskets, full half-washed linen—and there is the prison as it was that day.

The lunatic asylum, considered to be the work of the architect A. J. Davis, has a Greek Revival octagonal rotunda surrounded by four rooms separated by radiating corridors. It is especially notable for its spiral staircase constructed of cast iron with wood Ionic columns encircling a high central stairwell. This grand volumetric space was praised by Henry-Russell Hitchcock, the leading architectural historian of the mid-twentieth century, as being "as generous in scale and as interesting for the original sort of handling of space as a Baroque stair hall . . . [and] the grandest interior in the City dating from before the Grand Central Station concourse and a fascinating premonition of the Guggenheim Museum that Wright certainly never saw!" The original building was begun in 1835 and completed in 1839. That same year a long west wing was added, and in 1848 another long wing was built to the south. These wings where self-anointed royalty once hallucinated are now lopped off, and gone, too, are the asylum's auxiliary buildings: the Lodge, where the most violent inmates were kept, and the Retreat, for female patients, of whom there were usually twice as many as males. One cannot imagine what Dickens would think of the Octagon in its current state as a luxury apartment building.

Elsewhere, too, the historic island wears a far different face from that which I remembered when I first explored its eerie ruins in 1968. Then it was marked with an air of fascinating dereliction. With the exception of Renwick's smallpox hospital, most of the old institutional buildings had either been torn down or survived only as picturesque vine-covered ruins in a rubble-strewn wildscape. Yet the rubble, with antique wheelchairs lying here and there among strewn bricks from the demolitions, augured transformation. Furthermore,

the island was in the process of growing a 1,000-foot-long extension at its southern tip as a result of landfill created by the disposal of excavated bedrock debris when the F-train subway and New York City Water Tunnel No. 3 were being constructed under the East River.

Two municipal hospitals, Bird S. Coler and Isador Rosenfield Goldwater (now merged into one), were still in operation, serving patients with long-term disabilities and chronic illnesses. Practically all the rest of the publicly owned island with its panoramic views of the Manhattan skyline was poised for redevelopment, and the vacant landfill area with its tapering pile of rocks protruding from the waters of the river appeared to some to be an ideal site for a memorial to President Franklin Delano Roosevelt. Hailed by the architectural critic Ada Louise Huxtable as "the dean of American architects," Louis Kahn was hired to draw up plans for one. In assessing the site, Kahn conceived the configuration of the landfill as the prow of a ship, which is how it in fact took its final form. For thirty-eight years, however, his design of the memorial to FDR remained unbuilt. In the meantime, another bold urban planning idea was taking shape.

Planned Community

The 1960s and '70s were confident utopian decades when such terms as "master planning," "urban renewal," and "slum clearance" had not yet fallen into disrepute. Historic preservation as a civic ethos was in its infancy, and the leveling of old neighborhoods and rebuilding of large areas within cities was still being fostered as a matter of policy at all levels of government. Although Jane Jacobs's revisionist urban theories had recently begun to inspire opposition to the wholesale,

top-down, mega-project reconfiguration of neighborhoods, this long-ignored part of New York was already city-owned and essentially vacant except for the two still-functioning city hospitals and the remaining historic ruins, which were being used by the fire department for training exercises. It was highly unlikely that a community group or civic watchdog organization would campaign to prevent the de novo reconstruction of Welfare Island. Moreover, New York had become a city with a chronic housing shortage.

The first notion of a total redesign of Welfare Island dates back to 1961, when a syndicate of developers, including the architect Victor Gruen, proposed acquiring it from the city. The consortium planned to erect eight Gruen-designed fifty-story slab buildings to be used for housing and related amenities. They unapologetically claimed that the realization of this radically modern, Le Corbusier–style proposal would "mean unscrambling the melee of flesh and machine [in order to make] the first twentieth-century city." This arrogantly utopian, private-enterprise vision was turned down, but the decision in 1963 to build a new subway tunnel that crossed the East River beneath the island, making it accessible by mass transit, had already fostered a host of other proposals.

One idea, which was seriously considered, was to build a school there for the children of United Nations families. Other suggestions included turning the entire island into a recreational park on the order of Copenhagen's Tivoli Gardens or using it as a place to reinter the remains of those buried in the large cemeteries of Brooklyn and Queens in order to free up land for housing in those boroughs. All of these proposals were eventually dismissed as economically or politically impractical. With no firm plan in hand but determined to move forward, Mayor Lindsay confirmed the city's intention to redevelop the island soon after he took office in 1966. The first stage of this process was its "cleanup," and at Lindsay's behest the New York

City Department of Buildings promptly condemned forty-five of the island's deteriorating structures.

In 1968 Governor Nelson Rockefeller, a man with a passion for building and a predilection for modern architecture, encouraged state legislators to pass a bill establishing an independent, public-benefit corporation that would be structured to fast-track the design and construction of large-scale urban projects. Funded by moral-obligation bonds and thereby relieved of layers of state and city bureaucracy, the Urban Development Corporation (now known as the Empire State Development Corporation) was intended to create jobs, community facilities, and housing. To head the new government entity, Rockefeller appointed Ed Logue, an urban-renewal planner with a reputation for overseeing public works almost as formidable as that of the legendary Robert Moses.

To implement specific projects, the state created subsidiary corporations operating under the aegis of the UDC. The first of these was the Battery Park City Authority, which was established by the New York State Legislature in 1968 to finance and supervise the construction of offices, apartment houses, and a park on a section of Hudson River shoreline in lower Manhattan that had been augmented with landfill derived from the construction of the World Trade Center. A year later the city signed a ninety-nine-year lease with the state, creating the Welfare Island Development Corporation to build and subsequently manage a planned community on Welfare—soon-to-be renamed Roosevelt—Island.

Logue lost no time in commissioning Philip Johnson, the city's most renowned architect at the time, and his partner John Burgee to develop a master plan. The WIDC plan called for the retention of the two hospitals; the construction of four building groups containing 20,000 low- and moderate-income apartment units (because of the large disabled population on the island, around fifty of these

were reserved for hospital patients who could be mainstreamed into the community); the creation of five parks and four miles of waterfront promenade; and the building of a 2,000-car garage. Its financial underpinnings were provided by the 1955 federal Mitchell-Lama Housing Program, which offered tax abatements and other incentives to developers who would build affordable housing. Additional subsidies from federal, state, and city governments made low rents and low-interest mortgages for cooperative units possible, ensuring affordability for residents.

When the Johnson/Burgee plan was published in 1969, it garnered warm reviews from the architectural press. It was praised principally for its "unmodern" modesty of scale, sense of livability, stepped-down building heights, and provision of water views at the pedestrian level as well as from the apartments above.

Its attention to mixed use (street-level shops and living quarters above), sociable population density, and overall human scale caused Johnson to assert, "This is my Jane Jacobs period." However, the accompanying publication, titled *The Island Nobody Knows,* promoted the plan with sophisticated similes that would resonate with world travelers rather than the kind of neighborhood-oriented population Jacobs would have had in mind. Its open-ended colonnaded arcade was compared to Milan's Galleria Vittorio Emmanuele, while the harbor's riverside steps were said to evoke the ghats of the Ganges. A museumgoer's knowledge of art—Feininger's paintings, Piranesi's engravings, Sheeler's photographs—supplied the imagery used to describe the thrilling views of Manhattan. By calling the central corridor Main Street, however, the architects provided at least a nominal evocation of small-town America.

The publicity and praise for the Johnson/Burgee plan brought the island's potential to the attention of the statesman and diplomat William vanden Heuvel. In his capacity as chairman of the Four Free-

doms Foundation (so named for the four freedoms enunciated by President Roosevelt in his State of the Union address in 1941), vanden Heuvel suggested the placement of a New York City Roosevelt memorial on Welfare Island. At the same time, he put forth the notion that the island be renamed in Roosevelt's honor.

The mission of the Four Freedoms Foundation, which was later merged with the Roosevelt Institute, a Hyde Park– and Washington-based organization, is to perpetuate the legacy and values of Franklin and Eleanor Roosevelt. When I interviewed vanden Heuvel, I asked him to tell me why Roosevelt was such an important figure to him personally. He said that his admiration went back to his boyhood, when he was growing up during the Great Depression in Rochester, New York, as the son of Dutch immigrants. "My mother ran a boardinghouse, and my father was a laborer. It was a time of great hardship. My parents hardly spoke English, but they were very patriotic and would take me to torchlight parades and 'I love America Day.' From the time I was just a tad I loved politics." Vanden Heuvel, who subsequently became a lawyer, said, "I didn't do it to make money, but because I wanted to have a life of public service."

Although an assistant attorney general under Robert Kennedy and ambassador to the United Nations during Carter administration, vanden Heuvel maintains that "FDR was always for me the greatest president. My classmates in public school, who knew how much I admired Roosevelt, raised money for me to go to Hyde Park for the dedication of the presidential library. I hitchhiked with a Catholic priest, and when I got there I managed to slip in with a group of students who had been invited to attend the ceremony. After the Secret Service counted heads and found one extra, I ran over to Eleanor Roosevelt and told her I had come all this way, and she gave me permission to stay." This was the prelude to their future friendship. Vanden Heuvel remembers, "She was a formidable force

in politics. Later I got to know her well, and in 1960 when I ran for Congress against John Lindsay, she and Adlai Stevenson campaigned for me."

For vanden Heuvel, getting the island renamed in a legislative document was easy. Getting the Franklin Delano Roosevelt Memorial built proved to be far more difficult. The first obstacle was architect Louis Kahn's sudden death from a heart attack in Pennsylvania Station on March 17, 1974, shortly after his final design for the memorial had been approved; the second was New York City's fiscal crisis the following year, which put the project on hold indefinitely.

But while Kahn's design languished on the drawing board, the bond-financed Welfare Island Development Corporation was already realizing the Johnson/Burgee master plan. To fill its general outlines as rapidly as possible, Logue simultaneously commissioned several prominent practitioners to undertake various projects. The former

ADDISON GODEL

Rivercross, Roosevelt Island, Johansen & Bhavanani, architects

Harvard Graduate School of Design dean Josep Lluís Sert designed both 1,003-unit Eastwood (510–580 Main Street) and 360-unit Westview (595–625 Main Street). The firm of Johansen & Bhavnani was hired to design the island's two other original towers: Rivercross (505–541 Main Street), a Manhattan-facing building, and Island House, overlooking a plaza containing the restored Chapel of the Good Shepherd (today this building is used as a nondenominational church). The modernist landscape architect Daniel Kiley was given the contract for Blackwell Park, which would surround the preserved historic farmhouse, and Lawrence Halprin was asked to design the main plaza, a large central activity space dividing what the plan designated as Northtown and Southtown.

Logue was not above using ruthless tactics, pugnacious behavior, and strong language in the interest of getting things done. Armed with the power of eminent domain granted by the legislation creating UDC, which also allowed him to sidestep city building-code review and other time-consuming, city-mandated approval procedures, he was able to get 33,000 units of affordable housing built in seven years. When Rockefeller dismissed him from office in 1975, the first residents were already moving in. One challenge remained, however. No matter how agreeable and humane the plan, how praiseworthy the architecture, or how abundantly green and recreationally rich with parks, Roosevelt Island had to be better connected by transportation to the rest of the city.

During its years as a place of quarantine and incarceration, the island's inaccessibility except by boat had been an asset. Then, in 1916, to improve access for those who were employed on the island, two elevators were installed where the Queensboro Bridge crosses overhead; for decades, workers in the island's hospitals would take the trolley that stopped at the bridge's midway point where there were elevators to carry passengers to the island below. In 1955 a lift bridge linking the east side of the island with Long Island City in Queens

was constructed, but vehicles from Manhattan had to drive over the Queensboro Bridge and navigate several blocks of Long Island City in order to reach it. Then, when the plan for the new town on Roosevelt Island was already under way, a novel solution to the problem of direct Manhattan–Roosevelt Island access was found at Disney World: a prototype for an aerial tramway. Constructed alongside the trusses supporting the Queensboro Bridge, this unique feature within the New York City transportation system allows residents and visitors to spend three and a half exhilarating minutes in a gondola arcing to a height of 300 feet above the river before landing at the tram station on the island. Finally, in 1989, the Metropolitan Transportation Authority was able to complete the F-line subway station on Roosevelt Island a hundred yards north of the tram, thereby providing a single mode of transportation linking the island with both Queens and Manhattan.

Roosevelt Island is itself a miracle of engineering. Its lack of noise is not just due to the absence of the cheerful hubbub of ordinary street life. Garbage removal by an underground system of pneumatic pipes means that there are no large black bags containing trash mounded along street curbs and no big sanitation trucks blocking traffic as they follow their collection routes. Indeed, there is no traffic to block: Motorgate, Kallmann & McKinnell's multistory, thousand-car garage, may be a cavernous warehouse for cars, but its presence at the end of the bridge on the eastern side of the island means there are no automobiles parked on the streets and no yawning mouths of individual garages at the bases of residential buildings elsewhere. The free electric bus that serves as an alternative mode of transportation emits no motor noise or carbon dioxide as it plies back and forth between the tram station and the Octagon at the north end of the island. A special security force patrols the island and crime is reputedly nonexistent.

Life in Utopia

To get an insider's perspective on Roosevelt Island's storied past, as well as a sense of what it is like to live there now, I went to see Judy Berdy, the head of the Roosevelt Island Historical Society. Berdy has been an island resident since 1977, only two years after the first thirty-four middle-income tenants moved onto the island. Her apartment on the seventeenth floor of 531 Main Street is a sunny, one-room studio looking across the East River toward Queens. The Historical Society archives, consisting of newspaper clippings, letters, documents, old photographs, brochures, books, ephemera—anything that bears on the island's past up to the present day—are housed here. As the unofficial keeper of Roosevelt Island's history, Berdy continues to collect whatever pertinent materials she can find. They now fill plastic sleeves in around 130 white, spine-labeled three-ring binders, which occupy a series of six-foot-tall cupboards and wall shelves in the apartment. Her dining table is a work surface covered with items she is arranging according to subject matter in yet more notebooks. "The whole thing is a giant jigsaw puzzle," she exclaimed. "I just love putting it all together."

I asked Berdy how she is able to keep continually finding new items. She said, "Many people have memories of the place that they want to share. They find me through word of mouth or on the Internet. Some send me reports, some send stories, some send old snapshots. Often these are doctors who were doing their internships or residencies at Coler or Goldwater Hospital or nurses who lived in the dormitories on the island. The two hospitals were designed to provide care for the chronically ill, so I sometimes hear from patients who stayed on the island for long periods of time. In addition to those from Coler and

Goldwater, I hear from ones who were connected with City Hospital until it moved to Elmhurst in the fifties and Metropolitan Hospital before it relocated to First Avenue and Ninety-Seventh Street. I get letters, newspaper clippings, and old photographs from many of the doctors and nurses who worked in all four of these hospitals, and sometimes their descendants get in touch with me as well." To encourage such contributions to her ever-growing Roosevelt Island memory bank, Berdy runs advertisements in *The New England Journal of Medicine*. She says that she gets a response at least every couple of months from that source.

As well as being the social historian of the island, Berdy has trained herself to be its architectural historian. And her knowledge doesn't stop with the medical facilities that were once set in a gloomy but picturesque landscape of weeds, wildflowers, and spectral ruins; she is also an expert on the modern town that replaced them. She has a sound knowledge of city planning and period building styles as well as strong opinions about the pros and cons of the structures and landscapes of the island. The hefty tome *New York 1960: Architecture and Urbanism Between the Second World War and the Bicentennial* by Robert A. M. Stern, Thomas Mellins, and David Fishman sits in her bookshelf, and she can recite practically by heart the chapter on Roosevelt Island detailing the various stages of the island's transformation from a mid-twentieth-century urban planning ideal to a twenty-first-century reality. She was recently able to obtain an old trolley station from the line that used to run across the Queensboro Bridge—a charming structure built of ornamental cast iron and ceramic tile—and have it moved to the island. This period relic, which has been restored to its original appearance, now serves as a visitor center staffed by herself and the volunteers she recruits.

Berdy gave the kind of back-and-forth wrist rotation that means "sort of but not quite" when I inquired how much of what we are

looking at from her window is the fulfillment of the Johnson/Bur-
gee plan and how much has been accomplished by others. Inevitably,
the plan's realization was here and there compromised by cost and
other factors, and by decisions that have been made over the years by
the WIDC's successor entity, the Roosevelt Island Operating Cor-
poration (RIOC). But the overall appearance—buildings of varying
heights, car-free roads, a Main Street spine, a waterfront promenade,
and openings between building blocks to permit numerous water
views—is generally in keeping with the original scheme. Since land
was reserved for this purpose from the beginning, the new luxury
towers on sites that the RIOC has in the last few years leased to devel-
opers in order to sustain its budget for maintaining the island's public
spaces, roads, and basic infrastructure can still be considered part of
the intended implementation of the town plan.

With some outspoken reservations—she calls sixties-style architec-
ture in the then-fashionable idiom called brutalism "cementotecture,
all rather bleak and gray"—Berdy praises the original structures, add-
ing that "it really doesn't matter that it is ugly outside, because inside
it is so nice. If the apartments are small, they have wonderful views
and are filled with sunlight. The buildings themselves occupy a gen-
erous amount of square footage when you factor in the large lobby
spaces and their surrounding grounds. This kind of open landscape
around the buildings would be impossible in the city, where every
square foot of real estate is too valuable to leave unbuilt." Describing
the layout of her own apartment, she says, "Look how they paid so
much attention to detail here." Then, of course, there is the matter of
rent. "Where else," Berdy asked me rhetorically, "am I going to find
an apartment under a thousand dollars a month?"

"Let's talk about the island as a whole and what it is like to live
here," I suggested.

"Well, first of all, it is an island, which has its advantages and dis-

advantages," she replied. "It's peaceful and quiet, which is nice, but it has none of the liveliness of the city and practically no stores. It really is its own little world, and in a sense you feel cut off. Even though it is just a short subway or tram ride into Manhattan, if you work off the island you don't feel like coming home, changing clothes, and then turning around and going back for dinner or the theater."

When I remarked on the somewhat desultory appearance of Main Street with its many empty shop windows, Berdy said, "We have never been successful in keeping stores; there is not enough traffic. We are a town of fourteen thousand, but you see very few people walking up and down Main Street during the week. Except for the hospital workers, no one works on the island. We have a deli, a dry cleaner, a bank, a hairdresser, a video store, and a public library— that's about all. There used to be a fish store, a bakery, and a liquor store, but they all went out of business."

RIOC leases these ground-floor venues, and building management companies maintain the residential stories. Residents like Berdy have an activist role in just about everything else that goes on. "We're really a tight-knit community, and some of us have been here thirty years or more, so if you add up the time four people sitting in a room have been here it is one hundred twenty years! Naturally, we have a say in what happens on the island." The boundaries of one of the Manhattan community planning boards encompasses the island, and this provides a forum for discussion. In addition, there are committees of various kinds. Berdy engages with RIOC on a range of cultural and service issues, from the opening of the historic Blackwell House as a museum to the maintenance of roadways, parks, and the promenade. There is a residents' association to voice the same concerns, but she has chosen not to affiliate with it formally, allowing that "I'd rather be an expediter at large. As a simple gadfly I can get more done."

When I told Berdy that I wanted to speak to someone who could

provide me with a firsthand, old-timer's comparison of the island in its before-and-after-new-town incarnations, she put me in touch with Nancy Mirandoli Brown, who lives at 540 Main Street. Brown was the earliest patient at Goldwater Hospital to be "mainstreamed" into an apartment, a year after the first building was ready for occupancy in 1975. When I went to see her in her cozy, houseplant-filled home, she told me that although she found the island's former atmosphere rather romantic, there was a real sense of desolation. Back then she would go on excursions around the island with other patients, but the dirt roads were hard to navigate in a wheelchair, and of course most of those with disabilities could not explore the ruins but only look at them from the outside.

"I like it much better now," she said, "especially the promenade. Once the park and the memorial at the southern end are finished, you'll be able to go around the entire perimeter of the island. There are at least forty or fifty—maybe more—people like me in wheelchairs, and we like to just sit for hours by the water enjoying the sun and the views of the city, so I know I am going to enjoy being down there."

Brown is a quadriplegic, and her life story stands in stark contrast to the many incidents of scandal, corruption, bureaucratic ineptitude, and patient abuse that have marred the reputations of New York City's welfare, education, and health systems. It is, in fact, a testament to the humane liberalism that once made the city a cynosure in the area of government-funded social services.

"I missed the Salk vaccine by two years and got polio when I was seven," she told me. Being a victim of a severe form of this disease, her chest muscles as well as her arms and legs were affected, creating a chronic difficulty with her breathing. When first hospitalized, she was placed in an iron lung. After being weaned from this artificial respiration apparatus, she was able to go home to the

Mirandolis' walk-up apartment in Greenwich Village, where she received home schooling from a visiting teacher, eventually earning her diploma from Washington Irving High School. Before she was strong enough to walk with crutches, two or three times a week her mother carried her down the four flights of stairs so she could go to the movies or to the park. But whenever she had trouble breathing she would return to Goldwater Hospital because it was the only hospital in the city system that had a ward that dealt exclusively with this problem.

"That's where I met my future husband, Tom Brown, who also had polio," she said. Once they were married, Nancy, who was still an outpatient, asked if she could move into the hospital and live there full-time with him. After a year they were given a private room with a bathroom, and for eleven years they stayed in the hospital. As soon as the new Roosevelt Island apartments became available, the couple applied for one that had been designated for handicapped residents. When I asked her about her husband's whereabouts, she told me, "We're divorced now, but he is still here living in one of the other apartments."

Because of her dysfunctional lungs, a large rectangular box is attached to the back of Brown's wheelchair, and extending from it is a flexible hose with a mouthpiece from which she draws air day and night. When she says, "I don't cook," it is not that she doesn't have an interest in good food but because she lacks use of her arms and hands. Until a few years ago she was able to stand, but because of the long-term degenerative effects of polio, her leg muscles are now weakened to the point where she is permanently wheelchair-bound. Since she must be cooked for, fed, dressed, washed, assisted on the toilet, have her teeth brushed, and be put to bed by a helper, she needs home-care attendants around the clock seven days a week. In addition, they do her deskwork, writing letters, answering e-mail, and paying bills; they also perform a host of other chores, such as grocery shopping

and watering the lush greenery that dominates the south side of her living room.

One would think that such physical dependence would lead to psychological depression. Yet Brown feels herself in control of a full and happy life. Instead of simply accepting caregivers sent by the city, she and others in her building got permission to set up their own publicly supported, independently directed agency called Concepts of Independence. This allows her to recruit and interview the five attendants who care for her in twelve-hour shifts and the housekeeper who comes twice a week. Photographs of her nieces and nephews fill one wall. They come to see her regularly, and two or three times a year she makes the necessary arrangements to take a special bus that runs between New York City and Pennsylvania, where she visits her brother and his wife for a few days. Other activities keep her busy as well. She goes to Mass in the Catholic church on the island four times a week. She belongs to the Roosevelt Island Garden Club and is assigned a plot, where she grows tomatoes, zucchini, string beans, and cucumbers with the hands of her attendants doing the planting and weeding ("I like flowers, but being Italian, I have to have a vegetable garden," she says). She is an active member of the Roosevelt Island Disabled Association, an independent group that organizes picnics and other kinds of get-togethers on the island and arranges frequent trips to museums, restaurants, and parks. Their bus, which holds about ten people, four or five of whom are in wheelchairs, takes her shopping at such places as Walmart and Trader Joe's.

The Roosevelt Island Disabled Association's most recent trip was to Hyde Park. The group's desire to visit the former president's home and National Historic Site was motivated by a proposal to have a slightly larger-than-life-size bronze sculpture of Roosevelt in a wheelchair become part of the memorial. The architects who endorsed the Kahn design were not in favor of adding another sculpture—especially one

that depicted Roosevelt as disabled, a condition he took great pains to conceal. Fortunately, a compromise was reached, and a sculpture of Roosevelt in a wheelchair is planned to be sited in Southpoint Park, a short distance from the entrance to Four Freedoms Park. Brown told me, "We're still in the talking stage and deciding which artist to choose. I think it would be nice to have a little girl in bronze looking up at him."

As we were saying good-bye it struck me how different Brown's life would be without the amenities of Roosevelt Island and the ability to engage in daily life rather than live within the confines of an institution. "I love this place," she told me. "It is a little oasis in the middle of the big city with a warm community atmosphere. Here everybody knows everybody. People go out of their way to be helpful. When the blackout occurred, one of my neighbors went to the garage and unhooked the battery of his car and brought it up the stairway all the way to my apartment on the eleventh floor because he was concerned that my respirator would stop working."

Memorializing Roosevelt

William vanden Heuvel and the architectural aficionados who promoted the memorial on the grounds that it would realize Kahn's final work persisted in pursuing their dream. This took enormous patience, reverential memory, and unflagging determination. To meet the many challenges along the way, vanden Heuvel had to use all his political, diplomatic, and fund-raising skills. In 1980 he obtained a grant from the National Endowment for the Humanities to make an educational film narrated by Orson Welles showing FDR's importance in American history. (Now on CD, this has remained a promotional tool for fund-raising over the course of three decades.) The follow-

ing year, vanden Heuvel was instrumental in getting Senator Daniel Patrick Moynihan to reintroduce a bill in Congress "to establish a national memorial . . . on the [Roosevelt Island] site according to the plans prepared by the late, preeminent American architect, Louis I. Kahn." With the completion of working drawings according to Kahn's original plan by the architectural firm of Mitchell/Giurgola in 1985, New York governor Mario Cuomo approved the bill to fund the $53 million project.

There were immediate setbacks in 1986, when the state revoked the $6 million earmarked for the memorial because of the city's fiscal crisis and near bankruptcy at this time. Subsequent political support was long in materializing. In 1998, during the bottom-line-budget administration of George Pataki, vanden Heuvel and other board members of the Franklin and Eleanor Roosevelt Institute had to fight to defeat a plan to construct a tax-generating twenty-four-story Marriott hotel on the site reserved for the memorial. It became clear to vanden Heuvel that if the memorial's sponsors waited any longer for government to act, the project would never get built. Furthermore, he believed that the very principles for which Franklin Roosevelt had stood were being eroded. Thus it was that in 2008 he was instrumental in using the Franklin and Eleanor Roosevelt Institute as a nucleus from which to create the Four Freedoms Foundation, whose primary mission is to raise private money "in order to counter the diminishing levels of patriotism and our knowledge of American history." Not surprisingly, its goals included not only funding scholarships for students but also the construction of the FDR Memorial.

As a fund-raiser vanden Heuvel has had two strings in his bow. One is Roosevelt's popularity with people like himself who still see the president's accomplishments as cornerstones of twentieth-century American democracy. The other is the esteem in which Kahn's

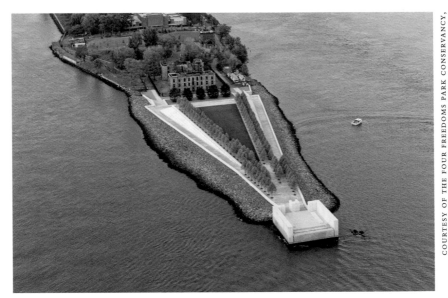

Four Freedoms Park, Roosevelt Island

remarkable body of modernist architecture is held. Under the leadership of Ambassador Bill vanden Heuvel and thanks to philanthropists Arthur Ross, Jane Gregory Rubin, Shelby White, and others, most notably media mogul Fred Eychaner, founder of Alphawood Foundation Chicago, it was possible in the spring of 2010 to break ground for the memorial.

To oversee the public outreach needed to achieve the final construction budget and to help create an endowment for the memorial's ongoing maintenance, vanden Heuvel asked Sally Minard, the former head of an advertising and marketing communications firm and a prominent Democratic Party fund-raiser, to serve as president and CEO of a corporation called the Franklin D. Roosevelt Four Freedoms Park, LLC. Architect Gina Pollara, who served as the park corporation's representative in overseeing the construction of the memorial, came to her job equipped with a deep appreciation and

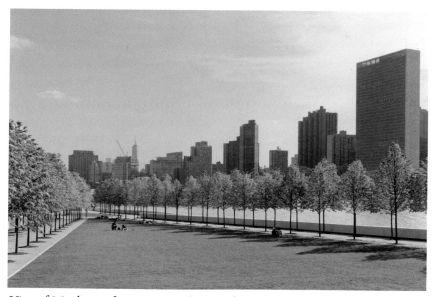

Side promenade, Four Freedoms Park, Roosevelt Island

View of Manhattan from Four Freedoms Park, Roosevelt Island

understanding of Kahn's design intentions. In 2005 she had organized an exhibition, *Coming to Light,* at the Cooper Union for the Advancement of Science and Art in which Kahn's notes and sketches for the project were displayed along with a model of the park containing the FDR monument. It was obvious that Kahn wanted a thorough integration of landscape, sculpture, and architecture, and he even spoke of the design as a room and a garden. The conjunction in Kahn's sentence is important. His FDR memorial is not a room *in* a garden, but rather a garden *with* a room as its focal point. Monumental stairs provide a solemn approach to an elevated axis in the form of a long triangular *tapis vert* defined by two allées of little-leaf linden trees (*Tilia cordata*). This downward-sloping lawn is compressed inward, creating a foreshortened view of the open-roofed granite-walled cube that is the "room" at the southernmost end of the island. With a genius for the use of Cartesian geometry in landscape grading worthy of the great seventeenth-century French designer André Le Nôtre, Kahn made the lower promenades on either side of the elevated greensward slope gently upward, an oppositional contrast in gradient that further dramatizes the approach to the monument as the downward- and upward-slanting grades of lawn and promenades converge at the level of the room.

Kahn's use of forced perspective in his design carries the eye toward a large bronze head of the president, which was modeled from life in 1933 by the portrait sculptor Jo Davidson. It is set in a niche within a freestanding granite wall. Wide flanking openings bring the visitor into Kahn's "room." Once inside, one is reminded again of the Lincoln Memorial in Washington with its words from that president's memorably eloquent speeches incised on the walls of its monumental three-sided interior. Here, turning 180 degrees to face the opposite side of the wall containing the portrait of Roosevelt, one reads his famous speech made on January 6, 1941, exhort-

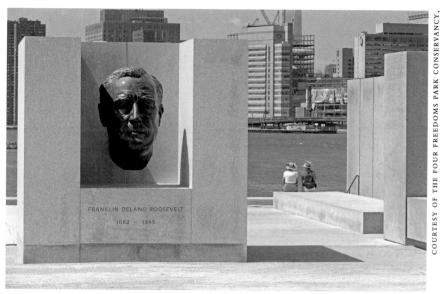

FDR Memorial, Roosevelt Island

ing Americans and other peoples of the world to be cognizant of the four pillars of democracy: freedom of speech, freedom of religion, freedom from want, and freedom from fear. Because the room is a roofless chamber, it has, in Kahn's words, "the endlessly changing qualities of natural light, in which a room is a different room every second of the day." There is an inch-wide gap between each of the thirty-six-ton granite blocks forming the two side walls, and if one stands up close to these barely perceptible slits, one sees, depending on the time of day, light shimmering off the East River as a reflective sparkle on their polished interior sides. The absence of a wall on the south, where the landfill tapers to the symbolical prow of a naval vessel, provides a thrilling view of the Manhattan skyline, which includes the gleaming glass slab of the United Nations. In this way, Kahn's design makes the city itself the visual apotheosis of his

scheme's grand controlling axis. By focusing the eye first on the portrait head of FDR at the base of the Four Freedoms Park's sloping greensward and then eliding the park's controlled perspective into an architectural frame for a great urban panorama, Kahn performed a feat not unlike that of the Greeks, who sited their temples in relation to spectacular natural forms within their mountainous landscape. This testifies to the degree to which his imagination was fertilized by a love of Classical ruins, and the fact that, although a thoroughgoing modernist in his architectural approach, he never abandoned the principles of symmetry and geometrical order derived from his education in the Beaux-Arts neoclassical tradition.

Kahn did not live to see the word "minimalism" become common parlance for architects or modern architecture classified as a historical style called modernism. But attempting to categorize Kahn is irrelevant. Unlike the work of Philip Johnson, whose keen sense of shifting trends and malleability as an architect propelled him to appropriate postmodernism and give a nod to several other planning and design ideologies, Kahn's architecture is sui generis. The design he created for the FDR Memorial is couched in a timeless idiom. Like all memorials, the ultimate test of this presidential monument will rest in the realm of emotion.

The appropriateness of the island's renaming in honor of Roosevelt resides in more than its location as the site of the long-awaited memorial to the thirty-second president of the United States. It is an at least partially successful testament to the utopian planning ideals derived from twentieth-century town planners. Although its social services and housing benefits have been somewhat compromised by economics, they remain the island's underpinnings, and strict free-market adherents would do well to observe the degree to which government-granted security has given Nancy Brown as nearly normal a life as possible. Reflecting in this fashion, one can see that in

a nation where nowadays government bureaucracy and legislative paralysis have vitiated New Deal humanitarian programs, Roosevelt Island and Roosevelt's memorial together serve as salutary reminders of American democracy's commitment to the principle of equality for all citizens.

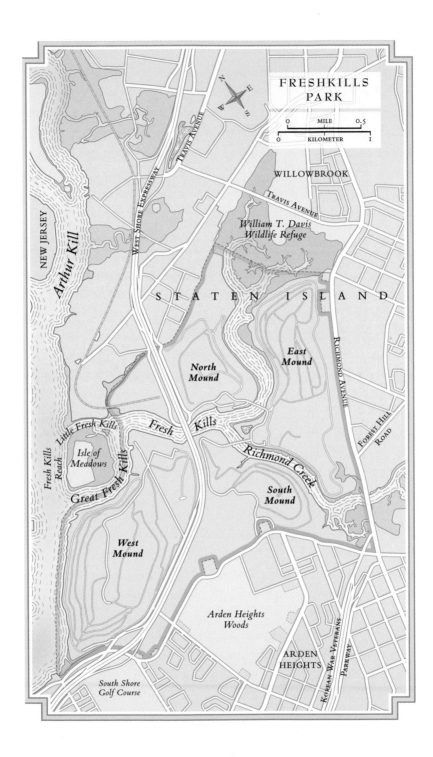

GREEN GARBAGE

Freshkills Park

Few people stop to consider the destination of the 13,000 tons of municipal garbage generated daily by New York City's 8.2 million inhabitants. Most residents take for granted the bulging black plastic bags that lie at curbsides ready for pickup and debris-filled dumpsters waiting to be hauled away. Once out of sight, the city's voluminous underside is mostly out of mind.

Yet garbage has to go *somewhere,* and until recently that somewhere has been on top of the city's once-vast marshes (where it might go still, if there were any marshes left to fill). They were where bottles, cans, broken appliances, newspapers, cast-off clothes, worn-out shoes, and food scraps were deposited, along with oil drums, obsolete machinery, construction rubble, and blasted bedrock from subterranean excavations. New York City Department of Sanitation trucks plied the slopes of growing garbage mounds in landfills—in reality, "marshfills"—like busy ants, layering them with more and yet more refuse until they became giant earthworks. For many years, until the closing of the Fresh Kills garbage dump on Staten Island in 2001—the

largest and last of the city's landfill operations—this was the way New York City handled what is called solid waste, to differentiate it from liquid waste, the effluent from sewer outfalls.

Pig Town

But let's go backward for a moment—before the "marshfills," before bulldozers, before New York was a giant city of five boroughs. Let's start with pigs. In the eighteenth and early nineteenth centuries, the streets of Manhattan were repositories for offal from butchered animals, manure from thousands of horses—the chief mode of transportation—and the contents of emptied chamber pots. Pigs, those scavenging, swill-consuming animals, were the chief reason the city was not buried beneath the daily load of rubbish. Left to roam at large, they were the sanitation workers of their day, although generally considered a nuisance except by the hungry poor.

By the middle of the nineteenth century, Manhattan was experiencing exponential growth. Industrial and commercial jobs drew people off the farm, and immigrants crowded into already packed slum neighborhoods. To accommodate the growing population and diminish a public nuisance, the police drove several thousand hogs uptown to what were then the city's outskirts.

The problem, however, was much greater than roving pigs. It involved the disposal of horse carcasses, bones of butchered cows and sheep, and carrion from public markets. To remedy the situation, certain well-connected businessmen initiated what might be called the city's first recycling effort: the boiling of animal bones to produce glue and other useful products. What remained was cut into buttons or ground and fired to create the bone ash used in the manufacture of china and fertilizer. Bone marrow was turned into tallow.

But the steaming caldrons in which bones were boiled wafted odors that were even more unpleasant than the stench of the streets. Beginning in 1858, bone-boiling works and laborers' shanties had to be removed from the area that was to become Central Park. Similar operations inconveniently close to the city's inhabited areas would also be pushed out. Yet the garbage remained. As an initial recourse, a consortium of businessmen began to purchase offal, carcasses, random bones, and hotel kitchen waste for a de minimis price, which they then had ferried to South Brother Island, located in the middle of the East River. There they set up a commercial waste-processing operation.

Offensive odors wafting across the river led to protests from wealthy South Bronx estate owners and residents of small villages in northern Queens. After the Queens County Supreme Court issued an injunction against the owners, blood and entrails were simply thrown into the East River. To get rid of this repulsive flotsam, the city began to search for waste-disposal sites farther away. Soon scows plying a route through the Narrows and along the southern shore of Brooklyn were ferrying refuse to Barren Island, one of the marshes on the western edge of Jamaica Bay. This then was the first bite out of a big marsh pie, of which the last mouthful would be Fresh Kills on Staten Island.

Through the late nineteenth and early twentieth centuries, randomly sited private disposal operations were replaced gradually by municipal garbage dumps on the remote, marsh-covered edges of New York City. Under the onslaught of waste, each locale followed the same progression, turning from a low-lying marsh into a hill as high as a ten-story building before being decommissioned and covered with a layer of soil. Today you can see these unnatural hills in several places around the city's perimeter. Four gargantuan ones are located on the former marsh at Fresh Kills, which until the second half of the twentieth century had remained much as it was when

botanist Peter Kalm beheld it in 1748, a vast tide-washed salt meadow with meandering creeks where Henry David Thoreau poked about Native American shell heaps and collected arrowheads. To learn how the city solved its waste disposal problem—at least until the closing of Fresh Kills—it is necessary to examine the role of Robert Moses as New York City's prime urban planner.

Moses's Landfill Parks

Robert Moses, a man with a vision as comprehensive as that of Baron Eugène Haussmann, whose monumental makeover of nineteenth-century Paris made it the world's first modern city, reigned as New York's virtual czar of public works from the 1930s until the end of the 1960s. During this period the city grew highway tentacles connecting it with great river- and bay-spanning bridges to the edges of its outer boroughs as well as its surrounding region. With the political clout to gain authority over the Department of Sanitation's decommissioned landfill sites, Moses was even able to designate which marshes he wanted filled next for the purpose of building new parks.

To get an idea of the amount of former marshland he converted to recreational use, take a tour around Jamaica Bay's perimeter via Google Maps, and drag your mouse alongside Moses's Belt Parkway across Canarsie Park's ball fields, Brighton Playground, Manhattan Beach Park, Spring Creek Park, and other swaths of green representing his well-publicized "unlimited possibilities for recreational development" on former landfills. And these were not the only parks Moses built on top of former marshes. Flushing Meadows Corona Park in Queens, site of the 1939 and 1964 World's Fairs, both brainchildren of Robert Moses, was once a thousand acres of salt marsh. On Staten Island there is 580-acre Great Kills Park, a Moses landfill park that

opened in 1949, which is now part of the Gateway National Recreation Area.

In 1947, when Great Kills reached capacity, Moses began eyeing another Staten Island wetland as a potential site for a post-landfill park. This was Fresh Kills. Its designation as such, however, occurred only after Moses had undertaken several ingenious political ploys, one of which was to get the Staten Island borough president to override the objections of some of his constituents by promising that the landfill would not accept raw garbage after 1951—a promise that was honored in the breach. He then made sure that the West Shore Expressway, the quid pro quo for the borough president's acquiescence to dumping on the Fresh Kills marshland, was funded in part by the Department of Sanitation, which paid for the construction of the infrastructure for the roadbed of the West Shore Expressway and a $4 million bridge across Fresh Kills Creek.

Although Fresh Kills's 2,200 acres could contain half a century's worth of refuse, when it reached capacity there would be virtually no New York City wetlands left. One by one, as older sites were decommissioned, the city's options for solid-waste disposal dwindled. By 1990, it had in operation only two remaining landfills: Edgemere in Queens and Fresh Kills on Staten Island. In 2001, after a fifty-three-year period during which approximately twenty barges, each carrying 650 tons of garbage a day, had dumped their loads, landfill operations at Fresh Kills ceased. Now the city faced a two-headed conundrum: how to dispose of its unceasing stream of waste and what to do with the gargantuan earthwork on Staten Island.

The first step was to cap and seed over the landfill's four 225-foot-high contoured mounds. An impermeable fabric layer was installed to prevent surface contamination and was covered with a six-inch layer of topsoil. Perimeter trenches were dug around the mounds to collect leachate containing toxic materials. A network of wells and pipes was

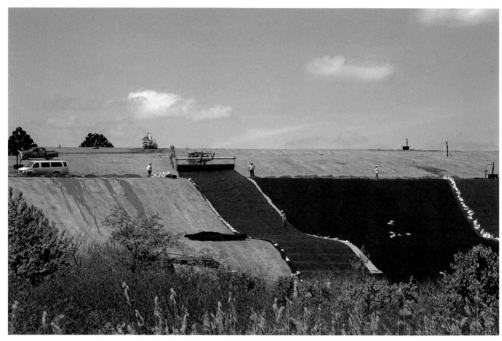

Capping of garbage mound at Fresh Kills

Methane release pipe, Fresh Kills

installed to release the methane gas that continues to form subsurface in the stew of decomposing garbage. This collection system is connected to an on-site treatment plant, which converts the methane to electricity powering 22,000 Staten Island homes. Native grasses were planted on top of the mounds and surrounding low-lying areas to create a landscape suitable for a much different kind of park use than Moses might have proposed.

A Park in the Making

Moses was no longer alive, and in any case authoritarian-style park planning by fiat had ceased when he had been dispossessed of his formidable political power thirty years before. A less autocratic determination of the future of Fresh Kills than he would have made was necessary, and the site was therefore put under the temporary jurisdiction of the City Planning Commission. In 2001 the commission, along with the New York Department of State Division of Coastal Resources, sponsored a two-stage International Design Competition to produce a master plan for Fresh Kills. Although such was its obvious destiny, the competition guidelines did not call for a public park per se, but rather "for the adaptive end use of this unique site."

The winning entrant, Field Operations, a New York firm headed by landscape architect James Corner, assembled a collaborative team composed of engineering, transportation, environmental-remediation, and habitat-restoration consultants. Implementation of the plan, which was begun in 2006, will take an estimated thirty years to complete. It calls for active recreation facilities along the perimeter and wetlands reconstitution in remnant marsh areas. The four central mounds that make up 45 percent of the site will remain grass- and scrub-covered and mostly treeless, lest roots penetrate the barrier fabric capping the

garbage. Only the pipes connecting to the wells that collect methane gas are allowed to perforate it.

To understand how his design of the park had taken the unconventional setting into account, I went to see James Corner. The answer I received was both romantic and practical. "First," he said, "you have to start with the place itself, its genius loci. Freshkills is vast by municipal park standards, nearly four square miles—that's three and a half times the size of Central Park. It is huge and hikeable, a remarkable sequence of journeys and panoramic vistas—of estuaries, New York Harbor, Lower Manhattan, and New Jersey. What we had to come up with were strategies for ecological restoration that take into account the unique conditions of the site."

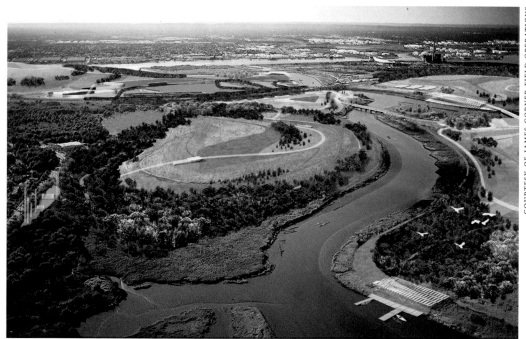

Design of Freshkills Park schematic plan

Mound meadow, Freshkills Park

Describing the area, he said,

It's a meadowland-in-the-making with something of the quality of
the English moors or midwestern prairies. There is a kind of melan-
choly about the place. Clearly, this is where overdesign could be a
problem. One thing you have to realize is that this is a very dynamic
landscape and, except for a couple of small recreational areas on the
perimeter that we were asked to design, fences had to be put up around
the entire landfill. The mounds are still deflating, so the topography
is continually changing. The landfill engineers have an obligation to
ensure that water sheds off their slopes and doesn't sink below the
surface, which would necessitate their having to be crowned again.
Therefore, the plan we submitted for the competition was not one
that could be realized in the short-term, even if that were possible.
Rather, our approach was to create a methodology and management
system that answers the problem of how to transform a closed landfill

over time, with all its issues of safety and environmental regulatory control, into publicly accessible parkland.

I asked Corner what the plan's methodology involved. He replied,

We have to start with soil. Right now the soil the landfill engineers used to cover the cap is a very thin layer of poor quality. It's not toxic, but it contains a lot of debris and has a high clay content. It doesn't meet the regulatory standards for public health or growing plants. Our methodology proposes creating topsoil of sufficient depth and quality in situ. This environmental approach is not one of immediate gratification, which is perhaps what politicians and the public might want. Here we were not so much designing in a formal sense as envisioning how to "grow" a park over a twenty- to thirty-year period. This is a time-based evolutionary approach that can be thought of as both agricultural and educational.

Getting down to specifics, Corner continued,

You have to think of it as a kind of farming, something like strip cropping, growing plants in ridges and furrows according to the contour lines of the slopes. In this case, the crops can be something fast-growing, such as kale, which can be plowed under every six weeks in order to build up an organically rich new soil layer. Within five years, this will increase to a depth of eight or nine inches. At the same time, when you plant this way in horizontal bands you are creating buffers against erosion. An agricultural landscape like this has its own integrity as scenery. For instance, if you are driving on the Staten Island Expressway at sixty miles an hour, you will see a band of gold mustard contrasting with one of green kale for three-quarters of a mile. The tractors plowing the organic material into the earth will be another visually interesting attraction. The whole process of this

kind of technologically engineered ecology provides an opportunity for Freshkills to offer a great educational demonstration in environmental sustainability.

Even with the in-situ soil creation Corner is talking about, it would be difficult to grow deep-rooted trees in the thin layer that will accumulate on the mounds. Nor would Corner find trees desirable in this location. He pointed out that the long waving grasses that have already taken root on the mounds echo the prairie aesthetic he hopes to see amplified over time, and that the idea is to get the four mounds to the point that they are stable and safe enough for long-term public use. Closer to the edge of the park, where there isn't a large amount of former landfill to contend with, there are sites with opportunities for eco-restoration. Explaining his vision for these areas, he said, "Instead of planting trees in a grid, here you can plant them in clumps, going back each year to add younger trees of varied species, such as you would see in nature. In this way, you get mixed-stage woodland stands in ten or fifteen years, which twenty years later would have matured into a continuous forest greenbelt, screening out the highway and all the development outside the park."

He added:

Don't forget that there are still some tidal flats and wetland meadows and ponds where you can see some of the native marsh vegetation, and in these areas, some eco-restoration projects are currently under way. The only problem is phragmites. It's an invasive reed that loves to colonize disturbed wetlands, and once it takes hold, it just keeps spreading. But we are starting to take control of this with grazing goats.

As I raised my eyebrows quizzically, he said, "The goats are an especially intriguing part of the story. You see, goats are partial to

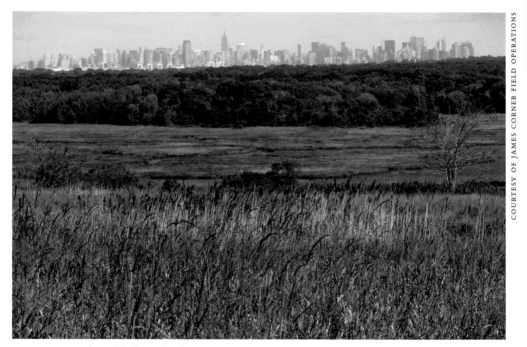

View of Freshkills wetland remnant and Manhattan skyline

phragmites, so we bring a herd in periodically and put them to work, which prevents the phragmites from spreading and forming a solid blanket."

Most of Freshkills will remain off-limits for several more years, until the landfill has settled sufficiently and the site meets the necessary regulatory standards for a public park. But there is a one-day annual event called Sneak Peek, a well-advertised, festive occasion that draws not only Staten Islanders but also numerous visitors from the other boroughs and New Jersey. Its purpose is to advertise the future in the form of Corner's plan. There is kayaking on the Arthur Kill and kite flying atop North Mound, hiking along defined trails, and guided tours in vans throughout the rest of the park-to-be.

When I attended the 2013 Freshkills Sneak Peek, it was a beautiful

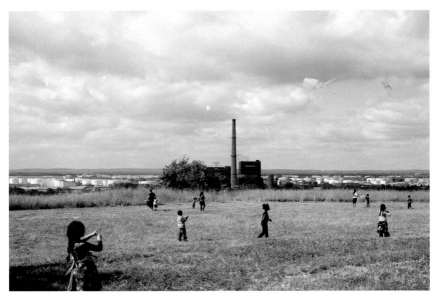

Kite flying at a Sneak Peak event, Freshkills Park

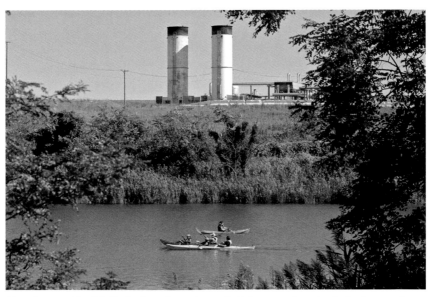

Kayaking at Freshkills Park with methane-fueled power plant in the background

autumn day, and two of the temporarily decommissioned phragmites-devouring goats were on display. It was obvious that wildlife does not discriminate between the natural and the man-made as long as the habitat is congenial. Snowy Egrets were poking their long bills into the shallow water next to mudflats, and Red-tailed Hawks and ospreys were cruising above revived marsh creeks and the former garbage mounds where garbage-scavenging gulls used to be the only birds to be seen. I spotted some white-tailed deer grazing in replanted, native meadow grass. Elsewhere the place had something of the air of a small-scale county fair. There were booths for food and kiosks for information and education, including an explanation of the recapture process that brings methane gas to the on-site reprocessing plant.

There are many old-time Staten Islanders who say they never want to go near Freshkills Park because of their memory of the repellent smell emanating from the site when it was still open landfill. But for Corner such negativity seems irrelevant when he considers the longer term, in which, according to his vision, there will be kayaking areas, lawns for events, and barges with floating flower gardens. Then there is the planned construction of a memorial atop the largest mound, where debris from the former World Trade Center site was deposited in 2001. Since some human remains had been gathered and loaded on barges inadvertently along with twisted steel, shattered glass, and concrete rubble, the memorial is intended to commemorate the recovery efforts that occurred in the aftermath of this discovery. As Corner describes it, the memorial will be a large earthwork consisting of two raised horizontal strips the same length as the height of the twin towers. Joined at their bases, they will form a V shape as they rise upward like canted ramparts. As with the Vietnam Veterans Memorial on the Mall in Washington, D.C., this memorial is intended as a walking experience: a pilgrimage that elicits a visceral response in the visitor. Because of their axial alignment with the footprint of the

World Trade Center, the panoramic view across the harbor at their apex will be focused on the site of the tragedy.

There are considerations besides those of design. Because of the park's remoteness from other parts of New York and New Jersey, Freshkills is not an obvious regional destination. Without ready transportation access, a park in this location will not necessarily serve as a stimulus for development, as in the case of Central Park, the High Line, and Brooklyn Bridge Park. There needs to be roadway access in and through it, and it is uncertain at present whether a currently proposed highway project will be designed as a scenic parkway or a straight here-to-there expressway. Corner says,

> It's an uphill battle, and there is a long way to go, but you could put a positive spin on it and argue that the Fresh Kills landfill is the best thing that has happened to Staten Island. What you have here is four square miles of land preservation, which will never be subjected to overdevelopment like the rest of the island. Our design methodology, based on landscape management through agricultural techniques and husbandry, is one that respects the scale, the character, and the lovely melancholy of the place just as it is.

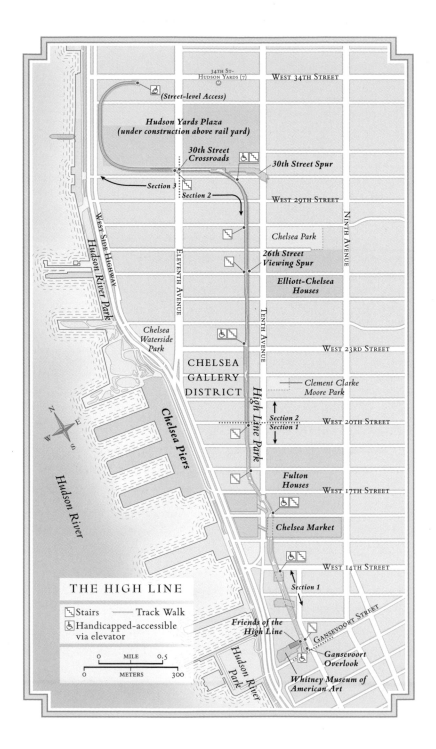

34TH ST-
HUDSON YARDS (7) Ⓜ WEST 34TH STREET

♿ (Street-level Access)

Hudson Yards Plaza
(under construction above rail yard)

30th Street
Crossroads ♿

30th Street Spur

Section 3

Section 2

WEST 29TH STREET

NINTH AVENUE

Chelsea Park

26th Street
Viewing Spur

Elliott-Chelsea
Houses

WEST SIDE HIGHWAY

Hudson River Park

ELEVENTH AVENUE

TENTH AVENUE

Chelsea
Waterside
Park

♿

WEST 23RD STREET

CHELSEA
GALLERY
DISTRICT

Clement Clarke
Moore Park

High Line Park

Section 2
Section 1

WEST 20TH STREET

N
W · E
S

Hudson River

Chelsea Piers

Fulton
Houses

WEST 17TH STREET

♿

Chelsea Market

♿

WEST 14TH STREET

THE HIGH LINE

🪜 Stairs ····· Track Walk

♿ Handicapped-accessible
via elevator

0	MILE	0.5
0	METERS	300

Section 1

Friends of the
High Line

GANSEVOORT STREET

Gansevoort
Overlook

Hudson River
Park

Whitney Museum of
American Art

CHAPTER EIGHT

GREEN PROMENADE AND ELEVATED RAIL SPUR

The High Line

In 1980 a train carrying three carloads of frozen turkeys rumbled along the 1.5-mile-long elevated trestle called the High Line into the manufacturing, warehousing, and meatpacking district located around Gansevoort and Washington Streets on Manhattan's far West Side. It was the last train to run on the High Line. The tracks had been elevated in 1934, after years of agitation over the frequent accidents at the on-grade pedestrian crossings along Tenth Avenue— or Death Avenue, as it was then called. But eventually containerized shipping made the West Side docks obsolete, and interstate trucking had caused a severe decline in rail transportation. Half a century after its inception, the useful life of this Hudson Line spur was over. Yet its owner, Conrail, did not want to shoulder the cost of taking it down.

For the next twenty years, as the railroad company made periodic efforts to sell off this unconventional piece of real estate, the surrounding neighborhoods of Chelsea and the upper West Village

were changing. The blocks of abandoned or marginally occupied buildings were steadily being converted into residential lofts, designers' studios, architects' offices, art galleries, and hip boutiques—a second-generation SoHo. If they thought about it at all, both the new occupants and pedestrians passing through the area wondered what this unusual overhead structure could be as it snaked into view and then disappeared again into warehouses where there had once been second-floor loading docks. Some passersby found the elevated track on which nothing moved intriguingly enigmatic, but most residents of the Chelsea Historic District to the east of Tenth Avenue thought of it as a blight on their neighborhood. Considering it an impediment to development, nearby property owners formed an association to urge its demolition.

Because it is thirty feet above street level, practically no one noticed that the High Line was also changing—but quite differently from the neighborhoods below. While the railroad company and City Hall dithered, time set in motion the inevitable process of decay and revegetation that makes all open-air ruins, even industrial ones, romantic evocations of the past. Slowly, inexorably, inconspicuously, nature was reclaiming a small piece of Manhattan. In a short time, a wide variety of plants had spontaneously seeded themselves in the spaces between the slowly rotting ties, and the disused rail bed had transformed itself into a linear meadow of wildflowers. The story of how the serendipitous vegetal colonization of this piece of abandoned train track inspired an elegantly designed, seven-acre public park is one of the most impressive chapters in recent New York City history.

From Novel Notion to Visionary Design

The story begins in 1999 when Robert Hammond, a young man who lived in the West Village just below the southern end of the High Line,

found his curiosity piqued by the puzzling piece of overhead industrial infrastructure he saw on his daily comings and goings through the neighborhood. Hearing that there was to be a community planning board meeting to discuss its future, Hammond decided to attend. As he listened to testimony that made the High Line's removal practically a fait accompli, he began to think it a shame that this relic of New York's past was being torn down. Only one other person in the room—Joshua David, who lived a few blocks to the north in Chelsea—seemed to share his contrarian view. After the meeting they exchanged business cards, then met again. As they talked about how to save this derelict piece of cityscape, they conceived the idea of forming an advocacy organization, which they named Friends of the High Line.

When the two subsequently obtained permission from the railroad to get up on the trestle, they stared in amazement at the ghostly sight of the steel rails, rotting ties, and the greenery growing up through the gray ballast in the roadbed. They were thrilled by the stillness and the breathtaking vistas of the Hudson River and surrounding city. They knew then that they wanted the High Line revived and put back into use, but in what way? One possible answer was light-rail transportation—an elevated subway line like the ones that used to run above Third and Sixth Avenues. But soon their first impressions of the place began to rule their thinking. Hammond says, "Our goal became to make what felt like a very private and privileged experience—almost like entering a magical world combining wildscape and incredible urban vistas—available to others without destroying that feeling." He and David began to envision the High Line as an elevated, linear park.

At the time Hammond was a business consultant versed in Internet marketing and David a freelance writer on subjects such as travel, fashion, and food; neither of them knew much about the workings of government or how to go about preserving a historic landmark.

Joshua David

Robert Hammond

They started out by consulting with members of the Central Park Conservancy and others who had formed public-private park partnerships. Looking for a precedent for an *elevated* park, they discovered the Promenade Plantée in Paris. Built on an abandoned nineteenth-century railway viaduct in the twelfth arrondissement, this 2.8-mile-long tree-lined walkway punctuated with individual garden areas did not to their way of thinking provide the right model. They preferred something that retained a semblance of the abandoned High Line's nature-taking-its-astonishing-course character, while at the same time capturing its potential as a free-flowing recreational space.

Establishing an organizational profile and raising money were obvious first priorities for Friends of the High Line, along with building trust among the different interests involved—neighbors, real-estate developers, City Hall, Community Board 4, Chelsea gallery owners, and others. Although the administration of Mayor Rudolph Giuliani had authorized the demolition of the trestle, Hammond and David's project had the good fortune to be endorsed by Mayor Michael Bloomberg immediately upon his taking office. But this critical boost for creative idealists treading on government turf was only the beginning. David's role was to sell the idea to all the disparate factions; this meant attending an almost endless number of evening meetings with local block associations and holding pizza parties for the residents of the nearby housing projects. It also meant simply getting out on the street in order to let people know that an organization called Friends of the High Line existed. "Flyers on lamp poles—you can't believe how important they are if you are trying to reach people in a geographically defined community," David says. "In the beginning, our voices simply weren't being heard. I did heavy, heavy papering of the neighborhood."

Meanwhile, Hammond was engaged in a different sort of networking. "I'm a problem solver," he says. "My biggest talent is getting

people together." His first effort was to build an electronic database by creating an e-mail list of all his friends and the friends of those friends. The next was to create a website that allowed Friends of the High Line to reach beyond this initial e-mail list and become a membership organization. Paula Scher, of the well-regarded graphics firm Pentagram, offered to create its signature logo and a correspondingly understated graphic style for all the publicity material. But Hammond realized that more was needed to promulgate the vision of the High Line that he and David shared. People had to be able to see what it looked like from above as well as below. Knowing that a professional landscape photographer, Joel Sternfeld, lived nearby, he contacted him.

Although Hammond may not have been aware of it at the time, Sternfeld, who is known for his utopian and dystopian depictions of place, had already displayed an interest in abandoned infrastructure; his book on the Roman Campagna contains many beautiful images of the first Claudian aqueduct. When Hammond took Sternfeld up on the High Line on a cold day in March 2000, the photographer was immediately hooked. As the two men stood in the strange quietness and gazed at its tangle of volunteer vegetation and the crossing and curving lines of the steel tracks, Hammond's idea of commissioning a publicity shot became for Sternfeld a yearlong project.

Provided with a pass by the railroad company, Sternfeld documented the site through the changing seasons. He only photographed, however, when the sky was a neutral gray: "I wanted it to be clear in the pictures that if there was glory in the High Line, it wasn't due to my skill as a photographer," Sternfeld says. "By not borrowing beauty from the sky, the High Line itself is what is important in the picture." More often than not, he set up his view camera with the lens pointing straight down the tracks:

> This sounds like a very obvious decision—to follow a path—but it is not. I was only ten when I read Thoreau. In time I read other nature

writers such as John Burroughs, Henry Beston, and Edwin Way Teale, but it was the writings of Joseph Altsheler that most influenced my work on the High Line. Altsheler wrote a series of "boy's" books that bore the general title of *The Young Trailers*. In these wilderness tales, skill in reading a path was a central element driving the drama. I decided to photographically follow a path. I felt as if I was the representative of eight or nine million New Yorkers who didn't have access to this secret landscape. I wanted to give them an unmediated sense of what it would be like to walk the High Line.

If nature was the first implicit partner on the High Line's yet-to-be-named design team, Sternfeld's compelling photographs, showing

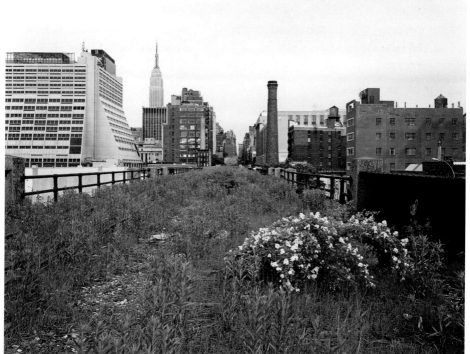

COURTESY OF JOEL STERNFIELD,
Looking East on 30th Street on a Monday Morning in May

The High Line, 2000

how the abandoned railroad trestle had already become a work of art, provided a compelling paradigm from which landscape architects might take their cues. His book, *Walking the High Line,* published in 2001, is a remarkable collection of views that reveal asters, goldenrod, Queen Anne's lace, and long grasses improbably set against a skyline background that includes the Empire State Building. And they depict not only the High Line's loveliness in summer but also its beauty in fall, when the dry grasses form a tapestry of ochre and sienna, and its graphic appeal in winter, when the dark steel rails appear as an elegant linear abstraction etched upon a band of white snow.

The evocative photographs of the serendipitous garden in Sternfeld's book and the accompanying exhibition at Pace/MacGill Gallery in the fall of 2001 were captivating. David made a point of getting other Chelsea gallery owners enthusiastic about saving the High Line; before long, Friends of the High Line had become a chic cause within the art world. A benefit auction in the summer of 2001 at the Mary Boone Gallery in Chelsea brought in 400 guests, propelled the young organization into the society columns, and raised $200,000. The following year, Martha Stewart, whose offices are in the 1932 Starrett-Lehigh Building, a landmark of modern industrial architecture occupying a full block just north of the Chelsea Market, cohosted a benefit with the actor Edward Norton. In 2004 the clothing designer Diane von Furstenberg opened her West Village studio for a cocktail party preceding a benefit held at Phillips de Pury & Company. Two years later, the proceeds from the summer benefit—a dinner held at Cipriani Wall Street—hit the million-dollar mark.

But more than money was needed. All politics in New York is, in the end, community politics: to hold sway, elected officials and organizations must have grassroots support. David, who is a populist by nature, was bent on rallying the residents of the housing projects, brownstones, and tenements in the surrounding neighborhood. The High Line was, after all, intended to be a public park in a part of the

city that had a very low ratio of green space relative to its population. With singular dedication, he put his personal life on hold and spent all his available time attending and organizing meetings with neighborhood block associations and getting members of the community to turn out for public hearings. It soon became apparent that he would have to give up his work as a travel writer and make Friends of the High Line his full-time career. As he immersed himself ever more deeply in promoting the park, he realized that getting appointed a member of Community Board 4 would give the Friends additional leverage. Serving on the board meant tending to numerous important, if not directly related, items of business, such as affordable housing and rezoning. His most important rewards were mastering the art of consensus-building and developing an intimate understanding of the issues that concerned his neighbors. For David the notion of the High Line as a park where all the diverse segments of the community could come together was an even more compelling vision than its potential as a unique urban planning opportunity.

Hammond, on the other hand, was committed to the idea that the new High Line should make a major design statement; he envisioned something outside the ordinary park paradigm. Like David, he found it necessary to give up his previous work in order to devote himself entirely to this end. In 2003 he decided to have what he calls an international, open-ideas competition, for which he assembled a jury of three well-known architects and two landscape architects. They ended up picking four winners from among 720 entries sent from 38 countries. Since ideas were being solicited instead of actual planning proposals, whimsy was not in short supply. One winner, Nathalie Rinne of Vienna, proposed a 7,920-foot-long swimming pool. Among the other ideas submitted were a fluorescent funhouse, a log-flume ride, a trellis-wrapped garden, a roller coaster, a mini–Appalachian Trail, and a landscape representing the three spheres of Dante's *Divine Comedy:* Hell, Purgatory, and Paradise. Hammond rented exhibition space at

Grand Central Terminal at a nonprofit rate and mounted a show of the winning schemes. To catch the attention of passersby, there was a continuous video presentation of brief clips in which project supporters praised the most important idea of all: turning the High Line into a park. In this context, the notion of converting a piece of starkly industrial architecture—and an elevated one, to boot—into a public green space no longer seemed particularly far-fetched.

If the ideas competition was chiefly for publicity, the international design competition announced in March 2004 was for real. Of course it generated its own considerable publicity, especially since the finalists included such international figures as the architect Zaha Hadid and the artist James Turrell. Hammond was delighted when the jury picked his first choice, the landscape architect James Corner, founder of the firm James Corner Field Operations.

When I went to see Corner, he explained, "My approach is always to let the site speak. I have to ask myself what is it that design may kill or destroy and how to design so that we not only preserve but grow and amplify existing potentials." Not surprisingly, his reaction was not unlike that of Hammond and David when they first saw the High Line at grade and not from below:

> I was really overwhelmed when I first stepped on the High Line and saw a thicket of trees growing there. Then I grew aware of the quietness of the place and of the magnificent vistas and views. I was very impressed with the way in which a structure of steel and concrete and ballast was being colonized by nature. You could see how the rotting wood of the decaying railroad ties was creating soil in which seeds blown by the wind or dropped by birds could germinate. The question became how to amplify this mysterious dichotomy between nature and the city by giving one a profound sense of being part of the urban fabric and yet divorced from it in some special way.

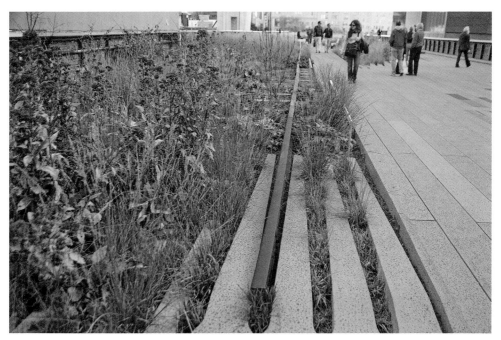

The High Line promenade

Elizabeth Diller and Ricardo Scofidio, principals in the architectural firm Diller Scofidio + Renfro, were Corner's collaborators, along with Dutch garden designer Piet Oudolf, who is known for naturalistic plantings of grasses and perennials, which he arranges in meadowlike drifts. Both hardscape and landscape elements were integrated by the design team in such a manner as to reinforce the visitor's sense of the High Line as a place with a past as well as a present and the fact that the park is indeed, as its name implies, *linear*. Corner explained:

> We made the paving planks open up and split apart to form a parallel series of linear planting beds, contained by bands made of the same concrete aggregate as the promenade planking. In size, color, and

texture, the stones within the aggregate resemble the ballast between the original ties of the railroad tracks. The volcanic gravel mulch in the planting beds also matches the original ballast. Irrigation of the planting beds was solved by canting the subsurface concrete platform for the promenade paving to allow water that falls into the joints of the planks to drain into the beds. The small amount of water that is not absorbed then flows into drains at the edges of the promenade where it is captured and recycled. As a final design refinement, pieces of track were left in place and incorporated into the paving, a ghostly memory of the High Line's former function.

Just Two Guys with a Logo

When an innovative design succeeds as well as the High Line's has, there is a sense of inevitability about it. But to realize a vision, particularly one as unconventional as the conversion of a rusting elevated rail spur into a park, takes political acumen, good leadership, management skills, creative fund-raising, and no small amount of luck. While everyone now takes the presence of the High Line for granted, people still ask, "How did those two guys do it?"

With his unerring instinct for the right kind of publicity, Hammond approached Terence Riley, then chief curator of architecture and design at the Museum of Modern Art, about the possibility of mounting an exhibition of the plan for the future High Line. To his surprise, Riley immediately agreed to exhibit the winning entry of the Field Operations team for three months. The exhibition opened in April 2005 and proved to be so popular that the museum extended its three-month run until October 31. This was a key moment, Hammond recalls, when "people's expectations changed and things really started to move forward."

As important as the buzz generated by the exhibition, which would help the Friends raise the $4.4 million in private funds that they would contribute to the construction of the first segment of the High Line, was obtaining the necessary government approvals and core financial support, without which the project would stall. This involved a good deal of grunt work long before and after the exhibition took place. By a stroke of good luck, Gifford Miller, a college friend of Hammond's, was the head of the City Council at the time, and he and fellow council member Christine Quinn scheduled a hearing in July 2001. David says, "We had to get everyone we could possibly get to be there. I worked on that for a month. All I did was call people, get them to promise to come or to give me letters to bring if they weren't coming. We got letters from all the important galleries, all of the important block associations. They made a big thump when I laid them down on the table."

Emerging victorious from the hearing, they still needed the City Council's financial support. Through Miller's leadership, $15.75 million for the project was voted into the council's capital budget. Then in 2004, City Hall announced a $43.25 million appropriation in the mayor budget. It appeared that only five years after David and Hammond had formed Friends of the High Line, their seemingly impossible dream had become a real project in the minds of both the public and the municipal government.

There was yet another hurdle to overcome: obtaining a Certificate of Interim Trail Use from the federal Surface Transportation Board. Under the terms of a congressional program called Rails to Trails, the railroad could donate the High Line to the city for use as temporary linear parkland. (Since it is unlikely that railroad companies will reactivate their service on currently unused lines, "interim trail use" is a concept that is practically always honored in the breach.) At last, on April 11, 2006, Mayor Bloomberg, Deputy Mayor Daniel Doctoroff, New York senators Hillary Clinton and Charles Schumer, and

philanthropists Diane von Furstenberg and her husband, media executive Barry Diller, smiled for the camera at what would usually be called a groundbreaking; there was, of course, no actual ground to break in this case: only tracks, ballast, and debris to be removed. Now that construction of the first phase, referred to as section 1, was certain, Friends of the High Line began to negotiate a license agreement with the city, which would allow the group authority over the day-to-day operations of the High Line when it became a public park. Within city government, Amanda Burden, chairman of the New York City Planning Commission, and a strong proponent of the project from the beginning, was given the job by the mayor of acting as client representative. Her eye for design detail, honed when she earlier oversaw the construction of the Battery Park City esplanade, made her an active participant in many day-to-day on-site decisions.

I first walked the High Line with Hammond in 2001 when the tracks were still covered with the same grasses and wildflowers one sees in Sternfeld's photographs. And although I had been interested in the project from the time when it was, in his words, "just two guys with a logo," I secretly harbored reservations about how it would turn out. Wasn't the small miracle of spontaneous revegetation in the most starkly industrial kind of landscape a humbling reminder of nature's enduring fecundity, something precious that would be lost? Like Hammond, David, and Corner, I wanted other New Yorkers to experience the magical views of the city from this unusual perspective, but at the same time, I feared that even the meticulous minimalism of Corner's design would destroy the kind of beauty that provided so much of the High Line's mysterious attraction.

My walk on the new High Line in the fall of 2009, shortly after section 1, the stretch that runs from Gansevoort to Twentieth Street, opened to the public, was a revelation. I was pleased to see how the remnant tracks, paving planks, and slim, backless wood benches pay homage to the fact that the High Line is still really a *line*. Its flow is

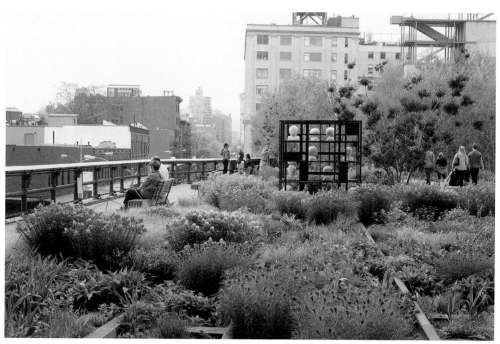

The High Line, section 1, looking south, planting by Piet Oudolf

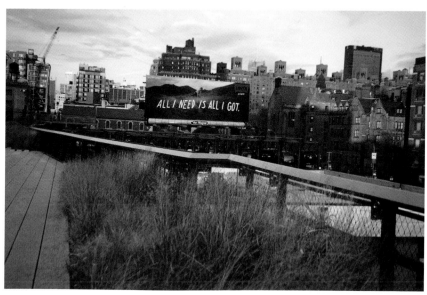

Cityscape view from section 1, the High Line

reinforced by the planting beds, which are defined by raised bands approximately the same width as the old railroad tracks. The plants growing in the narrow strips of soil in between have an air of spontaneity that evokes the vegetation that was there before. The contained bed built to accommodate the roots of the grove of birches next to Gansevoort Overlook has been given thin walls of COR-TEN steel, whose rust color harks back to the defunct trestle's decaying beams.

As Corner's "scripted" design-as-choreography envisioned, the High Line's intensely urban context is dramatized. Visible along the edges are a number of billboards oriented toward the drivers below. Their eye-catching, high-end advertisements constitute part of the design's borrowed scenery, making the visitor aware that the High Line is first and foremost an urban walkway separated from, but part of, the ever-changing city.

The wide passage running through what was once the second floor of a warehouse—now the Chelsea Market—where freight trains formerly stopped next to loading docks, is a "gallery" for public art. The permanent installation within this space is Spencer Finch's *The River That Flows Both Ways,* 700 individually crafted panels of colored glass in shifting, camera-captured, aquatic tonalities, depicting, image by image, the way in which the tidal exchange of water in the Hudson over a single day makes the current reverse direction. Friends of the High Line also seeks to exhibit temporary artworks. Working in collaboration with the New York City Department of Parks & Recreation, the organization has commissioned several site-specific pieces. Installed at various locations along the length of the High Line, they appear as casual rather than intrusive landscape interventions.

The High Line's most significant artwork, however, is not that of a sculptor, painter, or conceptual artist; rather it is found in the color, texture, composition, and scale of Piet Oudolf's continually transforming, four-seasons plant tapestry. This is where many visitors focus their cameras as they notice the subtle alterations in plant-

ing motifs and thematic contrast as each segment of the promenade merges with the next. When I walked with Oudolf one day on the High Line, I learned why his collaboration with Corner had turned out to be so successful. Explaining how he incorporated the landscape architect's fundamental design narrative into a vegetal narrative of his own, Oudolf said,

> The High Line really changed my style. More and more, ecology is part of my design approach. But not entirely. Ecosystems can be beautiful but not necessarily so. My approach is a design one; the plants have to have complexity and depth. They must make a picture. You have to have coherence within a free-flowing design. Ecology and aesthetics have to combine. Jim wanted me to translate his narrative into my own terms; to do this, I had to have a conceptual narrative too.

Oudolf's narrative can be said to be Neo-Romantic. It harks back to the same kind of wildness and mystery I experienced when I saw the High Line's overgrown roadbed for the first time. Oudolf claims, "I wanted to make my design both sensory and poetic, with an element of memory. People should *feel* something about this place in time."

When I inquired how Oudolf was able to orchestrate his planting plan so as to achieve what he calls thematic matrices—individual yet blended segments of the High Line landscape in which a series of dominant plant species, grasses as a rule, are used as a background medium for an amazingly varied vegetative palette—he replied, "Jim's narrative really helped me to create my own plant narrative within it. He has an ecological approach, and I liked that. On his plan for the High Line there were places he had designated as woodland or wetland or grassland. I knew what I had to do."

He went on to explain to me how he is able to achieve the effect of a landscape in which plants seem to come up spontaneously:

I think of the High Line and my other work, too, as four-dimensional design. Time and seasonality are critical factors. Plants grow, change, and die. They also seed themselves. You therefore have to think about succession—what will come up spontaneously and how that will appear within the context of what is already there. That is the dimension of time: thinking about how things are going to look next year and the year after that, knowing some of the rules of nature even though nature is often an unpredictable partner. You also have to think about seasonality—of what things are going to look like at different times of the year. I think it's beautiful when plants go to seed. Perennials don't need to be deadheaded. Coneflowers, astilbes, and echinaceas look great when their flower heads turn brown, and I like the way grasses get tall at the end of summer, with plumelike seed heads that wave in the breeze.

Fortunately, from the time the first plantings were installed up to the present, the High Line's horticultural staff have taken their maintenance cues from Oudolf's original scheme. The current director of horticulture, Thomas Smarr, has a keen appreciation of the unique landscape that became his responsibility, and it is clear that, while relying on his own day-to-day decisions as a trained botanical garden director, he has wholeheartedly bought into Piet Oudolf's aesthetic. "This is challenging plant material," he told me. "It is important that Piet stays involved, because this type of landscape is about changing ideas. I am fortunate to be in an ongoing dialogue with the place and also the designer."

The Home Stretch

The last segment of the High Line—section 3—was in construction when I called on Corner in his large, light-filled Tenth Avenue office

looking out at the sweep of the Hudson River and down toward the High Line's northern terminus at Thirty-Fourth Street. I asked him whether he thought the intense redevelopment of the Hudson Yards would cause the High Line to become overcrowded with an excess of visitors coming from the adjacent high-rise buildings. His reply was positive:

> There is such a frenzy of new construction taking place in the Hudson Yards, and this is going to produce thousands of nearby residents. This is something we have had to consider in our design. Also, we have had to take into account the fact that here we have an entirely different set of parameters than in section 1 and section 2. There are fewer existing assets you can leverage and fewer of the kind of adjacencies you have in Chelsea and the meatpacking district, where we had a lot of bricolage—balconies, fire stairs, bricks, collections of ad hoc stuff—to play off of. Section 3 is where the High Line is no longer parallel to Tenth Avenue but turns west and then runs north along Twelfth. Because it traverses the Hudson Yards, it is much more open visually. It has assets such as beautiful sunsets over the river and views of the Palisades, but the scale and surrounding urban scenery are entirely different. We call the place where section 3 begins at Thirtieth Street the Crossroads.

Explaining how the design negotiates this nexus of change, Corner continued, "This is a major entrance where people will be deciding in which direction they are going to walk: up to the Hudson Yards Plaza, which is a few feet above the High Line; south into section 2; west as they enter section 3; or along the spur that once delivered mail to the old Farley Post Office on Eighth Avenue across from Penn Station. Since we are anticipating congestion at this point, there will be an extended platform space with wooden stair-step seating."

On a beautiful Sunday a few months after the opening of section 3

I took a walk on the High Line. The weather and the fact that it was the weekend naturally brought out a large number of visitors, but a mood of pleasurable tranquillity was evident in the way people moved at a promenade pace or sat in quiet groups on benches. Just as Corner had suggested, the experience altered after I made the turn west where the tracks veer toward Twelfth Avenue. Although still confined by the High Line's steel side panels and moving along a directional corridor, I was now walking across a spacious platform with an exhilarating breadth of view in all directions. Here I could feel the breeze blowing off the Hudson and see the highway, bikeway, and Hudson River Park below being used by others who were enjoying the same kind of experience of scenery in motion as those of us who were walking the High Line. Tall cranes in the Hudson Yards signaled the growth of a dynamic district that is part of the new New York, a city where old skyscrapers are now being dwarfed by others built according to a revised building scale. At the same time, the place felt intimate and sociable wherever there were people gathered in clusters on the commodious benches found at intervals along the way.

An especially imaginative feature: a portion of the planking has been cut away to expose the beams beneath, making it possible for people to see the High Line as a piece of industrial infrastructure. More than an engineering lesson, however, these girders, which have been coated with a rubberized material, constitute a novel kind of playground.

An even more imaginative design move was the decision to allow the final stretch of the High Line to sink back into history. Where the tracks, which run parallel to Twelfth Avenue in the last segment of section 3, swing back toward the east, horticulture bows out and serendipitous vegetation growing amid the old rails and rotting ties makes an evocative final appearance of pre-park wildness. Skirted by a walk of stabilized ballast rather than the familiar concrete aggregate planking that defines the rest of the High Line, this piece of industrial

Section 3 of the High Line, looking north beyond the Hudson Yards

The High Line, exposed rubberized girders as a play feature

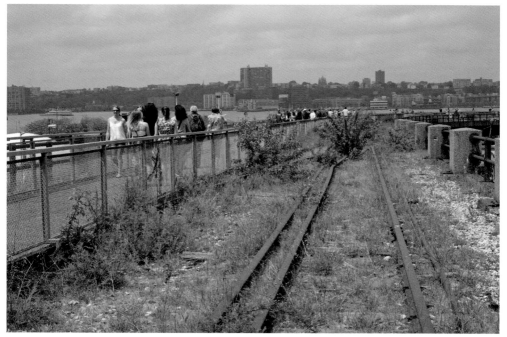

The High Line, remnant of original tracks

poetics is a lesson in nature's own dynamic, a continually evolving tapestry of plant life subject to forces of unending change.

It was a still fall night when I last walked the High Line. As I passed along the softly illuminated planting beds, surrounded by the lights of the sparkling city and the sweep of the Hudson River, my thoughts turned to the multifaceted, incomprehensible marvel that is New York. Pausing beside the grove of birches next to the Gansevoort Overlook, I was searching for words to express the emotion I felt. Then I recalled a passage from F. Scott Fitzgerald's *The Great Gatsby:*

> As the moon rose higher the inessential houses began to melt away until gradually I became aware of the old island here that flowered once for Dutch sailors' eyes—a fresh green breast of the new world.

Its vanished trees . . . had once pandered in whispers to the last and greatest of all human dreams; for a transitory moment man must have held his breath in the presence of this continent, compelled into an aesthetic contemplation he neither understood nor desired, face to face for the last time in history with something commensurate to his capacity for wonder.

But then I drew back from this reverie to ponder whether the New York cityscape at which I gazed wasn't also a marvel, one that would have been even more astonishing than the densely vegetated island to the eyes of Dutch sailors. And wasn't the recovery of this forgotten industrial scrap of it four hundred years later something commensurate with our own capacity for wonder at the endurance of both nature and human aspiration?

DIRECTIONS TO PLACES
DESCRIBED IN THIS BOOK

Below are some directions to the parks included in this book. If they do not suit your particular needs, the website of the New York City Department of Parks & Recreation, www.nycgovparks.org, includes a mapping function to provide individualized directions to specific parks through Google Maps. The Friends of the High Line website, www.thehighline.org, is also useful.

Staten Island: High Rock Park

Location: Richmond Parkway, Manor Road, Summit Avenue, Rockland Avenue, and Moravian Cemetery.

PUBLIC TRANSPORTATION
Take Staten Island Ferry to St. George Terminal. Transfer to bus S74 with a change to S84 (or S76 with a change to S57) to Rockland and Nevada Avenues (a short walk to the park entrance).

AUTOMOBILE
Cross the Verrazano-Narrows Bridge and in 2.5 miles take exit 12 for Slosson Avenue toward Todt Hill Road. In .03 miles take Manor Road to Nevada Avenue, and after 3.1 miles turn left on Nevada Avenue and proceed to park entrance.

Jamaica Bay Wildlife Refuge

Location: Cross Bay Boulevard between Howard Beach and Broad Channel, Queens.

PUBLIC TRANSPORTATION
Take A-train subway (Rockaway division) to Broad Channel station. Descend stairs and walk straight ahead on Noel Road to Cross Bay Boulevard. Cross the boulevard and turn right, heading north a short distance to refuge entrance and National Park Service Visitor Center.

AUTOMOBILE
Take Belt Parkway, Cross Island Parkway, or Woodhaven Boulevard to Cross Bay Boulevard. Proceed south on Cross Bay Boulevard for approximately 1.5 miles past North Channel Bridge to parking lot adjacent to National Park Service Visitor Center.

Inwood Hill Park

Location: 207th Street and Seaman Avenue, Manhattan.

PUBLIC TRANSPORTATION
Take A-train subway to 207th Street station. Walk west on 207th Street for two blocks and cross Seaman Avenue opposite park entrance.

AUTOMOBILE
Take Henry Hudson Parkway to Dyckman Street exit. Proceed east to Seaman Avenue and park car near park entrance.

Central Park Ramble

Location: Bounded by Fifth Avenue, Central Park West, Fifty-Ninth Street, and 110th Street, Manhattan. The Ramble is located mid-park between the northern shoreline of the Lake and the Seventy-Ninth Street Transverse Road.

PUBLIC TRANSPORTATION

To enter from the West Side, take the C-train or B-train subway to Eighty-First Street. Enter the park and walk east. Cross the West Drive, walk south beyond the Swedish Cottage Marionette Theater and the Seventy-Ninth Street Transverse Road, continue south alongside the northern lobe of the Lake and cross Oak Bridge.

To enter from the East Side, take the 6-train subway to Seventy-Seventh Street, walk west to Fifth Avenue, proceed north two blocks to the Seventy-Ninth Street park entrance, walk west on Cedar Hill Path, and cross the East Drive immediately south of the Seventy-Ninth Street Transverse Road.

Roosevelt Island

Location: Middle of the East River opposite Manhattan from Forty-Fifth to Eighty-Fifth Streets.

PUBLIC TRANSPORTATION

Take the F-train subway to Roosevelt Island station or take the Roosevelt Island Tramway from the Tram Plaza located at Fifty-Ninth Street and Second Avenue in Manhattan. Begin walking in either direction or take the red minibus that traverses the length of the island, making stops at various locations.

AUTOMOBILE

Take the Ed Koch Queensboro Bridge from Thirty-Sixth Avenue in Queens. Go down the ramp to Roosevelt Island, and at the stop sign turn right (north) on Main Street. Park in the Motorgate Garage at 688 Main Street.

Staten Island Freshkills Park

Location: Victory Boulevard, West Shore Expressway, Richmond Avenue, Sign Road, Travis Avenue, and Arthur Kill Road.

This park, which is under long-term construction, is open to the public only for guided tours. For events information, see http://www.nycgovparks.org/park-features/freshkills-park/.

The High Line

Location: Between Gansevoort and Thirty-Fourth Streets parallel to Tenth Avenue.

PUBLIC TRANSPORTATION

Take the C-train subway to Fourteenth, Twenty-Third, or Thirty-Fourth Streets. Walk west to Tenth Avenue. Or take 7-train subway to Hudson Yards station and walk west. Access points by stairs at Fourteenth, Eighteenth, Twentieth, Twenty-Sixth, and Twenty-Eighth Streets and Tenth Avenue, Thirtieth Street and Eleventh Avenue, and at street level at Thirty-Fourth Street (wheelchair accessibility via elevator at Gansevoort, Fourteenth, Sixteenth, Twenty-Third, and Thirtieth Streets and at street-level at Thirty-Fourth Street).

ACKNOWLEDGMENTS

Field trips as well as library visits were an essential part of my research. In this book, the reader will hear the voices of the longtime habitués of particular places whose specialized knowledge of various forms of nature revealed facts, secrets, and mysteries I would never have discovered without their helpful tutorials. These include Michael Feller, the former chief naturalist of the New York City Department of Parks & Recreation, who accompanied me on numerous expeditions to observe natural phenomena in High Rock Park on Staten Island as well as in several parks in New York City's other four boroughs; geologist Sidney Horenstein, who carried me back in time through millions of years as we explored bedrock formations in Inwood Hill Park; mycologist Gary Linkoff, who taught me about fungi and invited me to accompany him on a mushroom-hunting expedition in Clove Lakes Park on Staten Island; and Donald Riepe, head of the Northeast Chapter of the American Littoral Society and the Friends of Jamaica Bay Wildlife Refuge, who took me in his boat to explore the marshlands he is helping to restore and sustain. My Central Park education was significantly furthered by geologist Henry Towbin, former Central Park Conservancy director of horticulture Neil Calvanese, former Central Park Conservancy Woodlands Manager Regina Alvarez, ornithologist Joe DiCostanzo, and environmental conservationist and author Roger Pasquier. In terms of history received from firsthand sources, I am grateful to Roosevelt Island historian Judy Berdy, one of the early residents of the "new town in town," who gave me a great deal of information about the island's storied past; Ambassador William vanden Heuvel, who explained how his boyhood admiration for Franklin Roosevelt sparked his campaign to create the FDR Memorial and Four Freedoms Park; Sally Minard, current president and CEO of the Four Freedoms Park Conservancy, who explained how this dramatic new addition to the New

York cityscape came into being. Regarding the design of New York City's newest parks, I thank Freshkills Park administrator Eloise Hirsch, who offered me an experiential preview of the plans to convert the city's largest and final decommissioned landfill into a public park; and Robert Hammond and Joshua David, co-founders of the High Line, who, along with James Corner, Piet Oudoulf, Patrick Cullina, and Thomas Smarr, helped me follow the transformation of this industrial relic into an internationally famous aerial promenade.

No author works alone, and I have been particularly fortunate in having Amanda Urban as my agent, Knopf as my publisher, Ann Close as my editor, and Ellen Feldman as the book's production editor. I am greatly indebted to them for their professional experience and helpful advice in meeting Knopf's admirably exacting literary standards. I am also grateful to Sara Cedar Miller and Margaret Oppenheimer for their assistance as readers and advisers before the book was submitted for publication. As always, I thank my husband, Ted Rogers, for his encouragement of this and all my other endeavors. Finally, I am proud to consider myself a member of the Department of Parks & Recreation extended family as well as that of the Central Park Conservancy. Without their duty and dedication to managing the greatest park system in the world, there would be no green metropolis or story of how it came into being.

BIBLIOGRAPHY

Abbot, Mabel. *The Life of William T. Davis*. Ithaca, N.Y.: Cornell University Press, 1949.

Arbib, Robert S., Jr., Olin Sewall Pettingill, Jr., and Sally Hoyt Spofford for the Laboratory of Ornithology, Cornell University. *Enjoying Birds Around New York City: An Aid to Recognizing, Watching, Finding, and Attracting Birds in New York City, Long Island, the Upstate Counties of Westchester, Putnam, Dutchess, Rockland, and Orange, and Nearby Points in New Jersey and Connecticut*. Boston: Houghton Mifflin, 1966.

Barlow, Elizabeth. *The Central Park Book*. New York: Central Park Task Force, 1977.

———. *The Forests and Wetlands of New York City*. Boston: Little, Brown, 1971.

Bolton, Reginald Pelham. *Inwood Hill Park on the Island of Manhattan*. New York: Dyckman Institute, n.d.

———. *Washington Heights, Manhattan: Its Eventful Past*. New York: Dyckman Institute, 1924.

Burnstein, Daniel Eli. *Next to Godliness: Confronting Dirt in Progressive Era New York City*. Urbana and Chicago: University of Illinois Press, 2006.

Caro, Robert. *The Power Broker: Robert Moses and the Fall of New York*. New York: Alfred A. Knopf, 1974.

Danckaerts, Jasper. *Journal of Jasper Danckaerts 1679–1680*. Ed. Bartlett Burleigh James and J. Franklin Jameson. New York: Charles Scribner's Sons, 1913.

Davenport, W. H. "Blackwell's Island Lunatic Asylum." *Harper's Magazine,* vol. 32, no. 189, February 1866.

———. "The Work-House Blackwell's Island." *Harper's Magazine,* vol. 32, no. 198, November 1866.

David, Joshua, and Robert Hammond. *High Line: The Inside Story of New York City's Park in the Sky*. New York: Farrar, Straus and Giroux, 2011.

Davis, William T. *Days Afield on Staten Island*. New Brighton, N.Y.: L. H. Bigelow, 1892.

Demcker, Robert, Auturo Parrilla, and Henry Hope Reed. *Central Park Plant List and Index of 1873*. New York: Department of Parks, Frederick Law Olmsted Association, and Central Park Community Fund, 1979.

Denton, Daniel. *A Brief Description of New York, With the Places Thereunto Adjoyning, Called The New Netherlands*. Reprinted from original edition of 1670. Cleveland, 1902.

DeVries, David Piertsz. "Voyage from Holland to America, A.D. 1632 to 1644," in *New-York Historical Society Collection,* 2d ser., vol. 3, part I. New York, 1857.

Eldridge, Niles, and Sidney Horenstein. *Concrete Jungle: New York City and Our Last Best Hope for a Sustainable Future.* Oakland: University of California Press, 2014.

First Annual Report on the Improvement of the Central Park, New York. January 1, 1857.

Griscom, Ludlow. *Birds of the New York City Region.* New York: American Museum of Natural History, 1923.

Henrick, Daniel M. *Jamaica Bay.* Charleston, S.C.: Arcadia Publishers, 2006.

Hill, George Everitt, and George E. Waring, Jr. "Old Wells and Water-Courses on the Island of Manhattan," parts I and II of *Half Moon Series Papers on Historic New York.* New York, 1897.

Juet, Robert. The Discovery of the Hudson River from "The Third Voyage of Master Henry Hudson Toward Nova Zemble . . ." *Old South Leaflets* no. 94. Boston. 1898.

Kalm, Peter. *The America of 1750: Peter Kalm's Travels in North America.* Ed. Adolph B. Benson. The English version of 1770, revised from the original Swedish with a translation of new material from Kalm's diary notes. New York: Wilson-Erickson, 1937.

————. *Travels in North America.* New York: Dover, 1966.

LaFarge, Annik. *On the High Line: Exploring America's Most Original Urban Park.* New York: Thames and Hudson, 2012.

McCabe, Robert A. *The Ramble in Central Park.* New York: Abbeville Press, 2014.

Miller, Benjamin. *Fat of the Land: Garbage in New York: The Last Two Hundred Years.* New York: Four Walls Eight Windows, 2000.

Mitchell, John G. *High Rock and the Greenbelt: The Making of New York City's Largest Park.* Chicago: Center for American Places at Columbia College, 2011.

Peet, Louis Harman. *Trees and Shrubs of Central Park.* New York: Manhattan Press, 1903.

Peters, George H. *The Trees of Long Island.* Publication no. 1 of the Long Island Historical Society, Summer 1952.

Sanderson, Eric W. *Mannahatta: A Natural History of New York City.* New York: Harry N. Abrams, 2009.

Seitz, Sharon, and Stuart Miller. *The Other Islands of New York City.* Woodstock, Vt.: Countryman Press, 1966.

Smith, James Reuel. *Springs and Wells of Manhattan and the Bronx, New York City, at the End of the Nineteenth Century.* New York: New-York Historical Society, 1938.

Thoreau, Henry David. *Correspondence.* Ed. Walter Harding and Carl Bode. New York: New York University Press, 1958.

Van der Donck, Adrian, in "Description of New-Netherlands," *Collections of the New-York Historical Society,* 2d ser., vol. 1 (1841). (This volume also contains "Extracts from the Voyage of De Vries" and "Extracts from DeLaet's New-World" as well as "Verrazano's Voyage, A.D. 1524" and "Juet's Journal of Hudson's Voyage.")

Viele, Egbert. *The Sanitary & Topographical Map of the City and Island of New York.* New York: Council of Public Health and Hygiene of the Citizens Association, 1865.

INDEX

Page numbers in *italics* refer to maps and illustrations.

Acadian orogeny, 6
Ahnsahnghong, 65–6
Albany, N.Y., 79, 80
Algonquian Indians, 42
Alphawood Foundation Chicago, 158
Altsheler, Joseph, 187
Alvarez, Regina, 117–21
Ambrose Channel, 64
American Acclimatization Society, 123
American chestnut, 20–1, 120–1
American Littoral Society, 53, 56, 62, 69
American Museum of Natural History, 16, 72, 124, 128
American Notes for General Circulation (Dickens), 139–40
American Revolution, 11, 22, 71, 81–4, 138
Army Corps of Engineers, 44, 61–3, 64
Arthur Kill, 16, 22, 23, 36, 176
Atha, Daniel, 118
Atlantic Flyway, 50, 59, 122
Audubon Society, 17
 see also New York City Audubon Society

Baffin Island, 59
Baltimore Oriole, 122–3, 128, *129*
Barren Island, 45, 167
Battery Park City, 194
Battery Park City Authority, 143

Bay of Saint Marguerite, 15
Bayonne Bridge, 16
Beach Channel, 58
Belt Parkway, 47, 168
Berdy, Judy, 149–53
Bergen Beach, 44
Berry, Wendell, 36
Beston, Henry, 187
Bird Hazard Task Force, 61
birds, migratory, xi, 50–1, 59, 122, 124–5, 128, 132
Birds of the New York City Region (Griscom), 124
bird-watchers, 50, 56, 69, 112, 114, 122–33
Black Wall Island, 64–9
Black Wall Marsh, 63, *66, 67,* 69
Blackwell, Jacob, 137–8
Blackwell, Robert, 137
Blackwell Park, 147
Blackwell's Island, *see* Roosevelt Island
Bloomberg, Michael, 185, 193–4
Brief Description of New-York, A: Formerly Called New-Netherlands, 43
Britton, Nathaniel Lord, 16, 17
Broad Channel, 4, 44, 48, 51, *52,* 53, 57, 61, 66, 69
Bronx, N.Y., xiv, 5, 12, 72, 78, 82, 167
Bronx Zoo, 126

Brooklyn, N.Y., xiv, 8, 12, 29, 31, 41, 42, 43, 44, 45, 46, 142, 167
Brooklyn Bridge Park, 179
Brown, Capability, 91
Brown, Nancy Mirandoli, 153–6, 162
Brown, Tom, 154
Buffer the Bay program, 59, 61
Burden, Amanda, 194
Burgee, John, 143–4, 146, 151
Burnt Island (Deadman's Island), 22
Burroughs, John, 187

Cage, John, 27–8
Calvanese, Neil, *113,* 114–15, 117, 118
Canarsie meadows, 42–3, 44
Canarsie people, 42
Canarsie Pier, 45
Canarsie Pol, 47, 60
Cape May Warbler, *130*
Caro, Robert, 46
Catskills, N.Y., 18, 97
Central Park, ix, x, xiv, *7,* 24, 74, 89–133, *92, 94,* 167, 172, 179
 Bethesda Fountain in, *94*
 Bethesda Terrace in, 93, 96, 97, 130
 birdlife of, xi, 112, 114, 117, 120, 122–33, *129, 130*
 Boathouse in, 107–8, 110, 118, 131
 construction of, 92–6
 flora of, 108–10
 Great Lawn in, *94,* 100
 Hernshead in, 128–9
 Lake in, 96, 97, 98, 103, 105, 114, 122, 128–9, 131
 Moses and, 110–11
 Olmsted/Vaux design of, 89–90, 91, 95, 96, 97, 108–10, 111, 114, 128
 Ramble in, *see* Ramble (Central Park)
 Reservoir in, *94,* 122
 Strawberry Fields in, 122
 Wollman Rink in, 110
Central Park Conservancy, xv, 112, 114, 115, 117–18, 120, 185

Chapel of the Good Shepherd, 147
Chapin, James, 16–17
Chapman, Frank, 124
Chapman Hall of Birds, 124
Charleston (Kreischerville), Staten Island, 18
Chelsea (NYC neighborhood), 181–2, 183, 185, 188, 199
Chelsea Market, 188, 196
Christmas Bird Count, 124
Church of God, 64, 65–6, *66, 67,* 69
cicadas, x, 17, 31–5, *33*
City Hospital, 150
Claremont Park, xiv
Cleaves, Howard, 17
climate change, 8–9, 44, 106, 121
Clinton, Hillary, 193–4
Cloisters, 81
Clove Lakes Park, 28, 30
Cock Hill Fort, 81, 83
Coler Hospital, 141, 149
Columbia University, 10, 27
Coming to Light (exhibition), 160
Community Board 4, 185, 189
Concepts of Independence, 155
Congress, U.S., 41, 146, 157
Conrail, 181, 182, 183, 186, 193
Cooper, Chris, 132
Corner, James, 171–6, 179, 190–2, 194, 196, 197, 198–9, 200
Cretaceous period, 18
Crooke, John J., 16, 36
Cross Bay Boulevard, 47, 48, 53
Cross Bay Veterans Memorial Bridge, 48, 58
Crotona Park, xiv
Croton Aqueduct, 93
Crystal Water Company, 19
Cuomo, Mario, 157

Danckaerts, Jasper, 21, 22, 26, 43
Dauphine, La, 15
David, Joshua, 183, *184,* 185, 186, 188–9, 190, 193, 194

Davidson, Jo, 160
Davis, A. J., 140
Davis, William T., 17, 19–20, 26, 29–30, 36–7, 39
Days Afield on Staten Island (Davis), 17
Deadman's Island (Burnt Island), 22
Demcker, Robert, 109, 110
Denton, Daniel, 43
de Vries, David Pietersz, 20
Dickens, Charles, 139–40
DiCostanzo, Joe, *127*, 128–30, 131, 132–3
Diller, Barry, 194
Diller, Elizabeth, 191
Diller Scofidio + Renfro, 191
Dobbs Ferry, N.Y., 78
Doctoroff, Daniel, 193–4
Dubos, Jean, 59
Dubos, René, 59
Dutch settlers, 20, 21, 42, 80–1, 87, 137, 145
Dutch West India Company, 80
Dyckman, Jan, 81
Dyckman Institute, 84

Earth Day, 29
East Asia, 121
East River, 77, 135, *136*, 138, 141, 142, 149, 161, 167
eBirdsNYC, 131
eco-culture, 112, 114, 117–20, 122
Economic Development Corporation, 59
eco-restoration, 172–5
Edgemere landfill, 169
egrets, 49–50, *50*, 59, 60, *60*, 61, 122, 178
Eibs Pond Park, 30
Elgin Botanic Garden, 10
Emerson, Haven, 23
Emerson, Ralph Waldo, 22–3, 36
Emerson, William, 23
England, 79, 91, 123
environmentalism, 29, 53–4, 56, 59, 61–2, 68

Environmental Protection Agency, 61
Eychaner, Fred, 158

Far Rockaway, 51
fault zones, 6
Feininger, Lyonel, 144
Feller, Mike, 30–6, *30*, 38
Field Operations, *see* James Corner Field Operations
Finch, Spencer, 196
Fishman, David, 150
Fitzgerald, F. Scott, 202–3
Flatbush, Brooklyn, 42, 43
Flatlands, Brooklyn, 42
Flora of Richmond County, The (Britton and Hollick), 16
Floyd Bennett Field, 45
Flushing, N.Y., 10–11, 109
Flushing Meadows, 45, 168
Follert, Madame, 83
Fordham gneiss, 5, 6, 72, 74
Forests and Wetlands of New York City, The (Rogers), x–xi
Fort Amsterdam, 20, 80, 137
Fort George, 81, 84
Fort Tryon, 81, 84
Fort Tryon Park, 71
Fort Washington, 81, 82
Fort Washington escarpment, 71
Four Freedoms Foundation, 144–5, 157
Four Freedoms Park, xv, 156–63, *158*, *159*
Franklin and Eleanor Roosevelt Institute, 145, 157
Franklin Delano Roosevelt Memorial, xv, 135, 141, 145, 146, 156–63, *161*
Fresh Kills (marshes and landfill), xv–xvi, 21–2, 29, 165–6, 167–9, 173, 175–6, *176*, 179
 capping of, 169, *170*
 methane recapture system at, *170*, 171, 172, *177*, 178
Fresh Kills Creek, 169

Freshkills Park, xi–xii, xiii, xv–xvi, *164*, *165*–79, *172, 173, 177*, 207
 design competition for, 171
 eco-restoration of, 172–5
 goats at, 175–6
 long-term methodology of, 171, 173–4, 179
 planned 9/11 memorial at, 178
 recreation facilities at, 173
 wetlands at, 175
Freshkills Sneak Peek, 176, *177*, 178
Friends of Jamaica Bay Wildlife Refuge, 53, 56
Friends of the High Line, 183, 185–6, 188, 189, 193, 194, 196
Friends of the Staten Island Greenbelt, 29, 30
Furstenberg, Diane von, 188, 194

Galleria Vittorio Emmanuele (Milan), 144
Gansevoort Overlook, 196, 202
Gateway National Recreation Area, 38, 41–2, 51, 54, 56, 169
Gilded Age, xiv
Giuliani, Rudolph, 185
glacial till, 3, 8
Goethals Bridge, 16
golden ragwort, *111*
Goldwater Hospital, 141, 149–50, 153, 154
Google Maps, 168
Gratacap, Louis Pope, 16, 17, 18
Gravesend, Brooklyn, 43
Great Britain, 22, 81–3, 137, 138
Great Depression, 111, 145
Great Gatsby, The (Fitzgerald), 202–3
Great Kills Park, xi–xii, 36, 37–8, 168–9
 radioactive pollution at, xii, 38
Green-Wood Cemetery, xiv
Grenville orogeny, 5
Griscom, Ludlow, 124, 125
Grote, Augustus, 17
Gruen, Victor, 142
Guardian of the Bay, 51

Hadid, Zaha, 190
Half Moon, 19, 79
Halprin, Lawrence, 147
Hammond, Robert, 182–3, *184*, 185–6, 189–90, 192, 193, 194
Harbor Herons Shore Monitoring Program, 60
Harlem Meer, 122
Harlem River, xiv, 72, 77, 85
Harriman, Averell, 135–6
Harris, Elisha, 24
Hessians, 81–4, 87
High Line, 181–3, 193
 nature's reclaiming of, xvi, 182, 183, 185, 190, 200
 Sternfeld's photographs of, 186–8, *187*
High Line, The (Sternfeld), *187*
High Line Park, xiii, xvi, 179, *180*, 181–203, *191, 195, 201, 202*, 208
 community organizing for, 185, 188–9
 Corner team's design for, 190–2, 194, 196, 197, 199–200
 design competition for, 190
 fund-raising for, 185, 188, 193
 gallery space at, 196
 ideas competition for, 189–90
 MoMA exhibition on, 192
 plantings at, 196–8
High Rock (Girl Scout camp), 29, 31, 35
High Rock Nature Center, 16, 30–1
High Rock Park, x, 30–6, *37*, 38–9, 205
Hitchcock, Henry-Russell, 140
Hollick, Arthur, 16, 17
Hopkins, Gerard Manley, 36
Horenstein, Sidney, 72, *73*, 74, 77, 78
horseshoe crabs, ix, 51, 57–8, *57*
horticulture, 10–11, 50, 108–9, 112, 114, 120, 198, 200
Hosack, David, 10
Hudson, Henry, 19, 79–80
Hudson River, *6n*, 8, 11, 18, 71, 76, 77, 81, 83, 85, 143, 183, 196, 199, 200, 202
Hudson River Park, 200

Hudson River School, 97, 105
Hudson Yards, 199, 200, *201*
Huguenots, 10
Hunter Island, 11
Hurricane Sandy, 42, 48*n,* 67
Huxtable, Ada Louise, 141
Hyde Park, N.Y., 145, 155

igneous rocks, 6, 17, 18, 102–3
Indian artifacts, 20
industrial aesthetic, xv
International Design Competition, 171
Inwood, 71–87
 country homes in, 84–5
 deforestation of, 83
 geology of, 72
 Native American occupation of, 77–81
 Revolutionary War in, 81–4
Inwood Hill, 81, 82, 85
Inwood Hill Park, xiii, 11, 12, *70,* 71–87, *73,*
 75, 206
 birdlife of, 76, 77
 the Clove in, 74, 77, 78, 81
 forest of, 71, 74, 76–7, 85, *86*
 Indian Cave in, 12, 74, *75,* 78
 wetland of, 85, 86
Inwood marble, *5, 6,* 72, 74
Isham Park, *5,* 72
Island House, 147
Island Nobody Knows, The, 144

Jacob Riis Park, 49
Jacobs, Jane, 29, 141, 144
Jamaica Bay, ix, xiii, 41–69, *50, 66, 67,* 167,
 168
 Army Corps of Engineers and, 43–4,
 63–4
 Big Egg Marsh of, 58
 European settlement of, 42–3
 landfill projects in, 41, 45–6
 Little Egg Marsh of, 57–8, *57*
 marsh erosion in, 61–2, 63–8
 Moses and, 44, 46–8, 168

 Native Americans and, 42
 pollution of, 41, 43–4, 46, 62, 68
 port project for, 45
 wetlands in, 41, 44, 61–2, 63–8
Jamaica Bay Ecowatchers, 54, 62, 63, 66–7
Jamaica Bay Research and Management
 Informantion Network, 60
Jamaica Bay Wildlife Refuge, *40,* 47–51, *49,*
 53, 54, *55,* 205–6
 birdlife of, 49–51, *50,* 56, 58, 59, *60,* 61
James Corner Field Operations, xii, 171,
 190, 192
Japan, 11, 76
Jefferson, Thomas, 10
Jo Co Marsh, 59, 60, 61
Johansen & Bhavnani, *146,* 147
John F. Kennedy International Airport, 41,
 45, 56, 60–1, *60,* 135
Johnson, Herbert, 47–8, 49, 50, 54, 56
Johnson, Philip, 143, 144, *146,* 151, 162
Juet, Robert, 19, 20

Kahn, Louis I., xv, 135, 141, 146, 155, 157–8,
 160–2
Kahn, Peter, 167–8
Kallmann & McKinnell, 148
Kalm, Peter, 21–2, 23, 24
kayaking, 176, *177,* 178
Kennedy, Robert, 145
kettle-hole ponds, 7, 18, 25, 32, 38
Kieft, Willem, 20
Kiley, Daniel, 147
Kill Van Kull, 16, 25
Kissena Park, 11
kite flying, 176, *177*
Knyphausen, Wilhelm von, 81
Krafft, John Charles Philip von, 82, 83–4
Kreischerville (Charleston), Staten
 Island, 18
Kurz, Doug, 132

Labadist colony, 21
LaGuardia Airport, 45

landscape architects, xv, 24, 90, 171, 189
LaTourette Park, 16
Laurentia, 6
Le Corbusier, 142
Lenape Indians, 19, 42, 78, 80, 137
Leng, Charles, 29–30
Le Nôtre, André, 160
Lenten rose, *116*
Lewis and Clark expedition, 10
Lincoff, Gary, 26–7, *27,* 28, 29
Lincoln Memorial, 160
Lindsay, John V., 135–6, 142–3, 146
Linnaean Botanic Garden, 11
Linnaean Society, 123
Linnaeus, Carl, 21
Logue, Ed, 143, 146, 147
Long Island, 42, 45, 65, 111, 138
Long Island City, Queens, 147, 148
Long Island Rail Road, 47
Long Island Sound, 85
Lovelace, Governor, 20
Lower Paleozoic era, 17

Magothy formation, 18
malaria, 24–5, 84
Manclark, Elizabeth, 57, 64–5
Manhattan, N.Y.
 birdlife of, 122
 geology of, 72, 74
 waste disposal in, 166–7
 see also Central Park; High Line Park;
 Inwood Hill Park
Manhattan Beach Park, 168
Manhattan schist, 6, 72, *73,* 74, 89, 92–3,
 98–107, *98, 101, 103*
Manning, John, 137
marshes, *see* wetlands
Mary Boone Gallery, 188
Mellins, Thomas, 150
Melyn, Cornelis, 20
metamorphic rocks, 5, 100, 106
Metropolitan Hospital, 150
Metropolitan Waterfront Alliance, 53

Metropolitian Transportation Authority,
 47, 148
Miller, Gifford, 193
Minard, Sally, 158
Minuit, Peter, 80
Mitchell/Giurgola, 157
Mitchell-Lama Housing Program, 144
Moravian Cemetery, 16
Moses, Robert, 86, 143, 168–9, 171
 Central Park and, 110–11
 Jamaica Bay and, 44, 46–8, 168
 parks seen as places of recreation by,
 xiv–xv, 37, 47, 86, 110, 168
 Staten Island and, xv, 29–30, 37–8
Moynihan, Daniel Patrick, 157
Muir, John, 35
Mundy, Dan, Jr., 54, 62, 66–8
Mundy, Dan, Sr., 54, 62, 66–7, 68
Museum of Modern Art, 192
mushrooms, ix, 26–9

Nagel, Jane, 81
Nagel family, 81, 84
Narrows strait, 8, 36, 167
National Endowment for the Humanities,
 156
National Park Service, 38, 51, 54, 56, 67–8
Native Americans, 10, 12, 20, 23, 42, 77–81,
 87, 168
Natural Resources Defense Council, 53, 62
nature
 High Line reclaimed by, xvi, 182, 183,
 185, 190, 200
 as intrinsic part of New York City, xiii,
 xvi, 4, 12–13, 133
 regenerative power of, 68, 71, 86, 115, 203
 Romanticism and, 35–6, 91, 97–8, 105,
 108
 as source of inspiration and solace, xiv,
 36, 69
Navy, U.S., 45
Nearing, Guy, 27
New Amsterdam, 20, 81

New Deal, 163
New Dorp, Staten Island, 16
New England Journal of Medicine, The, 150
New Jersey, 15, 25, 29, 65, 126, 172, 176, 179
New Netherland, 20
New York, N.Y.
 botanical evolution of, 8–11
 geology of, 4–8, 72, 74
 municipal government of, 82, 182, 185,
 193
 parkland map of, *2*
 urban development in, 53
New York Botanical Garden, xiv, 5, 26,
 109, 118
New York Central Railroad, 84
New York City Audubon Society, 53, 59,
 60, 61
New York City Board of Estimate, 85
New York City Council, 193
New York City Department of Buildings,
 142–3
New York City Department of
 Environmental Protection, 68
New York City Department of Parks &
 Recreation, 19, 30, 46, 47, 59, 85, 109,
 110, 111, 196
New York City Department of Sanitation,
 43, 45–6, 47, 165, 168, 169
New York City Environmental Fund, 60
New York City Planning Commission,
 171, 194
New York City Transit Authority, 47
New York Department of State Division of
 Coastal Resources, 171
New York Harbor, 15, 172
New York Mycological Society, 28
New York 1960 (Stern, Mellins, and
 Fishman), 150
New-York Packet, 138
New York State, xv, 68, 125, 135, 179
New York State Department of
 Environmental Conservation, 62
New York State Legislature, 143

New York Times, x
New York Zoological Society, xiv
Nicaragua, 69
Nicolls, Richard, 43, 137
Nipinisicken (Wickquasgeck village), 79
North America, 8, 25, 79, 120, 121
North American Mycological Society, 27
North River, 79
Norton, Edward, 188
Nova Scotia, 22, 50

Old American Nursery, 11
Olmsted, Frederick Law, xi, xiv
 Central Park and, 89, 90, 91, 95, 96, 97,
 98, 108–10, 111, 114, 128
 Staten Island and, 24–5
orogenies, 4–5, 6, 17–18, 72
ospreys, 51, 54, *55,* 178
Oudolf, Piet, 191, *195,* 196–8

Pace/MacGill Gallery, 188
Palisades, *6n,* 199
Palisades diabase, 18
Paris, 10, 168, 185
parks
 Moses's recreation-oriented approach to,
 xiv–xv, 37, 47, 86, 110, 168
 restoration of, xi, xv
parkways, xiv
Parsons, Samuel, Jr. (grandson), 109–10, 114
Parsons, Samuel Bowne, 11
Parsons Nursery, 11, 109
Pasquier, Roger, 126–8
Pataki, George, 157
Peach War (1655), 20
Peet, Louis Harman, 109–10, 114
Pelham Bay Park, xiv, 11
Pennsylvania Station, 146, 199
Pentagram, 186
Phillips de Pury & Company, 188
phragmites, xii, 38, 44, 175, 176
Piranesi, Giovanni Battista, 144
plate tectonics, 4, 17–18, 74, 106

Pleistocene epoch, 6, 8, 18
Pollara, Gina, 158, 160
pollution, 41, 43–4, 46, 62, 68
Port Authority, 63
Prince, Benjamin, 11
Prince, William, 10–11
Prince, William (son), 11
Prince's Bay, 24, 25
Promenade Plantée, Paris, 185
Prospect Park, x, xiv
Prospect Park Alliance, xv

Queens, N.Y., ix, 8, 11, 12, 41, 46, 48*n*, 65,
 142, 147, 148, 149, 167, 168, 169
Queensboro Bridge, 147, 148, 150
Queens County Supreme Court, 167
Quinn, Christine, 193

Rails to Trails, 193
Ramble (Central Park), xi, xiii, *88, 93,
 96–124, 98, 99, 103, 104, 107, 113,* 125,
 128, 129, 131, 133, 206–7
 Azalea Pond in, 120, 131, 133
 Belvedere in, 96, *99,* 100, 105, 112
 bird-watchers and, 112, 114, 122–33
 construction of, 98–100
 eco-culture in, 112, 114, 117–20, 122
 flora of, 110, 111–12, 114–15, 117, 118
 geology of, 100, 102–3, 105–6
 the Gill at, 104–5, *104,* 107, 114, 131
 invasive plants in, 111–12, 114, 118
 the Point in, 130, 131, 132
 Romantic aesthetic of, 97–8, 105
 stone arch of, *102,* 103
 Vista Rock in, 96, *99,* 100, 105
Rapozo, Wilmer, 65–6
Raritans, 20
Raunt, 44, 48
Rechquaakie, 42
Renwick, James, 137, 140
*Report to the Staten Island Improvement
 Commission of a Preliminary Scheme of
 Improvements,* 24

Richmond Creek, 22
Richmondtown, Staten Island, 16
Riepe, Don, 51, *52,* 53–61, 62, 63–4, 66,
 68–9
Riley, Terence, 192
Rinne, Nathalie, 189
River That Flows Both Ways, The (Finch), 196
Riviera (Central Park), 131
Rockaway Inlet, 63
Rockaway Peninsula (Rockaways), 41, 42,
 43, 44, 48, 58
Rockaway Waterfront Alliance, 53
Rockefeller, Nelson, 136, 143, 147
Rockefeller Center, 10
Roman Campagna, 186
Romantics, Romanticism, 35–6, 91, 97–8,
 105, 108
Roosevelt, Eleanor, 145–6
Roosevelt, Franklin Delano, 141, 145,
 155–6, 157, 160–1
Roosevelt Island, xiii, xv, *134,* 135–63, *136,
 146, 158, 159, 161,* 207
 FDR Memorial at, *see* Franklin Delano
 Roosevelt Memorial
 history of, 137–41
 hospitals on, 141, 149–50, 153, 154
 Johnson/Burgee plan for, 143–4, 146,
 150–1
 Octagon at, 140, 148
 quality of life on, 148, 151–2
 redevelopment proposals for, 141–4
 Rivercross on, *146,* 147
Roosevelt Island Disabled Association, 155
Roosevelt Island Garden Club, 155
Roosevelt Island Historical Society, 149
Roosevelt Island Operating Corporation
 (RIOC), 151, 152
Ross, Arthur, 158
Rubin, Jane Gregory, 158

Sadowski, Paul, 28
St. George, Staten Island, 16, 26, 31
Saint Virgilius Roman Catholic Church, 53

Sandy Hook, N.J., 42*n*
Scher, Paula, 186
Schumer, Charles, 193–4
Scofidio, Ricardo, 191
sedimentary rock, 6
Seneca Village, 91
Sert, Josep Lluís, 146–7
Shakespeare, William, 123
Sheeler, Charles, 144
Shorakapok (Wickquasgeck village), 78, 79,
 80, 81
Shore Parkway, 44
Short Treatise on Horticulture, A (Prince), 10
Silence (Cage), 27
Silver Hole Marsh, 61
Silver Lake Park, 30
Skinner, Alanson, 16–17, 20
skunk cabbage, *19, 38*
Sluyter, Peter, 21, 22, 26
Smarr, Thomas, 198
Smithsonian Institution, 137
Snowy Egrets, 49–50, *50,* 59, 76–7, 176, 178
Snyder, Gary, 36
South America, xi, 4*n*
South Brother Island, 167
Southpoint Park, *134,* 156
Spring Creek Park, 168
Springville, Staten Island, 18–19
Spuyten Duyvil, 79–80, 81, 85
Stapleton, Staten Island, 16, 29
Staten Island, N.Y., ix, x, xi–xii, xiii, *7, 8,*
 12, *14,* 15–39, 42*n,* 205, 207
 aquifer of, 18–19
 birdlife of, 12, 38
 botanical history of, 20–2
 European settlement of, 20–2
 Fresh Kills on, *see* Fresh Kills; Freshkills
 Park
 geology of, 17–19
 Moses and, xv, 29–30, 37–8
 Native American occupation of, 19–20,
 23, 168
 Olmsted and, 24–5

South Shore of, 36–9
suburbanization of, 26, 30, 36, 179
Thoreau and, 22–3, 26, 168
wetlands of, 21, 24–5, 36, 167–9
Staten Island Citizens Planning
 Committee, 29
Staten Island Expressway, 174
Staten Island Greenbelt, 17
Stern, Robert A. M., 150
Sternfeld, Joel, 186–8, 194
Stevenson, Adlai, 146
Stewart, Martha, 188
Straus family, 84
striped white violets, *119*
Strong, George Templeton, 89, 90, 97
sustainability, xv, 174–5

Taconic orogeny, 5, 6, 17–18, 72
Tartter, Vivien, 28
Teale, Edwin Way, 187
Thomas, William Sturgis, 27
Thoreau, Helen, 23
Thoreau, Henry David, 22–3, 24, 26, 36,
 168, 186
Tottenville, Staten Island, 16, 18
Towbin, Henry, 100, *101,* 102–3, 104–8, 131
Trees and Shrubs of Central Park (Peet), 109–10
Tweed, Boss, 137, 139

Udalls Cove, *9*
Umpire Rock, *7*
Underwood, Lucien, 27
United Nations, 137, 142, 145, 161
Urban Development Corporation (Empire
 State Development Corporation), 135,
 143, 147

Van Cortlandt Park, xiv
vanden Heuvel, William, 144–6, 156–60
van Twiller, Wouter, 137
Vaux, Calvert, xiv, 89, 90, 91, 96, 100, 108,
 109–10, 111, 128
Verrazano-Narrows Bridge, 15, 29, 31, 36

Verrazzano, Giovanni da, 15, 16, 19
Viele, Egbert, 99, 108, 110
Vietnam Veterans Memorial, Washington,
 D.C., 178

Walking the High Line (Sternfeld), 188
Welfare Island, *see* Roosevelt Island
Welfare Island Development Corporation
 (WIDC), 143, 146, 151
Welles, Orson, 156
West Shore Expressway, 169
wetlands, xi, 9–10, 12, 21–2, 24–5, 36, 41,
 44, 61–2, 63–8, 85, 86, 175
 as waste disposal sites, 167–9
Whiskey War (1643), 20
White, Shelby, 158

White Plains, Battle of (1776), 82
Wickquasgeck, 77–81
wild geranium, 115–17, *116*
Wildlife Conservation Society, 126
William T. Davis Wildlife Refuge, 16, 18,
 19, *19,* 30, 38
Willowbrook Park, 30
Wisconsin glacier, 8, 18
Wolfe's Pond Park, 30, 36
Woodland Management Committee, 112
Wordsworth, William, 36
World's Fair (1939; 1964), 168
World Trade Center, 143, 178–9

Yosemite National Park, 35
Young Trailers, The series (Altsheler), 187

A NOTE ABOUT THE AUTHORS

Elizabeth Barlow Rogers is the president of the Foundation for Landscape Studies. A native of San Antonio, Texas, she earned a bachelor's degree in art history from Wellesley College and a master's degree in city planning from Yale University. A resident of New York City since 1964, Rogers was the first person to hold the title of Central Park administrator, a New York City Department of Parks & Recreation position created by Mayor Edward I. Koch in 1979. She was the founding president of the Central Park Conservancy, the public-private partnership created in 1980 to bring citizen support to the restoration and renewed management of Central Park. She served in both positions until 1996. She is the author of nine books.

Tony Hiss, who was a staff writer at *The New Yorker* for more than thirty years and is now a visiting scholar at New York University, is the author of thirteen books, including *In Motion: The Experience of Travel* and the award-winning *The Experience of Place*. His next book is about the twenty-first-century challenge to prevent a mass extinction crisis by setting aside half the planet for other species.

A NOTE ON THE TYPE

The text of this book was set in Bembo, a facsimile of a typeface cut by Francesco Griffo for Aldus Manutius, the celebrated Venetian printer, in 1495. The face was named for Pietro Cardinal Bembo, the author of the small treatise entitled *De Aetna* in which it first appeared. Through the research of Stanley Morison, it is now generally acknowledged that all old-style type designs up to the time of William Caslon can be traced to the Bembo cut.

Composed by North Market Street Graphics, Lancaster, Pennsylvania

Printed and bound by Tien Wah Press, Malaysia

Designed by Iris Weinstein